FASHION, DESIRE AND ANXIETY

FASHION, DESIRE AND ANXIETY

IMAGE AND MORALITY IN THE 20TH CENTURY

REBECCA ARNOLD

First published in the United States 2001
by Rutgers University Press, New Brunswick, New Jersey

First published in Great Britain 2001
by I.B.Tauris & Co Ltd

Library of Congress Cataloging-in-Publication Data

Arnold, Rebecca.
 Fashion, desire and anxiety : image and morality in the twentieth century / Rebecca
 Arnold.
 p. cm.
 Includes bibliographical references and index.
 ISBN 0-8135-2903-4 (alk. paper) — ISBN 0-8135-2904-2 (pbk. : alk. paper)
 1. Fashion—Social aspects. 2. Fashion—History—20th century. I. Title.
 GT525.A75 2001
 391′.009′04—dc21 00-062533

Contents

Illustrations

Acknowledgements

This project would not have been possible without the help and enthusiasm of all my friends, colleagues and family and, although I cannot name all of them here, their encouragement has been greatly appreciated. First, I would like to thank my editor, Philippa Brewster at I.B.Tauris, for her constant support and excellent advice and comments on my text. I am indebted to Aileen Ribeiro for suggesting the idea for the project and encouraging me with its progress and Valerie Cumming for helping me in the early stages of its development. My thanks also to my colleagues in the Cultural Studies department at Central Saint Martin's College of Art and Design for their words of encouragement and to all the students there and at the Surrey Institute of Art and Design for contributing with such enthusiasm to my seminars based on this research. Central Saint Martin's also provided me with research funding to help obtain illustrations for this book, for which I must thank Jane Rapley, Malcolm Le Grice and Caroline Dakers. I especially want to thank Beatrice Behlen, Caroline Evans, Linda Sandino, Andrea Stuart and Alison Toplis for uncomplainingly giving up so much of their time to read drafts and offer crucial advice, criticism and encouragement, their friendship, support and inspiration has been invaluable. Finally, my thanks to Adrian Garvey and Mary Arnold for their patience, understanding and support throughout this project. This book would not have been the same without the contributions and suggestions of all these people.

Picture Acknowledgements

I am very grateful to Susan Lawson for her patience and persistence in gaining permissions for many of these photographs. My thanks also to all the photographers who have allowed me to use their photographs in this book, particularly Niall McInerney for his unfailing help and generosity. I would also like to thank the following people who helped in the obtaining of pictures: Philippe Garner, Martin Harrison, Olivia Funnell at Z, Kate at Sean Ellis, Jacqueline at Streeters and John Parkinson at the John Parkinson agency.

Photographic Credits

Metropolitan Museum of Art, New York, Figs.2, 14, 24
Eamonn J. McCabe, Fig.3
Niall McInerney, Figs. 1, 4, 6, 8, 9, 10, 13, 16, 17, 23, 25, 27, 29, 30, 33, 34, 36, 37, 38, 41, 42, 43, 44
Museum at the Fashion Institute of Technology, New York, Fig.5
Barnaby & Scott, Fig. 7
Syd Shelton, Figs.11, 12
Samuel Bourdin, Fig.15
Damien Hirst, White Cube, Anthony Oliver, the Saatchi Gallery, London, Fig.18
Caroline Evans, Fig.19
Comme des Garçons, Gilbert Benesty, Figs.20, 21, 22
IPC magazines, Fig.26
Juergen Teller, Fig.28
Sean Ellis, Figs.31
Jenny Saville, White Cube, Anthony Oliver, the Saatchi Gallery, London, Figs.32
Victoria & Albert Museum, Fig.40
National Portrait Gallery, Fig.39
Marcus Tomlinson , Fig.35

For Adrian Garvey and Mary Arnold

Introduction

At the end of the twentieth century fashion became increasingly spectacular. Catwalk shows by designers like Alexander McQueen and Versace were theatrical displays, commanding international press attention and a host of celebrity guests. Designers needed to produce ever more intricate displays in their shows and their advertising to continue to attract media and public attention and thus obtain financial backing as well as consumer sales. In the mid-1990s couture houses staged an elaborate revival, with Dior, Givenchy and Chloé all employing younger designers to bring added glamour and provocation to their images. The resulting focus on luxurious fabrics, intricate detail, extravagant accessories and glittering cosmetics affected all levels of the fashion industry, enticing consumers into sensory overload with their fantasies of escape. Even the parallel trend for minimalist basics pushed by Helmut Lang and Prada became caught up in the desire for luxury with exclusive materials overtaking early 1990s utilitarian chic. They created fashions that were as decadently expensive as those of more flamboyant designers like Antonio Berardi and which were equally concerned with sensual delight, albeit tactile rather than visual. Fashion seemed entranced by excess, fascinated by nostalgic recollections of previous decades, the 1970s at Gucci and the last *fin de siècle* at Galliano.

However, combined with this glamour was a disquieting feeling of anxiety: McQueen's statuesque models may have been dressed in couture luxury but they were often adorned with animal skulls or layered with torn leathers that spoke of death and threat. Photographers also brought notes of brutality to fashion magazines, both in Juergen Teller's and Corinne Day's realist depiction of models as fragile mortals rather than invincible superhumans and Sean Ellis's gothic images of dark fetishes. Fashion presented the interplay of contradictions: self-expression, self-creation, sensual desire counterbalanced with ambiguity, threat and anxiety.

Fashion reflects and indeed takes part in the construction of ideas surrounding the body and its display. Frequently trivialised as mere surface, fashion provides a space for image-makers and consumers to experiment with and challenge mainstream notions of physical display. Fashion demonstrates clearly that morality is not a set of fixed absolutes stating a monolithic culture's unchanging standards of acceptability but, rather, constantly shifting beliefs that can be moulded and challenged to reflect the

myriad social and cultural groups of western culture. As traditional religious, political and economic structures fractured during the twentieth century, stable notions of morality were in turn undermined. Richard Stivers discussed this in his 1994 book, *The Culture of Cynicism, American Morality in Decline*:

> In the past, public opinion formed around Christian morality and was subservient to it. Today, public opinion is largely but not exclusively wedded to the growth of technology and its promise. This form of morality is an expression of the instinctual power of desire.[1]

Fashion displays the promise and the threat of the future, tempting the consumer with new identities that shift with the season and expressing the fragmented moralities of cultural diversity and social uncertainty. As the twentieth century wore on, those alienated from the mainstream sought visibility and identity by creating their own fashions. Whether through subcultural provocation or couture excess fashion provided an arena in which to negotiate and theatricalise the shifting ideas and ideals of the century.

In this book I aim to explore these ideas by focusing on the last 30 years of the twentieth century, while drawing upon earlier examples where relevant. By setting key themes relating to power and status, violence, sex and gender within the context of developing attitudes towards fashion and fashion imagery I hope to show that fashion is inherently contradictory, revealing both our desires and anxieties and constantly pushing at the boundaries of acceptability. I want to begin by analysing fashion's ability to reveal western culture's uneasy relationship with consumerism, constructing identities that use stylish dress as a route to self-creation and yet ultimately to self-destruction.

One: Status, Power and Display

Sleek, groomed and confidently noncha-
lant, the model strides down the catwalk
in a vibrant scarlet trouser suit. The inten-
sity of the colour is overwhelming: its
redness drawing the viewer's gaze yet
repelling physical contact. The cut of the
suit is clipped and stark, with hard,
pointed shoulders and slim waist
producing a strong, controlled silhouette.
The model is aloof and untouchable, her
hair slicked back from her face, further
streamlining the image. Shown in
Moschino's spring/summer 1991 collec-
tion, the outfit represents the last gasp of
self-assured 'power dressing' more
usually associated with the 1980s. At first
it appears to simply restate the notion of
consuming designer fashion to display
status, wealth and power, yet the glit-
tering gold embroidery around the jacket
does not parade the designer's logo to
reinforce the wearer's purchasing power,
but reads: 'Waist of Money'. This satirical
word-play at once undermines the confi-
dence of the wearer's status claim, ridi-
culing those who buy any garments that
bear the 'right' designer label, yet adds the
kudos of self-awareness: the ability to take
part in fashionable consumption while
laughing at those who are taken in by its
excesses. It reveals our desire for the
power that stylish clothing can confer but
also highlights our concern that we are

being tricked by the allure of designer
label.

Such contradictory messages haunt
fashion imagery. Chris Von Wangen-
heim's photograph of louche glamour
published in *Harper's Bazaar* in 1972 spoke
of similar tensions. Caught in the artificial
glare of the supermarket aisle, trolley
overflowing, two fur-clad models pause
for the camera. The over-sized square
frames of their sunglasses, like kitsch tele-
vision screens, reflect the gaudy brands of
the products that surround them,
reducing the models' faces to lipstick-
mouths, a halo of glossy, groomed hair
adding to their glamorous, manipulated
image. Their needlessly thick fur coats
stand away bulkily from their slight
frames, wrapping them in a cloud of
luxury that juxtaposes the fantasy of
fashion with the banal world of tinned
food they have been placed in. The ordi-
nariness of the supermarket makes the
swagger of their attire seem both alluring
and ridiculous, amusingly inappropriate
to such a mundane shopping trip, yet
temptingly decadent. They appear
nonchalantly oblivious to the reality of
their surroundings.

As Martin Harrison pointed out,
photographer Chris Von Wangenheim felt
his purpose was to 'sell clothes, and the
means to that end was seduction.'[1] Thus

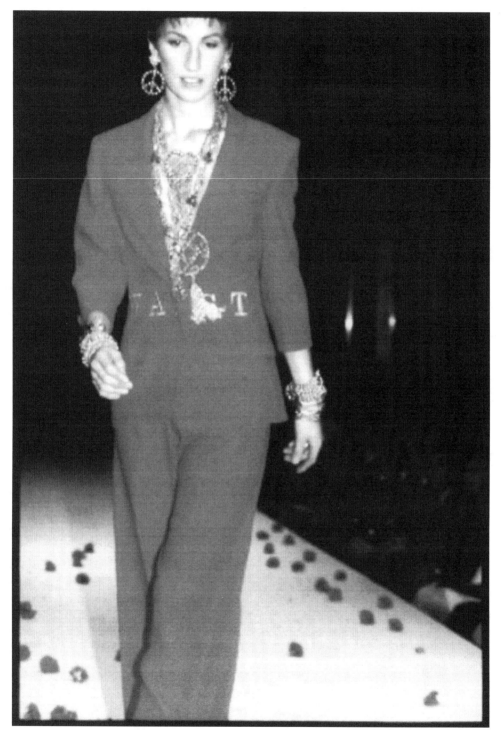

Figure 1: Moschino, spring/summer 1991, photograph by Niall McInerney. Copyright Niall McInerney.

the shopping models pastiche the consumption of the viewer, who devours the fashions visually, imbibing the image, the ideal, the potential identity, even if no literal purchase is made. The comic disparity of signifiers contained in the image both reinforces and questions the status that high fashion confers upon the consumer. The mixture of real fur and chunky plastic accessories, of real food and constructed brand images, the artificiality of their supposed shopping trip, and the apparent realness of the setting, conflate the roles fashion has played in offering simultaneous escape from, and entrapment within, the culture of status and consumption.

Mica Nava has pointed out that, 'Consumerism is far more than just economic activity: it is also about dreams and consolation, communication and confrontation, image and identity.'[2] The web of meanings and emotions that attaches both to products and the images that are used to entice the consumer has great impact in western culture, where identity is so often judged by appearance. The ironic tone of Von Wangenheim's photograph and Moschino's design shows that, although image-makers and consumers have become increasingly conscious of the power of visual manipulation to seduce and ensnare, this knowledge has not lessened their fascination with the promise that such images hold out.

Earlier instances of the power wielded by consumption also demonstrate this process by which fashion has come to play so crucial a role in conjuring with and renegotiating the power relations of status and identity. By the first decades of the twentieth century, modern city life had already provided the space in which new categories and new fashions could breed and multiply, responding to the desires and fears of the growing population. Women in particular were drawn further into fashion's realm to seek fulfilment through its fantasy images, to construct a self based upon desires rather than needs. The 1920s flapper, who seemed to live 'only to consume',[3] was a potent symbol of a lifestyle promoted through advertising and popular culture as a means to create a truly modern identity, which capitalised upon new freedoms. She seemed to live for the glamour of the moment, apparently without a past, and oblivious to the future.

Reaction to the challenges that such identities made to conventional morality regarding class and taste merely pushed high fashion and street style further, constantly pursuing new thrills, a further shock to the stifling monotony of 'real' life. The constant exchange and appropriation of ideas and images blurred the gap between these categories of fashion. As the century progressed, increasing numbers sought compensation in the spectacular, when no concrete means of advancement seemed attainable. As H.G. Barnett noted, by the 1950s:

> Employing dramatic techniques to gain recognition, are those individuals who adopt extravagant behaviours in place of customary means that are beyond their grasp. This device is practically universal among the frustrated members of minority groups whose activities are not rigidly controlled.[4]

The twentieth century has witnessed the increasing reliance upon the constructed images of the fashion world as the most

Status, Power and Display

direct challenge to delineated notions of status, gender and ethnicity, in a period of rapid change and insecurity. As shifting employment patterns, widespread joblessness, and ever-expanding cities have alienated people from more traditional notions of status linked to their work and environment, consumption acts as the salve for this lack, driving the economy, yet seeming to assuage the inequalities it enforces. Members of the upper classes fought to maintain status by asserting their superior taste and financial strength, through the elitism of couture. However, the escalating power of images has meant that previously excluded groups now seek to create 'imagined' status for themselves through the construction of styles which mark out their own territory, immune to the taunts from their supposed betters. This process of pressing against social constraints by snubbing the social etiquette of taste through visually defiant style and fantasy freedoms provided by fashion imagery, has enabled women to confront and subvert the trivial status allotted them. It has also allowed other groups pushed to the margins to revolt, from gay men to black teenagers, all seeking to channel the power of consumption towards their own ends, to escape the alienation of contemporary existence.

Excess

Extravagance has always been a major motif of high fashion, with couturiers fabricating spectacular fantasies of luxury for the upper echelons of society. The impact of the Second World War on the Parisian couture trade and, crucially, on attitudes to femininity and fashion is a key to understanding reasons for later examples of excess in dress and reactions to them. While some couture houses remained open during the Occupation there was no information coming out of Paris about the styles being shown. The impetus therefore shifted to New York, where simplicity and functionality were the dominating themes, and to London, where rationing and textile shortages excluded the possibility of any form of couture-style extravagance. Since the class structure that reinforced couture's pre-eminence was also affected by the war, it was inevitable that Dior's New Look, the 'Corolle' line of 1947, which so strikingly reasserted earlier hierarchical ideals, would prove controversial. Nancy Mitford, writing to Edward Sackville-West in December 1947, clearly conveys the contradictory emotions that extravagant dress provokes.

Have you heard about the New Look? You pad your hips and squeeze your waist and skirts are to the ankle it is bliss. So then you feel romantic … and people shout ordures at you from vans because for some reason it creates class feeling in a way no sables could.[5]

For many ordinary people, unable to escape the continuing austerity of the immediate post-war period, Dior's Victorian-inspired designs were a sharp reminder of social divides, as well as an affront to patriotism at a time when rationing still applied, and fabrics were in short supply. The sight of full skirts blossoming from tiny, sculpted jackets prompted outrage on the streets of Paris. In an infamous incident on the rue Lepic, models clad in Dior's 'Corolle' line were

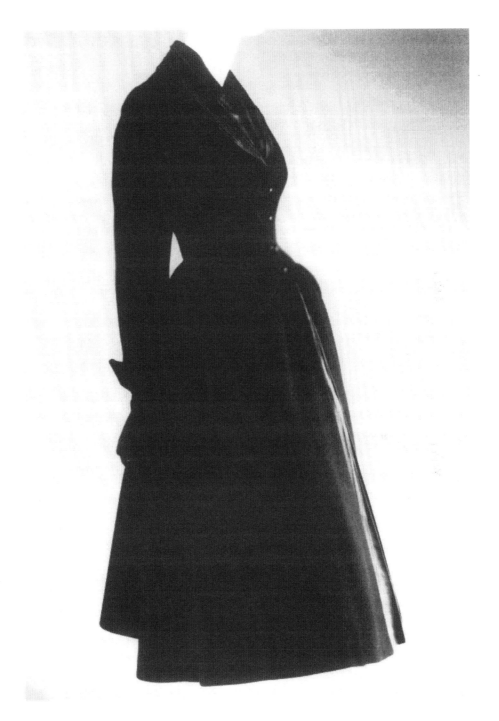

Figure 2: Christian Dior '*mystère*' coat, 1947, The Metropolitan Museum of Art, New York, Gift of Irene Stone, in memory of her daughter, Mrs Ethel S. Green, 1959 (CI 59.26.2). Copyright The Metropolitan Museum of Art, New York.

Status, Power and Display

attacked, angry women ripping at the yards of material that gave the skirts their feminine fullness. The New Look sought to reaffirm the exclusivity of the couture salon, the luxury of the few, who had no need to worry about such practicalities as cost or availability of fabrics. The theatricality of the style provided the anxieties of the period with a serene mask. It created a semblance of poised calm after the turmoil of previous years, using nostalgia as an escape to an imagined, stable past, which was symbolised by objectified femininity and *haut bourgeois* 'good' taste.

In Britain and America there was also alarm at the style, its symbolic renunciation of the wartime spirit of unity and commonality of cause, leading in Britain to its discussion in Parliament as well as the media. One British commentator looking back at the period from the 1960s felt that:

> The volume of the outcry at what was basically merely a return to traditional feminine lines was indeed a remarkable tribute to the grip which the puritan discipline of Austerity and Fair Shares had gained on our island life.[6]

The New Look seemed retrogressive in both its status-conferring elegance, and its ability to turn women into delicate creatures, teetering on spindly heels. As Mitford remarked though, this constructed image could be 'bliss'; enabling a dramatic return to the spectacular after the desolation of the war years, encouraging the return of the couturier's power to engross women in a fantasy of richness that evoked earlier, less desperate periods. The appeal of excess is undeniable, of succumbing to the sensuality of copious amounts of fine fabrics, of indulging in the pleasure of craftsmanship and handmade exclusivity, albeit smoothed out into Dior's sophisticated tailoring.

The turbulent upheavals of the 1940s reverberated throughout the rest of the twentieth century. Issues of class, status and gender, although by no means new, were thrown into fresh perspective by people's experiences of a long-drawn-out war. In fashion terms the sense of shifting and evolving identities was reflected in the increasing number of styles that were used by all levels of the industry to reflect and create new images and attitudes. Dior had helped to re-ignite couture, his New Look becoming a watermark that stood for its rarefied ideals, but its confident flaunting of nostalgic status symbols could not disguise the continuing movement away from monolithic dictates of style and taste. Extravagance was increasingly to be used to refute as well as to uphold couture ideals. It is telling that this period was such a reference point in the 1970s; another era when ideas of femininity were being questioned, this time in response to feminist texts and protests, and when fears of women's greater assertiveness were therefore more acute. It is ironic though that in the early 1970s it was the reminder of wartime austerity, rather than decadent excess, that caused uproar at Yves Saint Laurent's couture show. The 1940s-inspired styles he showed, crêpe dresses and wide-legged trousers teamed with masculine-shouldered jackets, all worn with platform shoes and tiny hats, evoked memories of the Occupation all too effectively. Marie-José Lepicard, who represented the magazine *Jardin des Modes*, recalled its stunned reception:

> Some of the older French journalists had lived through the War. They were

appalled. Saint Laurent had gone too far for them, beyond the boundaries of good taste. They were so angry that they couldn't see the clothes.[7]

Fashion has great resonance, acting as a collective memory; nostalgic styles are traces of the past, mapping individual and group experiences, recalling both reassuringly familiar and yet, as in this case, upsettingly clear evocations of earlier histories. For the younger generation, which did not remember the hardships of the war, the cold glamour of 1940s fashions was appealing. The allure of the style made luxurious and theatrical by Saint-Laurent did not raise the same moral questions for them: bourgeois good taste was there to be challenged, and the 1940s became a favoured reference point. Just as the New Look lost its controversial edge, and was assimilated into all layers of fashionable dress, so the padded-shouldered silhouette of the war years rose again as a symbol of vampish sophistication for the 1970s.

Alongside the late 1960s hippie street-level renunciations of consumerism and excess, was a continuing revolt against 'good' taste as defined by bourgeois conservatism. Labels like Fiorucci pushed to the limit the mixing of pop culture and fashion, which had been so prominent in the 1960s, printing tiny T-shirts with garish Vargas girl pin-ups, and cutting jeans so tight they appeared to be sprayed on. Worn with the sparkly eyeshadow and cherry lips of the 1970s disco scene, consumption was conspicuously throw-away and parodic. Purchasing power could be defined as much by the ability to emulate a particular image successfully, as by the amount of money actually spent. There was a sense of liberation in the deliberately *declassé* brightness of such fashions that used visual excess as a joky rebuff to the quiet status symbols of the older generation.

The 1970s disco provided a darkened space that encouraged hedonistic style and refuge from the constraints of taste. In New York's Studio 54 the mundane reality of day-to-day existence was forgotten in the performance of nightlife spectacle. Even if the clothes worn were the expensive unadorned classics of Halston's signature line, which epitomised laid-back American glamour, it was the association with an indulgent lifestyle that conferred fashionable status. This aura of heady abandonment was accessorised with jewellery designer Elsa Peretti's 'diamonds by the yard', introduced at Tiffany's in 1974, and drenched in Yves Saint-Laurent's perfume, Opium. The sense of nihilistic excess such fashions provoked was not new. Such extravagance in a sphere deemed trivial in the wider culture because of its perceived absorption in surface appearance is often – ironically, given this attitude – viewed as a signifier of deeper cultural decline. As John Reed observed of reactions to examples of decadence: 'Concern about cultural decay is not a modern peculiarity, but rather a perennial expression of political and social hypochondria.'[8]

The feeling of malaise may have been real, but the desire to create a visual simulacrum of status through dress was to have become a defining feature of fashion by the late 1980s, moving on from the romantic decadence of Saint-Laurent towards an increasingly brash vision. Fashion had become increasingly spectacular and blatant in its use of excess as the decade progressed, with the seasonal

catwalk shows themselves turning into theatrical extravaganzas that combined music, lighting effects and ever-more famous models. This progress towards fashion as entertainment, with designer as celebrity, model as icon was crystallised in Thierry Mugler's show of 1984, when the usual audience of press and buyers was supplemented by paying ticket holders. The crowd totalled 6000, brought together to witness a carefully choreographed display of fantasy and ephemerality that was designed to promote Mugler's image, creating an aura of glamour and success which would boost his label's selling power. Fashion's relationship with entertainment grew increasingly strong. Versace's use of models like Linda Evangelista, Christy Turlington and Naomi Campbell, brought together in his catwalk shows and advertising campaigns, made a link between the two fashion arenas, generating yet more publicity. The greatly inflated salaries he paid enthralled the tabloids and made Evangelista et al. into celebrity 'supermodels', whose pictures were to dominate magazines and newspapers in the way that those of film stars previously had.

Despite rising unemployment figures, right-wing governments' taxing policies meant that the rich were encouraged to spend with abandon, the very act of purchase a symbol of success. The fascination with consuming was evidenced in the boom in designer accessories, the Filofax, Hérmès scarf, Tag Heuer watch, all became emblematic of fashionable extravagance. Shopping became a parody of living, a means to construct and maintain identity, to pursue happiness. The conservatism and traditional symbolism of many of the objects purchased served to validate the insecure foundations upon which many of the status claims were built. A British *Elle* photo-shoot of October 1987 drew together the style classics that were so important at the time. In one of Eamonn J. McCabe's images, the model holds aloft a selection of deluxe carrier bags, bearing the most desirable labels, the sources of her carefully styled outfit. She wears a simple white shirt, open at the collar to reveal the bright silk of a Hérmès scarf; another is twisted through her belt loops, adding a rich glamour to her Levi's 501 jeans. Also around her waist is a shiny gilt Gucci chain belt, supplemented by matching key rings that circle her frame with the distinctive double 'G' insignia. The gold colouring is echoed in the snaffles of her Gucci loafers, the look is the epitome of late 1980s relaxed chic. Each article is invested with extra meaning by virtue of its aura of monied ease. Each item is anointed a 'classic' by the burgeoning style press, which imparted insider fashion information to an upwardly mobile readership eager to appropriate the symbols of success and aspiration. Philip Norman noticed the conscious use of such emblems to construct a series of identities for the wearer:

> Once mimicry and masquerade were the prerogative of a few, aesthetes, bohemians or hippies. In late eighties Britain, virtually every man, woman and child is, consciously or unconsciously, playing a role, striking a pose or acting out a daydream.[9]

Since the launch of Yves Saint Laurent's Rive Gauche line in 1966, designer ready-to-wear labels had increasingly been regarded as having replaced couture as

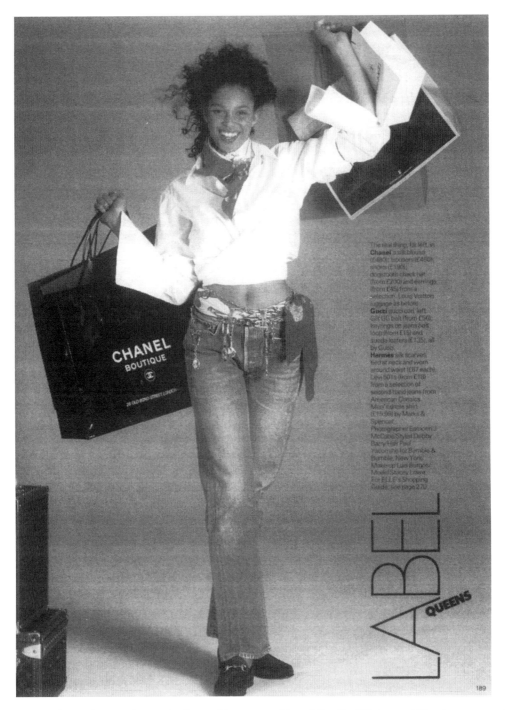

Figure 3: Marks & Spencer's man's dress shirt, second-hand Levi's 501 jeans, Hérmès scarves, Gucci loafers, belt and key-rings. Photograph by Eamonn J. McCabe, from British *Elle* October 1987. Copyright Eamonn J. McCabe.

Status, Power and Display

the experimentation ground for new styles. In the 1980s, established couture houses like Chanel may have enjoyed a renaissance, but sales were based on their perfume and cosmetics lines, and, importantly, on their accessories, which bore the crucial entwined 'C' insignia. It was this logo which gave the bags, earrings and T-shirts the cachet of couture without the huge price tag, and which was incorporated into both high fashion and street looks, particularly within hip-hop culture. The style press and indeed the consumer obsession with designer goods spawned the notion of the 'fashion victim', led by media promotion of particular designers, ready to adopt their every style, regardless of taste or appropriateness. Drawn to more eclectic names like Jean Paul Gaultier and Bodymap, rather than safer couture house logos, the term 'fashion victim' became the ultimate insult to the aspirational. A spiteful pleasure was taken in berating those who had 'failed' to successfully assimilate the designer's dictates; the line was thin between acceptable taste and the exclusion that resulted in too obvious an interpretation of the designer lifestyle. The rapidly moving trends of the late twentieth century meant that even items previously deemed the epitome of style could quickly drop from favour. The shallow satisfaction of the act of shopping further speeded up the desire to consume, the blurring of real feeling, real status into the fantasy of image and commodity adding to the sense of confusion. As Guy Debord had written in *The Society of the Spectacle* in 1967, the blur of sensationalism and images of contemporary life destroys:

> The dividing line between self and world, in that the self, under siege by the presence/absence of the world, is eventually overwhelmed; it likewise erases the dividing line between true and false, repressing all directly lived truth beneath the *real presence* of the falsehood, maintained by the organisation of appearances.[10]

In Lee Tulloch's novel *Fabulous Nobodies*, of 1989, the emptiness of image-dominated culture is parodied in a description of the twilight zone of clubbers, stylists and wannabes, who live for the masquerade of fashion. The heroine, Reality Nirvana Tuttle journeys through New York's nightlife, she adopts a variety of styles before realising the vacuity of an existence driven entirely by the latest 'look'. 'Life is cruel to people who aren't fabulous,' she says. 'They're always going to be staggering behind the fashion leaders, tripping over the jagged hems of their unravelling rip-and-tear outfits and madly scrambling to catch up.'[11]

As ever the moral implications of over-expenditure on fashion were overridden by the desire to fit into a particular group, to achieve a particular sartorial identity convincingly enough to be accepted by rather than excluded from the realms of the fashionable. Films like *Wall Street* of 1987 represented a trend that revelled in the harsh, money-driven existence of the stockbroker, the hero of a culture drunk on individualism and flaunted wealth, while simultaneously exposing this world as hollow and corrupting. For Susan Faludi the prime example of this uncaring attitude came ten days after the stock market crash in October 1987, when Christian Lacroix launched his 'Luxe' collection. Lacroix's designs embodied the decade's excesses in vibrant, jewel-coloured frills, the apex of which was the 'bubble' skirt, a

hollow balloon of silk that represented a vision of *haute* femininity. Faludi deemed this style to be as severe a backlash against women's advancement and moral taste as Dior's New Look. The mixed messages delivered by the conflicting styles being promoted, from Lacroix's conspicuously consumed femininity to Armani's sleek trouser suits, undermined any real sense of women's progress towards equality:

> The only 'identity crisis' that women faced when they looked inside their wardrobes was the one the eighties fashion industry had fabricated. The clothing manufacturers had good reason to try to induce this personal anxiety: personal identity is the great motivator to shop.[12]

The recession of the early 1990s, however, led to predictions of a new, more caring, sobriety. William Langley, writing in London's *Evening Standard*, warned of the demise of couture, prompted by the decline in sales figures and shift in attitudes, saying, 'Now the world has sobered up, and ostentation is not simply unaffordable but passé.'[13]

While it is true that companies suffered from the financial crisis, with a more minimal style that focused on quality and therefore value for money becoming a major preoccupation of designers and stylists, glamour and excess never really disappeared. Versace continued to show glittering ensembles that eschewed the tasteful abstinence of designers like Jil Sander and Helmut Lang. One Versace outfit from 1992 demonstrated his enduring fascination with luxury fabrics, contrasting a soft black leather bustier, studded with gilt medallions, with a full skirt of scarlet silk. For his customers,

flaunted wealth snubbed its nose at good taste. His advertising was equally extravagant, parading an array of supermodels in various stages of undress, caught in a sun-drenched world of Italian villas, furnished with the designer's homestyle range of silk cushions, throws and fine china, all embellished with the splendours of classical and Renaissance motifs. His gilt Medusa head logo had gained status during the 1980s, made famous by the rock stars and celebrities who wore his clothes, blurring the lines between the fashion and entertainment industries still further, as each gained credibility from the association. His work provided a fantasy vision of decadent excess, which spread from his hugely successful (and widely pirated) designer denim line, to the couture range he developed. His designs turned women into vamps and some commentators expressed unease about his signature clingy dresses, cut to reveal and enhance an hourglass figure. To them such sexualised imagery, so brashly displayed was the epitome of bad taste, showing that ideals of femininity are still closely tied to notions of modesty and 'respectable' taste. After Versace's murder in 1997, one journalist encapsulated this by writing that the designer would be remembered as, 'the man who made vulgar and tarty into an artform.'[14]

At street level as well, the lure of logo-driven consumption continued. The rappers of the 1980s had worn weighty coils of thick gold, adorned with Mercedes and Porsche insignia to appropriate mainstream status symbols for themselves. Artists like Run DMC and LL Cool J had celebrated the swagger given by the obvious wealth of real jewellery, coupled with the laid-back kudos of sportswear

brands like Adidas and Nike. The allure of designer labels continued into the 1990s, a subtle code of style symbolism continuing to evolve among Black youths in London in the early years of the decade. Display may have become less obvious, but the ability to acquire labels unavailable in Britain, or deleted lines of trainers, led to a club culture predicated on exclusivity and knowledge, not dissimilar to the ethos of high fashion, which also relies upon its ability to continually stay ahead and surprise. Brands like Chipie[15] were adapted and customised, label patches cut off other garments and piled on to a single pair of jeans, worn three sizes too big, a love of excess merging with the label's leisure-wear aesthetic. Trends in style and customisation moved fast, led not by the company itself but by innovations in the wearers' styling of their designs.

The use of customised dress codes – visible to all but the subtleties of which were known only to insiders – continued to evolve over the decade, taunting the mainstream culture which did not value black teenagers. Gangsta rappers and ragga artists vied for the most extreme style. The elaborate costumes of Jamaica's dancehall style added vibrantly coloured skintight ensembles to the provocative mix. High fashion, as ever, drew upon this innovative Black street culture, British designer Owen Gaster was one of the first to be influenced by the unabashed display of ragga girls, demonstrated in the abbreviated fitted dresses, low slung pants and gold jewellery of his spring/summer 1998 collection.

The previous year London's *Evening Standard* had noted the shift in 1990s sensibilities, stating, 'Flash, which blends vulgarity and flamboyance, is the style statement of guiltfree hedonism.'[16] The revival of couture during the middle of the decade increased the sense of decadence fed by the extravagant designs of Galliano for Dior and McQueen for Givenchy. For writers like Brenda Polan the world of fashion had become, 'corrupt, sick and self-deluded'.[17] The lure of luxury fabrics and the relish taken in extravagant decoration, may be seen as vulgar, lacking any sophistication in its appeal, but it should perhaps be remembered that fashion's 'blatant consumerism shocks the culture whose heart it yet speaks so well'.[18]

Cruelty and Power

In 1904 Georg Simmel wrote of the dichotomy that has haunted fashion: 'Thus fashion on the one hand signifies union with those in the same class, the uniformity of a circle characterised by it, and, *uno actu*, the exclusion of all other groups.'[19] Dress can be used as an indicator of group identity, including all those who adhere to particular tenets of taste and style, but this necessarily excludes anyone who does not adopt the group's dress codes. This can apply at street level, where subcultural groups create visual identities that reflect their ideals in opposition to those of both the mainstream and other contemporary subcultures. It can also be seen at high fashion level where, for example, wearing couture brings with it connotations of elitism and wealth that exclude those unable to afford such luxuries. Fashion can be used in this way as a means to assert a type of visual and stylistic power by those who feel alienated from the main flow of political life, whether because of gender, class or ethnicity.

For those who feel excluded, fashionable dress is a route to constructing visual identities that can be aspirational or subversive. The exclusion of others is as important to the couture-wearer as it is to mods or punks. The outsiders' lack of knowledge of the subtleties of a particular style or taste, their inability to assimilate its tenets accurately, contrasts with the sense of strength gained through inclusion within a group. A frisson of envy and desire is thus added to the clothing worn by those within a particular circle. This ability to define membership mimics the control that the real power-brokers have, in the case of capitalist society; this has traditionally been the male, white middle and upper classes. Subcultural groups could create a friction against establishment definitions of the 'norm', of acceptable appearance and behaviour. At the opposite end of the scale, in the first half of the twentieth century at least, the strict codes of high fashion could equally create images that are potent, even while their power is constantly displaced, visual rather than 'real'.

In the West, especially in class-dominated countries like Britain, the notion of the refined, sophisticated, elegant, 'Lady' of the upper middle and upper classes, was a dominant exemplar of this controlling fashionable taste. All others were measured against the perfection of her image, women of lower classes were instantly seen as lacking, their own, necessarily cheaper, clothes signalling their exclusion from the world of leisured ease defined by couture or high fashion. For economic historian, Thorstein Veblen, writing at the end of the nineteenth century, the Lady was the glittering chattel of her husband, consuming voraciously to maintain the facade of his lofty status. Her own status was a mirage, dependent on her husband's or father's wealth, her energies channelled into the creation of an indestructible image of unattainable good taste. Her own alienation from real power was anaesthetised by the sensual allure of luxurious fabrics and handcrafted decorations.

To early twentieth-century feminists, the Lady was an anachronism, whose need to uphold her own insecure claims to status led her to ignore the needs of other women. Wilma Meikle wrote in her book *Towards a Sane Feminism*, of 1916:

> Loathsomely she has kissed the feet of decaying religions and moralities, and political dogmas, of putrescent faiths of every kind. She has not known, or has not cared that honest, individual, continuous thought is the only real morality.[20]

Meikle felt that in Britain a controlling notion of femininity was being imposed upon women by the patriarchal establishment and the women who reinforced its ideals, condemning those who could not attain its goals to continual failure because they lacked the wealth, the leisure time and the 'correct' taste. She stated: 'The Lancashire mill-girls who think that no woman can be a lady if she has a thread of white cotton sticking to her coat are essentially right; the Lady has never worked for a living.'[21]

By the middle of the twentieth century, while political suffrage and the impact of two world wars had brought women greater status and rights, the aura that surrounded those in the West who could afford the fashion-plate perfection of couture still had a mesmerising quality. Diana Vreeland spoke of this in her autobiography:

A woman dressed by Chanel back in the twenties and thirties – like a woman dressed by Balenciaga in the fifties and sixties – walked into a room and had a dignity, an authority, a thing beyond a question of taste.[22]

While the power and appeal of such sleek images is undeniable, the couture-wearers' ability to destabilise the security of identities that do not match up to their rigorous tenets is equally irrefutable. Fashion advertising and magazine images, constantly hold out the promise of the attainment of such ideals, yet for all but the very wealthy the products contained are unobtainable, consumed visually rather than literally. In the period after the Second World War there was a booming trade in stylebooks, which detailed the appropriate attire for every conceivable occasion, asking the reader, 'Now would you like to play a game of Pygmalion?'[23] Clothing, accessories and cosmetics were held out as the route to social advancement, as long as they were used in line with the correct tenets of modesty and respectability. While it is liberating to have the possibility of constructing your own identity, and create your own personal self, what is implied here is clearly that a woman will be 'improved' by imitating the tastes of her social superiors. The fantasy of the fashion images like those of Richard Avedon, Cecil Beaton and Norman Parkinson, which encapsulated these ideals, was captivating, allowing for sensuality and indulgence, yet it denied complete freedom, since the power of these images was predicated on an impenetrable exclusivity. Betty Friedan saw this as a motor of capitalism, warning that the advertising media:

and their clients in American business can hardly be accused of creating the feminine mystique. But they are the most powerful of its perpetuators; it is their millions which blanket the land with persuasive images, flattering the American housewife, diverting her guilt and disguising her growing sense of emptiness.[24]

It was not just white housewives in America who could feel excluded from high fashion and 'good' taste. Women from other ethnic groups were also disregarded by mainstream fashion. Photographer Eve Arnold estimated in the 1950s that there were around 300 fashion shows a year in Harlem, organised by black women who were tired of the slender white models that dominated the fashion magazines. Arnold wrote, 'The clothing was made either by the models themselves or by local seamstresses, partly as protest against the white establishment Seventh Avenue "schmatte" trade.'[25] The images they created, while taking into account the fashionable line, celebrated an alternative set of ideals which, rather than being seen as a 'filtered down' version of couture styles, should be recognised as a genuine reflection of other, equally valid, tastes and desires.

The pop culture boom of the 1960s shattered couture's status as sole purveyor of legitimate style. The rise of ready-to-wear, and the alternative icons of rock stars and fresh-faced young models, undermined the declining status of the Lady still further. While glamour never went out of fashion, the images associated with leisured opulence, reliant upon the support of a man's wealth, dwindled in influence, appearing only as a swooning, bohemian pastiche in occasional fashion

shoots in subsequent decades. The 1980s saw the rise of the suited career woman, who had finally penetrated the managerial classes. This success was epitomised in Donna Karan's advertising campaigns, with sleek, black-clad models shown juggling work and motherhood, while remaining eternally in control, and, importantly, the implication was that the money was her own, her clothing a symbol of personal success.

It is surprising therefore that the *haute* symbol of the Lady, the fur coat, the emblem of both the aloof aristocrat and the kept mistress, has seen a tentative revival on the catwalks of high fashion designers since the mid-1990s. During the previous decade, groups such as Lynx and People for the Ethical Treatment of Animals (PETA), had fought hard to raise awareness of the unnecessary cruelty involved in the production of furs. They harnessed the power of the media in campaigns such as Lynx's famous poster slogan; 'It takes 40 dumb animals to make a fur coat. But only one to wear it', photographed by David Bailey in 1985. The campaign helped to underline the immorality of killing animals for adornment, while sparking controversy in its depiction of women who wear fur, whom it showed as mindless, sexualised objects.

Such high-profile sloganeering continued into the 1990s, notably with PETA's posters that bore the legend 'We'd Rather Go Naked … Than Wear Fur'. However, by 1994, designers were beginning to take advantage of the fashion for fake furs, to sneak real pelts back into their collections. The inclusion of real furs in the film version of *Evita* in 1996, starring Madonna, further legitimised the trend which was brought to the fore in March

1997, when Naomi Campbell, who had appeared in PETA's poster campaign, opened Fendi's catwalk show in a full length fur coat. After the recession of the late 1980s and early 1990s the fashion industry, and all too many of its followers seemed to wish to immerse themselves in decadence and extravagance. Luxury fabrics, including real fur, became increasingly popular. They wrapped the wearer in sensual symbols of wealth and quality that could not easily be faked.

Mid-range and high street fashion labels had become increasingly adept at producing high fashion looks, aided by the early 1990s' love of cheaper synthetic

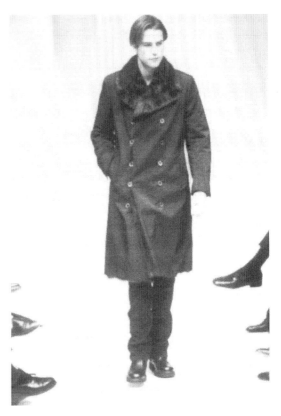

Figure 4: Valentino Menswear, autumn / winter 1997/8, photograph by Niall McInerney. Copyright Niall McInerney.

Status, Power and Display

fabrics at all levels of the industry. There was a search by fashion leaders for more unattainable status symbols, to reinforce the feeling of exclusivity that would sharpen the consumer's desire. Accessories such as the shatoosh, a luxurious shawl made from the down of an endangered breed of Tibetan antelope, began to appear in magazines like *Vogue* and *Harper's Bazaar*. New couturiers like Galliano, McQueen[26] and Gaultier all showed furs, at first dyed in guilty pastel colours as a feint, then looking increasingly natural. The temptation to embrace luxury and decadence was compelling, and ready-to-wear labels like Dolce & Gabbana, and Gucci also included furs in their later 1990s collections. Many fashion journalists continued to express unease at the implications of the return of fur to fashionable dress. However, as Sammy Harari, who was director of the advertising agency Yellowhammer that was behind 1980s Greenpeace and anti-fur campaigns, pointed out: 'It's the curious blend of blatant raw cruelty and the indulgent glamour of the catwalk that makes the fur debate so compelling and so powerful.'[27]

This heady cocktail confers a strong sense of sexual power on the fur coat. In both pro- and anti-fur advertising, the notion of woman is invariably conflated with that of wild animal. While this may undermine the moral stance taken in the images created by the anti-fur organisations, it adds to the appeal of real fur for many women (and, significantly, many men), creating an aura of unbridled sensuality, the fantasy of power tinged with the cruelty of the kill. Andrée Collard wrote in *Rape of the Wild*, that the fur industry is eager to connect 'hunting, fur animals and women', arguing that women are ultimately made submissive in this role:

> In reality she is the prey being brought down. She and the fur animal – one 'alive' and the other dead – are one and the same … Even when man does not actually hunt animals, his success is still reflected in the kill.[28]

The fact that the cost of furs makes them attainable to only the richest provides their wearers with the thrill of exclusion. Unlike prestige brand accessories, furs cannot be pirated and cheaper pelts like rabbit are instantly distinguishable from the unbridled luxury of mink. As Quentin Bell noted in his book *On Human Finery*: 'Nothing can compensate for the lack of "real" products, "real" pearls, "real" silk, "real" lace, "real" mink … in other words the materials employed must be difficult to obtain or laborious to produce.'[29]

The desire for the unattainable, the 'authentic', for reunion with the 'natural', and the thrill of owning something unique in the era of the simulacra, has been combined with a fatigued retreat from the calls for a 'caring' 1990s to assuage the perceived monetarism assigned to the previous decade. Jane Proctor of *Tatler* commented in 1997: 'don't you get the feeling that people who kick up the most fuss can't afford real fur?'[30] This argument demonstrates the continued allure of elitism, the comforting thought that others might envy your ability to obtain the cruel power of fur.[31] It is significant that at the end of the century the disregarding, flaunted wealth associated with the ideal of the Lady can still command loyalty. It tempts and teases the onlooker with its suggestion of unassailable status, and thrilling sexuality. However, the signifiers that cling to real fur are more

complex and, as in the mirage of the Lady's power, are reliant upon patriarchal concepts of femininity, sexuality and status.

Simplicity

Luxury is a recurring motif of fashionable dress, offering sensual delight to the wearer and frequently a visual feast for the onlooker. For some designers and consumers though, obvious indulgence in fine fabrics and decoration is to be spurned in favour of subtler, more restrained fashions. In the novel *Generation X* of 1991, Douglas Coupland commented upon this drive for rational simplicity in his mocking dictionary definition of Giorgio Armani's work:

> Armanism: After Giorgio Armani: an obsession with mimicking the seamless and (more importantly) *controlled* ethos of Italian couture. Like *Japanese Minimalism*, Armanism reflects a profound inner need for control.[32]

Coupland's description may be satirising the contained sophistication of Armani's unstructured, modern tailoring, but it betrays the covert meanings of this style. It is a style that appears to snub the decadent extravagance that is such a feature of high fashion, yet its focus on detail, its desire to demonstrate an intellectual distancing from the frivolous ephemerality of trend-led fashion, constructs an alternative set of expensive obsessions. In the 1980s Armani stripped designs to their most basic form, expressing an admirably modernist aesthetic, but also voicing a desire to police definitions of 'good' taste. His work only allowed indulgence in clothing for those consumers knowledgeable enough to appreciate the subtlety of a well-cut jacket, the sensuality of luxurious, yet deceptively plain, fabrics. Financial and personal indulgence are as much a part of consuming the sleek navy blue trouser suits made by Armani, or the narrow cashmere coats of Jil Sander, as they are of the purchase of a sparkling Versace outfit. However, Armani and Sander's work wears the mask of puritan abstinence, of rational, functional design and the longevity of the 'classic'. Rosalind Coward comments that such clothes are: 'designed to make a statement about what they feel like. They are designed to connote a sophisticated sensuality, that enjoys touching itself all the time.'[33]

In the early part of the twentieth century, the desire for a simple style that would sweep away the multi-layered excess of *fin-de-siècle* couture was epitomised in the work of Coco Chanel. Her sleekly minimal designs fused the tenets of dandyism – close attention to detail, high quality, basic forms – with an irreverent attitude, piling on to simple black dresses and separates the previously *déclassé* glitter of fake jewellery. Her style was at the cutting edge of couture fashion, mocking bourgeois sensibilities that still clung to the more obvious wealth of rich fabrics and complex designs. Her work gave women a sense of ease and confidence in their clothing, a rational anonymity, which belies the quality and expense of their garments. This modesty and understatement provides a 'never-ending dialectic of status claims and demurrals',[34] at once ascetically simple and decadently expensive.

In the 1940s and 1950s American designer Claire McCardell's work expressed a similar interest with pared

down forms although her designs were much less expensive to buy. She used utilitarian fabrics like jersey and cotton, imbuing them with high fashion status by virtue of the image and ideals conveyed by their designer. McCardell drew upon sports- and dance-wear to create clothing that worked with the natural body. She designed six-piece travel wardrobes, popover dresses and playsuits for the proto-career woman, who needed a reduced and rationalised collection of easy pieces to simplify dressing with multipurpose garments that were appropriate for the varied roles she took on at the office and at home. McCardell's work was in tune with the contemporary mood; she

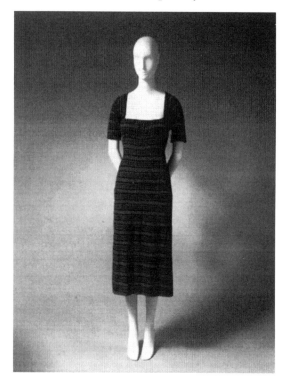

Figure 5: Claire McCardell wool-knit day dress, c.1950. Museum at the Fashion Institute of Technology, New York. Gift of Sally Kirkland (76.33.35). Photograph by Irving Solero. Copyright Museum at the Fashion Institute of Technology, New York.

adapted easily to the shortages caused by the Second World War, promoting ballet pumps to be worn as shoes when leather became scarce. The American Look that McCardell's designs epitomised favoured an athletic body and a busy life, the opposite of the cosseted couture client. Yet while McCardell worked within the context of mass production, and Chanel in the rarefied atmosphere of couture, each attracted the avant-garde and the daring to their clothing at the start of their careers. Potential wearers had to be willing to risk being misunderstood by onlookers, unversed in the coding of inverse status symbols, which rejected the obvious wealth of decoration and rich fabrics. Instead Chanel and McCardell favoured deceptively simple designs that represented a new femininity based on independence and vitality.

There is a history of artists and intellectuals adopting simple, utilitarian clothing as a symbol of their contempt for the constantly shifting whims of fashion. An example of this is seen in Roger Fry's portrait of Nina Hamnett of 1917. The sitter wears a plain sweater and skirt signifying the loftier concerns of the artistic, which focused on cerebral rather than sartorial concerns. Simple garments could in this case be used as a distancing statement, removing the wearer from the realms of conspicuous consumption and demonstrating his or her contempt for capitalist pressures to conform. For the artist status came from cultural capital – the kudos associated with fine art and intellectual pursuits – rather than by flaunting wealth. Indeed, a certain shabbiness in appearance would merely underline abdication from restrictive notions of social acceptability. However,

the bourgeois fashion consumer needed to be sure of the unassailable nature of her status to reject the seasonal tread of high fashion and embrace simplicity of style. Albeit working in different sections of the fashion industry, both Chanel and McCardell provided women with clothing that was appropriate to their new, more active lifestyles, and which represented femininity as confident and streamlined, rather than as a decorative confection. One commentator wrote of McCardell: 'The designer's idea is that clothes should fit the individual and the occasion, and should be comfortable as well as handsome. The colour and line should flow with the body.'[35]

The reasons for choosing to wear this kind of clothing were complex though, representing the desire to express a different kind of status as well as an appreciation of harmonious design. In the 1950s, Robert L. Steiner and Joseph Weiss revised Veblen's theory of conspicuous consumption to demonstrate the elite's need constantly to create new status symbols in order to maintain their position. In an increasingly prosperous America, where more and more people could afford the obvious splendours of luxury, new significers of status and taste were sought out. They wrote:

> As a result of the long practice of conspicuous consumption, ornate objects have become associated in the common mind with vast wealth. Therefore, if the old elite is to demonstrate a disinterest in money, it must deplore ornateness and adore simplicity.[36]

This so-called 'counter-snobbery' ensured that the old elite and, importantly, the fashion *cognoscenti*, could maintain their superior taste and style, through their apparent contempt for such base instincts as the accumulation and display of vast wealth. However, as the authors pointed out:

> underneath the shy, retiring, unassuming ways and masquerading as quiet, good taste, shines forth a distinctive exhibitionism quite as flagrant as the pomp and circumstance of former years.[37]

In the 1970s another American, Halston, developed this theme of 'stealth wealth' further, purveying reworked classics: cashmere twinsuits, simple car coats, and wraparound suedette skirts, which combined the sensuality of luxury fabrics with simplified forms. His statement on the success of his designs is telling, 'You're only as good as the people you dress.'[38] His comment highlights the problem of pared-down fashion that does not immediately stand out to the potential consumer, and therefore needs to be seen adorning the rich and famous to reinforce its exclusive status. Designers who produce such simplified clothing need to create an aura of exclusivity and glamour about their labels, since they lack the instant status cachet of more elaborate designer fashions, enticing consumers with the visual images attached to the designer's name.

The use of simple clothing had, by the 1980s come to be associated with a conservative need to ensure the validity of the status claim. No longer regarded as avant-garde, as Chanel and McCardell had been in the first half of the twentieth century, labels like Donna Karan and Calvin Klein provided the essential wardrobe for those who wished to be viewed as

Status, Power and Display

serious and career-minded. Even their more casual diffusion lines were signifiers of a utilitarian reasoned approach to dressing that sidestepped the flamboyance of much of the era's fashions. Both by association with glamorous star names (Demi Moore and Bruce Willis for Donna Karan, Jodie Foster and countless other Oscar candidates for Armani), and the use of lifestyle-enhancing marketing campaigns, the prestige of such labels was raised. The crucial links between editorial, social and advertising pages of fashion magazines that this publicity created forged a link in consumers' minds between the image and reality, elevating the status of simplicity.

However, the economic recession of the 1990s led to growing anxiety about fashions that flaunted their expense too flagrantly. As Phil Thornton wrote in *The Face*: 'The collapse of Eighties affluence showed how hollow and precarious a game aspirational [dressing] can be.'[39] This feeling of disaffection with displays of excess was compounded by consumer exhaustion with obvious designer labels. The previous decade had seen a rise in awareness surrounding designer fashion, which, as noted earlier in this chapter in relation to Thierry Mugler's work, was covered more extensively in newspapers and magazines and treated as a branch of the entertainment business, with designers and models considered as celebrities. Widespread pirating of brand logos from Dolce & Gabbana to Gucci and Chanel also exacerbated consumers' fatigue with designer goods as fakes became available in street markets around the world. People at all levels of society were more familiar with prestige fashion brands than ever before. Designers at the cutting edge of fashion's

elite like Helmut Lang were now able to assert minimalist style as the obverse of 'vulgar', obvious designs that by the 1990s seemed so unfashionable. While excessive designs continued to make headlines for Versace and Mugler, it was Lang's cool, urban silhouettes, marrying basic shapes with edgy colour combinations and advanced technological fabrics, which were both the crucial look for fashion insiders, and the key influence on other designers, eager to find a new vision of the modern.

Lang helped to reinvigorate the fashion for simplicity, as did the subtle style of Prada. By using cheap, industrial fabrics and discreetly complex construction methods, they added an urban sophistication to their designs, a feeling that the consumer had to have greater fashion knowledge to appreciate the complexity of such seemingly basic items. They suggested a cultivated taste, and, as Pierre Bourdieu noted:

> What is at stake is indeed 'personality', i.e. the quality of the person which is affirmed in the capacity to appropriate an object of quality. The objects endowed with the greatest distinctive power are those which most clearly attest the quality of the appropriation, and therefore the quality of the owner.[40]

The need to construct an identity that spoke of both fashion and cultural capital was acute at a time of anxiety and insecurity. Both the etiolated, androgynous chic of Lang's work, and the ironic subtlety of Prada's inverted status symbols, enabled consumption that was gratifyingly fashionable, yet eluded the taint of obviousness. Gap's utilitarian basics fulfilled a need to 'downsize', to strip away unnecessary objects that cluttered up already

complex and confusing lives, cheaply and accessibly, while designer goods by Prada or Lang provided the rational cachet of the stripped down lifestyle, with the cocooning feeling of exclusivity. In 1995 Lisa Armstrong wrote in British *Vogue*:

> Eighties snobbery may have been simplistic, but … it was democratic, easily grasped by everyone. This new version, by contrast, has taken to its heart a completely different system of status symbols that, far from being recognised from the other end of Bond Street, couldn't be identified from next door.[41]

Another fashion journalist, Amy Spindler of the *New York Times* interpreted the domination of late 1990s fashion by so-called 'minimalist' style in a more disquieting way. For her the plain fabrics and basic shapes were a distancing device, the blankness of the clothes's surface hiding the identity of the wearer from prying eyes. In 1998 she considered Calvin Klein's advertising campaign for that season, seeing anxiety rather than tranquillity in the spartan, minimalist interiors and simple garments it showed, and asked: 'What if nothing was happening, and we finally had time to sit and think, but our minds were as minimalistic as the room, as blank as our faces, and as empty as our eyes?'[42]

Individuality was disguised by the universal simplicity of much of late 1990s fashion, which hid difference behind its smooth silhouettes. Anxieties were muffled still further as the decade wore on, when the understatement of minimalist style became increasingly influenced by the revival of luxury and detailing that came from couture's newcomers. People also desired to possess less easily pirated objects which, as has already been

discussed in the case of fur, relied on the supreme luxury of expensive fabrics. Narciso Rodriguez provided midnight blue or oyster cashmere separates that glimmered with the iridescent shine of constellations of self-coloured sequins; Marc Jacobs for Louis Vuitton presented the sensual delight of rich claret silks against pigeon grey, floor-length fine wool. The latter marked another shift in attitude towards prestige brands, for at the end of the decade a number of more progressive designers were recruited by luxury brands to revive their profiles, most notably, Martin Margeila at Hérmès. His first collection for them in 1998, consisted of deceptively simple reversible short-sleeved

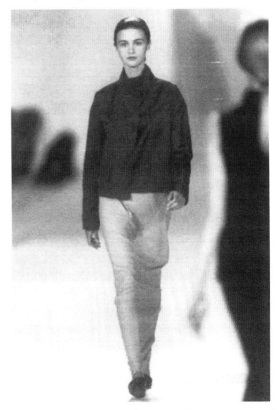

Figure 6: Marc Jacobs for Louis Vuitton, autumn/winter 1998/9, photograph by Niall McInerney. Copyright Niall McInerney.

sweaters, worn with 'soft suede gauntlet gloves and gentle long skirts. In contrast with the challenging designs that he is known for, the look he created was simple and luxurious. His designs suggested a positive reading of simplified style, for as Sarah Mower wrote: What more mordant a put-down of current Paris runway sensationalism than a statement of wearable classics for older women?'[43]

Imperfection

The model is framed in a rough wooden box, her figure completely enclosed, cropped halfway down the face and just below her waist. The restrictive casing is set against a steel-grey backdrop that reinforces the sense of solemnity, the stillness conveyed by her containment, and the focus upon her torso. This recalls the gravitas of an artwork, an *objet trouvé*, a boxed treasure. Her slim, pale body is at once clothed, yet revealed, by a gossamer thin chiffon top, which mimics the grey of the surrounding environment. Its surface is ragged with cobbles of chiffon, caught up into an irregular honeycomb of bedraggled twists of fabric, the clear spaces in between exposing the smooth skin beneath. The top is at once a finished garment glimmering with a delicate sparkle against the fine weave of the chiffon, and yet incomplete. Its surface belies the smooth perfection we usually require from material, the frayed layers confuse the eye; it is new and yet resembles older, deteriorating fabric. There is an echo of Miss Havisham romance in this feeling of a piece of clothing kept and cherished for its imperfection, and a contradictory edge of defiance in its torn folds. As

Richard Martin noted, such 'deconstructed' designs may speak of conceptually conceived fashion, born out of ideas rather than seasonal themes:

> But even that tough-minded regimen of the mind has its visual romantic counterpart in the enchantment of ruins, the long tradition of enjoying remnants for their evocation of what previously existed.[44]

The top, by Alberta Ferretti for spring/summer 1998, is juxtaposed with the smooth masculinity of Versace Prince of Wales check trousers, hinted at through the transparent fabric, photographed by Barnaby & Scott. Ferretti is not particularly associated with the questioning of fashion's tenets of perfection and luxury. Her signature style is quietly, confidently, feminine, favouring soft layers and spindly decoration. While this clothing rekindles those elements, it also demonstrates the pervasive nature of the so-called 'deconstructionist' trend, or *'le destroy'*, as it is called in France. This is an approach to fashion that seeks to highlight rather than eliminate its inherent contradictions, and to examine and reflect cultural and physical imperfections, instead of constructing a lie of transcendent beauty. The process of the design and construction itself is brought to the surface of the garments, instead of being concealed as part of the mystique of the designer as creative genius. An attempt is made to reconcile the oppositions of new/old, rich/poor, masculine/feminine, that are continually reasserted in western visual culture, reflecting a value system that has tended to favour the former definition in each case. The heritage of such questioning of accepted ideas of representation in more conventional fashion could

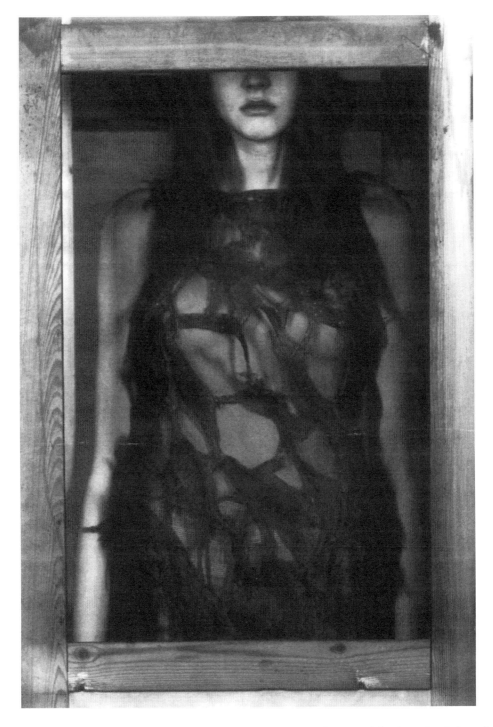

Figure 7: Alberta Feretti shredded top, Gianni Versace trousers, photograph by Barnaby & Scott from *The Guardian Weekend*, 11.4.98. Copyright Barnaby & Scott.

be traced to the 1920s and 1930s, when Madeleine Vionnet's radical construction methods examined the process of making fashion, and accepted notions of the way a garment should fit the body. Her bias-cut dresses rethought the way that fabric related to the figure, causing it to hover around the wearer instead of restricting and shaping it into the contemporary ideal. Vionnet challenged existing construction techniques in her handkerchief point dress of 1922, eliminating darts and other tailoring devices and allowing the folds of rectangular *crêpe romaine* to form enveloping drapes around the figure.

This challenge was rephrased in Schiaparelli's 'Tear Dress', made in collaboration with Salvador Dali, in 1937, with its 'real' tears, and painted simulacra. It exposed the shell of fashion, dramatising, instead of concealing, fashion's masquerade of flaunts and feints around the body. These challenges remained within the confines of couture, chipping its polished surface, but essentially upholding ideals of luxury and perfectionism. It was not until the deliberate destructiveness of Vivienne Westwood's punk styles of the 1970s, that the break-up of fashion's smooth surface became a cultural movement. Punk did not just signify a contemptuous disrespect for social hypocrisy; it also reflected the sense of discontent of a generation, which wanted clothing to provide a costume for their angry lives, not an unreal fantasy of pleasure. In Britain during the recession of the early 1980s Westwood dressed her models in the bulk of wadding petticoats, dyed dull browns and olive greens, worn with silky bras over the top of hooded T-shirts, paying homage to the way women in the Third World

flaunted such trophies of western dressing. Combined with the thrift shop masquerading of the New Romantics, whose theatrical and nostalgic style permeated London clubland in the early 1980s, an alternative set of status symbols was appearing. It fused multicultural and historical reference points to create a look that aestheticised poverty, despite its actual high fashion status and cost. Angela Carter described the early stages of this style in 1980: 'A poor fit is essential because garments must look twice-used, as if rescued from some nameless disaster. In its own unique way, the rag trade has acknowledged the recession.'[45]

Figure 8: Vivienne Westwood, Buffalo Girl, autumn/winter 1982/3, photograph by Niall McInerney. Copyright Niall McInerney.

In 1983 an in-store boutique at Bloomingdales in New York, selling these kinds of distressed designs by British designers, was picketed. The protesters objected to what they saw as a condescending aping of poverty by expensive and elitist fashion designers, inappropriate to the more financially buoyant situation in America. As Harold Koda observed in his discussion of the event:

> Worn by alienated British youths, the exaggerated, theatrical aspects of the poverty references suggest self-satire and the nihilistic hedonism of economic frustration ... [In America] the necessarily ironic posture of the middle-class purchasers becomes the trivialisation of poverty, or worse, tasteless 'slumming'.[46]

The meanings attributed to deconstructionist style were fluid; its significance shifting according to the particular cultural context in which it was shown. Japanese designers Rei Kawakubo for Comme des Garçons and Yohji Yamamoto echoed a feeling of unease in their collections. Each sought to explore new ideas about fashion, which would show an appreciation for 'people's flaws and weaknesses',[47] rather than attempting to design new personalities for the wearer that denied the body's natural asymmetry. For these designers human frailty became a strength, the ageing process the window to different types of beauty, and a link to the authentic and natural. The oversize shapes and dark hues of the designs they showed in Paris in the early 1980s shocked western commentators, unable to read the meanings of their unfamiliar style. They condemned the clothes as 'shrouds', seeing only black, shapeless forms, not the textures and shading that Kawakubo and Yamamoto wished to foreground.

As these designers became more established and influential, the reflexivity of their work has become apparent: their clothes talk of the process of fashion itself, of the shifting definitions of status, gender and ethnicity that we attach to dress. In the late 1980s a group of designers from Antwerp, including Anne Demeulemeester, Dries Van Noten and Martin Margiela, became famous for a similar approach. Their designs once again acknowledged the decay of fabric and flesh and their ambivalence towards the fashion world that their clothes nonetheless inhabited became particularly apt as the 1990s wore on into recession. Elizabeth Wilson wrote of this 'aestheticisation of dystopia', seeing such fashions as symptomatic of a late twentieth-century malaise of postmodern existence. Postmodernity is characterised by the breakdown of 'grand narratives' and stable definitions of identity. Prescribed ideas of identity have been fragmented by both the impact of cataclysmic large-scale wars and shifting employment patterns, and by feminist, gay activist and the civil rights campaigns. While such developments have opened up the possibility of greater equality and recognition of diversity, they have also contributed to a general feeling of confusion surrounding identity, which has been heightened by the effects of living in overwhelmingly large cities and being bombarded by the images of consumer society. The poverty and decay that consumerism seeks to mask have been appropriated by designers as a theme in their work, becoming at once a reaction to such dark elements of contemporary life and yet inevitably also a

consumable object. Wilson describes this process: 'Postmodernism expresses at one level a horror at the destructive excess of western consumerist society, yet, in aestheticizing this horror, we somehow convert it into a pleasurable object of consumption.'[48]

The style of these Belgian designers became caught up in the trend for so-called 'grunge' in the early 1990s. Their more serious and thoroughgoing examination of fashion and design was, however, never really a part of the grunge mix-and-match look, that drew on the nihilistic mood of contemporary rock music exemplified by Nirvana and the rejection of overt consumerism in a backlash against 1980s designer excess. Margiela, especially, wanted to excavate fashion's past, to create clothes from the linings of old cocktail dresses, skirts that were clearly constructed from old pairs of jeans. They represented souvenirs from a collective past, rather than the bland retro borrowings that were so much a feature of 1990s fashion. Each garment was both old and new; designs were repeated in later collections, breaking the tyranny of seasonal dressing. His blank linen labels attempted to erase the cult of designer, but although certainly more discreet than the name logos used by most designers, the labels have acquired their own cultural capital, signifying an insider knowledge of fashion and an intellectual distancing from the brash displays of more mainstream brands.

By reusing fabrics, his clothes bore a distinctive patina, quietly but proudly displaying 'the small signs of age that accumulate on the surface of objects'.[49] Their status was validated by their recognition of the heritage of style, the anathema

of fashion's usual denial of its immediate past. While the garments themselves were made individual by this patina, Margiela's approach undermined the notion of designer as unique, individual creator, by conceding that each design is the product of fashion's history. In 1954, Christian Dior wrote his own *Little Dictionary of Fashion* for women. It was a perfect example of the ideal of the designer – in Dior's case, the couturier – as dictator, every aspect of dressing carefully delineated for the consumer, questions of taste taken out of her hands, and decided by the couturier. He advised: 'Be very careful of adapting any frock … When any frock has been created with much thought and care it is always very difficult to change the design without ruining it.'[50] The designer's word was final; Dior defined the couturier's role thus: 'Most of the art of *couture* is the art of camouflage because perfection is rare in this world and it is the *couturier's* job to make you perfect.'[51] For Margiela, like Kawakubo, such ideas were destructive: fashion should reflect upon and cocoon real bodies, allowing the wearer the final decision as to how a garment should be worn or wrapped about them. To recognise imperfection is for these designers an imperative, a route to authenticity, to reconciliation with the past and foregrounding the marginal, in contrast to fashion's traditional role as the purveyor of ephemeral, perfect fantasies.

Eco

In the second half of the nineteenth century the ongoing effects of living in big cities and the relentless drive of consumerism induced in certain groups of society

a yearning for greater authenticity, for products and lifestyles that would unite man and nature, maker and consumer, clothing and body. The attitudes which the Aesthetes and Rational Dress Society voiced about the impact of fashion on health and the body anticipate late twentieth-century environmentalists' wider concerns regarding the impact of the fashion system on the planet.

In the nineteenth century fashionable dress came to be seen by the Rational Dress Society, founded in London in the 1880s, as the tainted plaything of corrupting capitalism. Its members strove for a reconciliation of self and body that was to be achieved through a hygienic approach to dressing, using natural fabrics and designs that related to the natural, rather than the constructed, fashionable body. In late nineteenth-century London, the Aesthetes, a group of artists and bohemians including Oscar Wilde and Aubrey Beardsley, also wished to unify the disjointed conceptions of identity. They viewed medieval styles in muted jewel colours as more naturally beautiful than contemporary fashions, although for aesthetic rather than hygienic reasons.

Ken Montague has argued that the Aesthetes' endeavour to institute new forms of dress can be related to contemporary scientific advances, which enabled the internal body to be viewed in microscopic detail. This 'mapping' of the body defined the concealed inner body as more natural and real, with the mask of outer appearance needing to be adjusted to create an accord. The Aesthetic Movement's flowing medieval styles related to: 'a model of Aesthetic "hygiene" as the integrity of signification achieved through the unity of the female body – of the inner and outer body, and the body with its clothes'.[52] Clothing was to be used as an emblem of this harmony, the modern body was to represent meaning and beauty by its return to a more natural form.

In the twentieth century, fearing technology and science as agents of unstoppable change and enemies of nature, certain groups have extended this yearning for unity of the body, to unity with the surrounding environment. Perhaps the greatest anxiety has been that the encroachment of technology will cause loss of self, that machines will take over the work and leisure activities of humans, and identity will be lost through such interaction. The importance of conserving the countryside and stemming the tide of consumerist desires is linked to this sense of an alienation of the self, and an erosion of interwoven ideas of self and natural environment. For more radical environmentalists, the supposed successes of capitalism are a chimera, hiding corruption and decay, a culture obsessed with inauthentic desires, dreamt up by advertisers and salespeople, instead of real bodily needs. One commentator in the 1970s warned that we may believe we are seeking positive goals: 'But this humanity, [is] striving for happiness, to the ruin of the inner world, the experience of meaninglessness, and to the ruin of the environment, the complete loss of all life's grounds and securities.'[53]

For the hippies of the late 1960s and 1970s, rejecting the restricting uniform of the world of commerce and industry was intrinsic to their stand against capitalism. The hippies' loose, flowing garments were an emblem of inner freedom, and liberation from the rule-driven lifestyle of those

Status, Power and Display

caught in the treadmill of office jobs and 'respectable' domestic life. They showed contempt for the mainstream by painting flowers and peace signs on their faces, and wearing a heady combination of home-made tie-dyed dresses and tops, ethnic beads and tunics and denim and velvet flares. Long, unkempt hairstyles for both men and women blurred gender divides further; their fluid 'natural' style was a protest-fuelled renunciation of the American dream and the ethics it stood for, in particular the American government's policies concerning the Vietnam War. To some, the firmly middle-class teenagers who made up the bulk of hippies were simply expressing an adolescent desire to irritate and confuse the older generation. René König wrote of hippies' protest dress in 1973 as of a game of gainsaying, and while many hippies were genuine in their protests, there was also an element of antagonism towards their parents' bourgeois ideals of dress and cleanliness to their style. König pointed out the hippie's wish to always stay ahead of respectable dress codes: 'Whereas the businessman wanted a white shirt, the hippie wanted a colourful one. As soon as the businessman wore a colourful shirt, the hippie looked for a garish one; he always wanted to be different.'[54]

While in the second half of the twentieth century youth culture has been constantly pursued by the mainstream, which appropriates and normalises its iconoclastic styles, for some hippies there was more at stake than the need to be contradictory. Over the next two decades, environmentalists became increasingly committed to 'saving nature', and promoting a more thoughtful approach to all aspects of life, from town-planning

and road schemes to eating habits and the design and efficiency of household products. While 'hippie' became a term of abuse in a culture obsessed with consumption and the progress of technology, hippie culture evolved in Britain, to include the army-surplus-clad Crusties of the 1980s and the New Age Travellers, who were some of the most ardent ecological campaigners. Their dress once again necessarily rejected obvious expenditure, favouring second-hand and home-made garments mixed with cheap leggings and sturdy boots. At first they were turned into folk devils by the media, they embodied fears of a breakdown in law and order, fed by a misunderstanding of alternative lifestyles, which were perceived as attacking the status quo. The peripatetic lifestyle of the New Age Travellers made them unpopular with landowners, keen to get them off their property, and when collectives like the Spiral Tribe became involved in staging illegal raves their media image was further tarnished. Such groups were firmly rejected by the mainstream, which was alarmed by so obvious a rebuke to 'accepted' lifestyles. While the later anti-road campaigns over the planned construction of the Newbury bypass of 1996 may have made heroes out of some New Age environmentalists, hailed in the tabloids for their stand against government transport policy, suspicions remained about those who opted out of conventional lifestyles.

However, even among the more conservative there was a genuine desire to seek out more environmentally friendly products, and thereby not only help to save the planet, but gain a tangential sense of union with a mystical ideal of nature.

This vision was formed as much by marketing strategies that played on feelings of guilt and a sense of lack in an era of rapid technological advance, as on long-held, picturesque, visions of the natural world, as the opposite of constructed culture. This perception of the natural is itself culturally constructed, relying upon both contemporary anxieties about the environment in post-industrial society, and a desire to retreat into false nostalgia for a dreamt-of countryside Eden. As Kate Soper has pointed out:

> It is only a culture which has begun to register the negative consequences of its industrial achievements that will be inclined to return to the wilderness, or to aestheticize its terrors as a form of foreboding against further advances upon its territory.[55]

For fashion designers, this desire for products which are ecologically sound has meant a search for fabrics that are derived from sources that have as low an impact on the environment as possible, and which are either left unbleached and undyed, or coloured with natural dyes. Mass market brands like Esprit strove to produce an eco-friendly range of clothes, exchanging bright colours for the softer hues of natural dyes. Designers like Dexter Wong, looked into using hemp, possibly the greenest fabric available, but it would take the commitment of major chain stores to enable hemp to be produced and manufactured in a cost-effective and ethically sound manner. The problem with such fabrics and processes was that consumers still hankered for vibrant shades like the turquoises and shocking pinks fashionable in the summers of 1997 and 1998, but lacking in eco-ranges.

Katherine Hamnett has been particularly committed to using green cottons and other fabrics that combine both ethical production methods, and the dream of ethical consumption, with all the nostalgic ideals this embodies. In her spring/summer 1994 collection, she showed svelte bias-cut dresses, with low-cut backs criss-crossed with skinny straps, their soft beige hue the sign of natural cotton. Moschino also used green cotton the same year in his Ecouture! collection, that developed his critique of fashion and consumerism. He had already printed T-shirts with the slogans, 'Fashion is full of chic', and 'Status Symbol', as well as the embroidered scarlet

Figure 9: Katherine Hamnett, spring / summer 1994, photograph by Niall McInerney. Copyright Niall McInerney.

suit with the legend, 'Waist of Money' discussed at the start of this chapter. However, his clothes, as Moschino himself acknowledged, were bought by rich women, who flaunted their self-conscious logos and eco-friendly fabrics as new status symbols, potent emblems of both caring attitudes and wealth.

While such acts showed an ironic wit, and a wish to undercut the rampant consumerism and hyperbole surrounding high fashion, they did not cut the quantity of clothing consumed. It is, of course, important to move towards using more ecological fabrics, including synthetics that, despite cultural conceptions to the contrary, can sometimes be greener than cotton, which is often bleached and dyed with poisonous chemicals. Fashion designers and consumers alike may wish to see clothing that embodies aspirations towards a unification of body and environment, but the ideal becomes confused in a culture driven by image and a search for the elusive identities sewn into the signification of dress. Concern about the ecology of fabric production links to deep-seated fears about technology and industry, the fear of death and disease and the destruction of the planet. Green consumerism reflects a loss of faith in the progress of science and the capitalism of big business but, according to Gilles Lipovetsky, is too entrenched in the drives and desires of consumerism itself, to enable a genuine alternative to be pursued. Lipovetsky has written of 'ecoconsumption and ecobusiness':

There is no exit from the global fashion system; the new is simply propelled in the name of saving the Earth and preserving one's health. What is 'real', lasting, the 'green' antifashion, functions

as the new vector of consummate fashion.[56]

It is true that it would be hard for retailers to exit the fashion system altogether, since their efforts are directed at encouraging consumers to buy. However, it is surely possible for the system to be reformed from within by companies committing themselves to more ecologically friendly production and packaging methods. It should also be remembered that violence is not just committed against the planet in the name of consumerism. Workers are often paid very low wages and struggle in sweatshop conditions to produce fashionable garments. Fashion constructs a fantasy realm in which all notion of creation stops with the image of the designer. The reverence in high fashion for the individual artist, as in western culture as a whole, excludes any mention of those who actually make the clothes. For the destructive elements of the fashion system to be obliterated and a genuine sense of unity to be achieved, the issues of wages and conditions for factory workers must be addressed, as well as the processes of fabric production. As Angela McRobbie has pointed out:

In effect the emphasis on the social meaning of fashion in contemporary culture and in everyday life has often occurred at the expense of thinking seriously about the work that goes into making fashion consumption possible.[57]

The Permanent People's Tribunal held in Brussels in May 1998 included an International Forum on Clean Clothes that highlighted the poor conditions and paltry wages of many garment workers, most of whom were women. The Tribunal's findings focused on the need for pressure to be

brought to bear on large multinational companies to alter their policies to ensure fair treatment and wages within the fashion industry. These recommendations have been acted upon by the 'Clean Clothes Campaign', which has branches in a number of European countries including Britain, Germany and Spain. Oxfam's 'Clothes Code Campaign' pushes for similar measures, again highlighting the importance of big retailers like Marks & Spencer and the Burton Group in Britain in influencing the way production processes are carried out and the recognition of worker's rights. Both Oxfam and the Clean Clothes Campaign have sought to publicise the poverty and deprivation caused by bad working conditions and low wages to force companies to change their approach. The Clean Clothes Campaign has targeted major events like the World Cup in 1998 to draw attention to the violation of workers's rights by sports-wear companies.

The moralities that fashion negotiates visually, through both image and clothing, may offer the possibility of using consumption as a liberating force, but there must also be recognition that fashion, like all big industries, must address the ethics of its business practices. While fashion may enable the fulfilment, if only momentarily, of a desire for unity and authenticity in a time of uncertainty, it must take responsibility for the abuses it enables, for the brutalities of advanced capitalism it so clearly reflects.

Status, Power and Display

Two: Violence and Provocation

Cropped abruptly at the waist, only the model's ultra-short skirt and tanned legs are visible. She stands girlishly, one knee slightly bent, the pastel tones of her clothes and the strappy retro style of her high-heeled sandals contrasting starkly with the silver metal of the gun she holds and the sticky red of the blood that drips and trickles down her legs. The photograph's colour is heightened, the vibrant green of the grass verge she stands on intensifying the effect of the red fluid that stains her lower body. The model seems to be standing in an anonymous American suburb, which features in each of the series of images taken by Jean Baptiste Mondino for *The Face* in June 1994. Revealingly, this graphic tale of Middle America's fragile mask of respectability fractured by gun violence was entitled 'Reality Bites'. As Richard Stivers noted in his book *The Culture of Cynicism, American Morality in Decline* of 1994, since western culture is drowned in imagery: 'Violent images are the *most real* images because they provoke the strongest emotional response: they simultaneously give us a sense of being alive and of having control over others.'[1]

The photo-shoot's visual impact is a mix of deathly calm, models seem carefully posed in bloody tableaux that recall the 1993 film *True Romance's* seedy glamour,

and throwaway references to violence, combined with the claustrophobic hyper-real environments conjured up by David Lynch's film *Blue Velvet* of 1986, which depicted suburbia as a stifling world of hidden vices and threat. There is a contrast between the model's youth and beauty, and her gaudy too-tight clothes that ape the trailer-park aesthetic that permeated both fashion and film in the mid-1990s. This visual 'slumming' represented a form of rebellion against designer dictates of style and 'good' taste epitomised in the conservative tailoring of Giorgio Armani, that had taken hold in the late 1980s. When combined with carefully choreographed scenes of violence this aesthetic plays upon western culture's fears of and fascination with the underbelly of consumer society. Such images represent dark dreams of taking control of the chaos of contemporary life by resorting to violence. Jean Baptiste Mondino's photographs parodied tabloid headlines dealing with hit-and-runs and serial killers. His pictures showed models, themselves physical emblems of consumerism, acting out fantasies of revenge for the alienation and sense of lack felt by those who are too poor to gain power through the acquisition of lifestyle-enhancing goods. Spiralling violence is shown as a response to exclusion, boredom and lack of opportunity

that a culture predicated on the drive for more and status based on consumption and wealth generates.

In the last quarter of the twentieth century, fashion designers and photographers increasingly examined anger, frustration, rebellion and destruction in the images they created. Both bloody physical violence and an insidious internalised violence that spoke of self-abuse, inner torment and physical decay were explored in fashion photographs and advertisements. They drew upon the excitement and allure of films like *Reservoir Dogs* of 1991 and *Kalifornia* of 1993, which dealt in a heady mix of brutality, narcotics and style.

However, the seeds of this move towards images that reflected cultural anxiety had been sown much earlier in the century. During the inter-war years, surrealist artists like Man Ray brought a strong sense of ambiguity and brutality to their fetishised representations of the fashion mannequin in photographs that fragmented the model's body, blurring between shop dummy and real woman in disturbing collages of body parts. The devastation of the Second World War had also dented fashion's immaculately groomed self-image. Cecil Beaton's photographs of elegant models against the dereliction of bomb-sites brought feelings of dissonance and gritty realism to fashion photography that hinted at the possibility of more serious and disturbing issues being reflected in fashion magazines. In one photograph by Beaton published in British *Vogue* in December 1945, a model is swathed in a plain Balmain jacket, her hair wrapped in a chic turban that mimics factory workers' practical styles. She poses against a bombed building, the walls crumbling, pockmarked by bomb scars. The image evokes the numb silence of fractured cities and destroyed houses. The model's body seems as frail and as fallible as the structures that surround her.

By the 1960s latent violence and drug culture were increasingly explored in fashion representation. Images imbued with references to melancholy and self-destruction were created by American photographer Bob Richardson, who produced photographs of suicide and alienated youth culture for stylish magazines like *Nova* and French *Vogue*. In contrast, in 1961, British photographer Terence Donovan produced dynamic film-still inspired shots of male models for *Man About Town*, dressed in snappy black suits and shades clutching pistols that they pointed at the camera. His pictures had parallels not just with the sleek Hollywood hoods of 1930s gangster films like *Scarface* of 1932, but also with newspaper photographs of London's East End gangland and the stylish image of the Kray Twins.

Such imagery has entered the vocabulary of western culture, as potent icons that repulse and yet thrill. It was inevitable that fashion would reflect the rise in both real violence and violent imagery that have saturated newspapers, television and film. Feeding on the same influences as the rest of the arts and popular culture, it has been used to create styles of aggressive display for subcultural groups from the gangster to the skinhead, just as it has in photographs. Groups who felt disenfranchised from mainstream culture, and therefore from any real possibility of gaining status or power, turned to visual codes that would give them some control of their identity and would express their

sense of alienation in a direct and confrontational way. Men who had a strong feeling of being outsiders, because of the loss of status of their social group found ways to create an alternative lifestyle. At first this exposure of the underbelly of capitalist society was reserved for the real criminals, it then spread to the subcultural styles of young men (for it was mainly men), keen to be rebellious, while maintaining group loyalty through uniform styles.

They used conspicuous consumption subversively to create their own visual codes of status, loyalty, wealth and, importantly, of the threat they potentially pose to the 'norm'. In the West, notions of morality and social acceptability have traditionally centred around the belief in a stable 'norm' around which all other behaviour, belief or representation is defined as unacceptable or even deviant. In the aftermath of the Second World War, as traditional institutions such as religion, politics and faith in the establishment declined, various subcultural groups, artists and designers have sought to explore the increasingly blurred lines between what is acceptable and what is transgressive. The fissures that have developed from the fragmentation of traditional belief systems and the impact of various ethnic, gender and class groups seeking to assert their own versions of the 'norm' has highlighted the fluid nature of ideas of 'acceptability'. Fashion has provided a fertile realm for negotiating new moralities, able to construct and reflect continuously mutating moralities of representation through the directness of visual display.

Both street and high fashion represent spaces in which anxieties surrounding violence and decay have been explored. The flipside of the consumer dream of comfortable affluence and vibrant city life, violence has been used as both aggressive confrontation with the flawed nature of capitalism that taunts bourgeois morality, and as a means to assert glamorised visions of power for the alienated. It sparked the dulled senses of the post-war generations, raised on a barrage of images and constantly seeking to consume new thrills, either by membership of a provocative subcultural group or through the vicarious excitement of visually consuming fashion imagery.

Ultra Style, Ultra Violence

Clothing can act as a disguise that confers power by drawing the wearer into a particular social or cultural group. Consuming fashion can also assuage the monotony of existence, the pressures of work and the alienating effect of anonymous city life. During the late twentieth century, in the relentless search for satisfaction through shopping, the consumer has been continually assailed by images promising newer, greater experiences that may provide opportunities for creating new identities but which also have a brutalising effect. People are reduced to generic consumers, labelled and defined by market research into lifestyle groups, and individuality is sought in vain in a marketplace that is carefully stratified and driven by forecasting trends.

Bret Easton Ellis's novel *American Psycho* of 1991 crystallised the malaise that can develop as a result of the need to

perpetuate and conform to unwritten rules of visual expression. The book caused a huge moral outcry, both because of the graphic detail of murders, and the hollow world of consumer obsession it portrayed. It was an evocation of the city as hell, catapulted by the media and technology into a postmodern simulacrum of life, where communication is through technological and sartorial codes. It drew upon the rise of violent imagery and its links to high fashion, which was to become such a dominant strand in the 1990s. The novel morbidly satirised glamorous depictions of brutality in film and fashion with grindingly realistic descriptions of violence intercut with obsessive notes on both killer's and victim's clothing and accessories. Easton Ellis constructed a dark parody of the 'sex and shopping' novels that were so popular in the 1980s. His anti-hero, Bateman, segues between sex, shopping and violence, consuming and consumed by each in turn.

While others sought to shape the 1990s as a decade of New Age understanding, authors like Douglas Coupland and Easton Ellis examined urban life. Easton Ellis's novel dwelt on the degeneration of a wealthy city financier, trapped in a spiral of sartorial display and mental decline, as his self-revulsion and alienation from his environment leads him into ever more grotesque acts of violence. The minute details of each character's clothes are obsessively listed and given more importance than their characters, each of whom descends into a bland conformity to the latest designer labels: 'Evelyn stands by a blond wood counter wearing a Krizia cream silk blouse, a Krizia rust tweed skirt, and the same pair of silk-satin d'Orsay pumps Courtney has on.'[2] The

loss of personal identity that leads Easton Ellis's characters to hide behind blandly similar clothing, leads to constant cases of mistaken identity, and subsequently the anonymity and apathy that enables his anti-hero, Bateman, to perpetrate numerous murders.

This nightmare vision is a dark satire of the fears that dominated the end of the century, anxieties about disease, poverty and insecurity, that are papered over with consumer dreams, the promise that the right fashions will produce the required lifestyle, that appearance will overcome the empty reality. Ultra style becomes a substitute for job satisfaction or home life and a corollary to violence. As long as the designer objects – the contemporary totems of power and status – are in place, the facade of respectability is maintained. The relationship of this controlled exterior, gym-toned body, healthy tanned face and impeccable suits to the chaos and casual, brutal violence of the novel remains shocking, as does the lack of any consequences for Bateman. The lack of moral judgement was difficult for many critics to accept, despite the ending of the novel that underlined the ultimate imprisonment in this destructive maelstrom with the final words, 'This is not an exit.'[3]

It was the James Bond films of the 1960s, like *From Russia with Love* of 1963 and *Goldfinger* of 1964, which started to make violence into entertainment. The slick, rather camp treatment of the 007 story formalised the relationship of sophisticated fashions married with the ultimate masculine accessory: the gun. The fast-moving action and witty one-liners made Bond a screen hero that many wished to emulate. His cool, controlled, suited image somehow neutralised the impact of the

Violence and Provocation

violence itself; it distanced Bond from the messy realities of killing, as he remained forever intact, unscarred by the battles he took part in.

This cartoonish handling of violence continued in the action movie genre, as mass entertainment, and influenced many areas of culture. Fashion reflected this casual, spectacularised use of violent imagery. The jeans label Soviet ran an advertisement in 1995 which depicted a young female model licking the barrel of a gun, the clearly sexual import of the image adding to its impact. The saturation of fashion images and brands, and the need to attract the attention of the increasingly media-aware consumer has meant that such imagery is used to generate publicity and add a frisson of danger to a particular label or outfit. In 1996 Red or Dead sent models down the catwalk in tight transparent outfits decorated with streaks of black and worn with satin wonderbras. Their bloodied white gloves and the knives they carried undercut their dainty accessories, black net veils, patent handbags and neat shoes. While designer Wayne Hemingway stated that this was a protest against French nuclear testing in the Pacific, as ever it was the shock of violent motifs in the context of a fashion show that drew the media's attention, rather than the significance of the protest. To some, such events were a symptom of the general decline in standards that pervaded contemporary popular culture. Margaret Thatcher was moved to comment on this perceived laxity, 'The younger generation is being reared in a morally corrosive atmosphere where they are taught in the name of liberty that anything goes.'[4]

The idea that young people are exposed to too much sex and violence at too early an age has been much debated in the 1990s, with computer games being particularly criticised. PlayStation's character Lara Croft, from the *Tomb Raider* game, embodied many of the issues raised. With her voluptuous figure, and multiple weaponry, she drew upon earlier cartoon heroines like Tank Girl for her tough image. Although her costume in the game itself is minimal, her cult status led to her computer-generated form being used to model the latest high fashion styles in the June 1997 edition of *The Face*. Clad in skimpy Gucci bikini or Alexander McQueen fitted suit, with accessories by

Figure 10: Red or Dead, spring / summer 1996, photograph by Niall McInerney. Copyright Niall McInerney.

Uzi, she combined erotic fantasies of sex and power in images that used ultra style with the threat of ultra violence in the guns she carried. Inspiring numerous websites, mainly concerned with her digitally created hourglass figure, and making an appearance in U2's Popmart tour, she demonstrated the continued fascination for violence with a stylish, eroticised face. Quentin Tarantino's films have mined the same rich vein of postmodern, stylised violence, presented with an ironic artificial over-wash. 'Tarantino has said that violence is just another colour in his palette. His films are so referential, parodic and playful that this could be true: everything is artifice, composition.'[5] It is true that both *Reservoir Dogs* and *Pulp Fiction* encapsulate the 1990s nostalgic, self-referential stylisations that have also dominated fashion, but this has, if anything, made them more controversial, as treating extreme violence and drug abuse in a semi-humourous manner is disquieting to many.

Tarantino has seen, though, that the use of sophisticated, subtle suiting by Agnès b, constructs a slick exterior, which he uses with sharp, slangy speech to give his characters an instant air of cool status, even if they are essentially small-time criminals. This image, the gestures and the spoken style of his films have been much copied, the narcissism of his male characters defused by the sudden plunges into violent excess, the clothes bathed in fake blood, highlighting the instability of the facade that he has created. This instability has done nothing to diminish the appeal of the film's imagery, which has inspired numerous fashion shoots in men's style magazines like *Arena*, eager to appropriate the fantasy of careless, brutal style that Tarantino's work portrays.

Confusion in some sections of the public between the fiction of such filmic images and the perceived increase in actual violence muddies moral debate about depictions of inner-city crime. The desire to preserve a semblance of calm and control, and the appearance of secure identities has led to the use of simple silhouettes and structured, clean styles that confer value upon the perpetrator of fictional violence and conceal the chaos of city life. The push by both consumers and producers for new experiences means that in the blurred areas of the real and the fictional, new moral boundaries are constantly negotiated. Both market forces and photographers' and designers' desire to push boundaries and attract the attention of increasingly media-literate consumers jaded by over-exposure to visual stimuli means that cultural perceptions of acceptability in relation to the depiction of violence are continually questioned, in the name of art as well as commerce. As Durkheim said: 'Reality seems valueless by comparison with the dreams of fevered imaginations … A thirst arises for novelties, unfamiliar pleasures, nameless sensations, all of which lose their savour once known.'[6]

Gangsters

The desire to create new rules, to break free from social and moral restraint has always had a strong fascination. For those who feel they cannot gain status and value through the normal channels, violence, combined with a distinctive visual style, signals directly the anger and alternative loyalty of groups who, on the outside, seem contained and controlled. The gangster

was an early exponent of ultra style, ultra violence, combining the controlled exterior of sharp tailoring with the constant threat of brutality to become at once a folk devil and a folk icon, evoked with nostalgia and terror in equal measure.

Combining flamboyant styles and sartorial swagger with the Italian love of visual display, the Mafia gangsters of the 1930s cut a swathe through the despondency and poverty of the Great Depression in America, using intimidation to enforce their power and control over sections of American cities. Real gangsters like the infamous Al Capone paid great attention to their attire, aware that a coherent, highly stylised image can help to realise and maintain the fantasy of setting your own rules, creating your own power base. Capone's all-white ensemble of individually tailored three-piece suit, handmade shirt, trilby hat and full-length overcoat created a striking image that combined individual style elements with uniformity in its eerie inversion of the business-man's dark suiting.

Stella Bruzzi, in her account of fictional gangsters, highlights the significance of this style: '[these] are characters who have cultivated an aggressively masculine image and are immensely vain, and whose sartorial flamboyance, far from intimating femininity or effeminacy, is the most important sign of their masculine social and material success'.[7] The wealth, and therefore the success of the gangster, is substantiated by the quality of his tailored suits, his monogrammed silk shirts, his flawless accessories, his slick trilby, and the strength of his instantly recognisable silhouette. The inverted triangle of the gangster's figure is so potent a symbol of his power, that films need only show his menacing shadow to signal a character's potential threat.

The vanity and obsessive detail of the real and fictional gangster's image could be construed, as Bruzzi noted, as feminine, especially since it requires constant attention and careful consumption to be maintained. But, crucially, the oppressive threat of violence, the knowledge that the gangster is no mere passive consumer, but a man of action, neutralises such accusations. Just as in the military narcissism and attention to the details of outer appearance are legitimised by their link to potential violence, to duty, discipline and power, so too in the world of the gangster, a subversive vision of this stereotype of masculinity reigns supreme. Any lack of a sense of individual worth is overridden by the inclusive nature of the gang style.

Gangsters' constant inspection of appearance and lesser criminals' aspiration to the impeccable style of big-name gangsters has been rehearsed continuously in films since the 1930s. The essential amorality of those who created their own codes of business practice in bastardised versions of the city suit was ignored by those for whom the image outweighs the reality of the gangsters' lifestyle. The messages of films like the *Godfather* trilogy remain confused; even if the brutality and violence is shown in graphic detail, and the main protagonists are punished for their crimes, the fascination and strength of the image overpowers any moral lessons to be learned. The desire to emulate gangster style was discussed by Martin Scorsese in 1996, who recalled the mobsters he had seen in New York as a child:

When we were kids we were very aware of the shirts the wise guys wore, and

tried to copy them … But you could never find these shirts in stores; they were always made to measure. That was power to us.[8]

As with the legitimate gentleman, exclusivity and an elitist desire for the handmade, individual garment, were paramount. The shirt-maker used in Scorsese's film *Casino* of 1995, Mike Athanasatos, went on to collaborate with London-based designer David Butler. They produced sharp lapelled shirts in narrow stripes or jet black, with contrasting white collars and cuffs, that enabled their wearers to consume this image of notoriety and exaggeration. Real gangsters from Bonnie and Clyde to the Krays are also remembered with fear, and yet viewed through a gloss of nostalgia as those who have taken the law into their own hands, who have lived out the fantasy of power and status that holds such fascination. This conflict between the critical and the envious responses to the style, may be 'symptomatic of the American ambivalence towards law and order, the general desire for order, and the resentment of laws'.[9]

The gangster's style quickly became a 'classic', quoted endlessly in fashions and film costumes since the 1930s. The mix of vulgar conspicuous consumption and sharp tailoring has appealed to both men and women, the frisson of amorality and violence that the silhouette carries merely adding to its attraction. Many have sought to emulate the style. The French New Wave films like *A Bout de Souffle*, of 1959, depicted gangsters obsessed with every fetishised aspect of their American predecessors' image. The film *Bonnie and Clyde*, of 1967, also influenced contemporary fashion, the stylish wardrobe inspiring

women to adopt berets and pencil skirts mimicking those worn by the star, Faye Dunaway. Angela Carter spoke at the time of the added resonance a garment could be given by the transformative power of film, describing the mix-and-match dressing-up style of fashion popular in the late 1960s. She described a girl dressing for a party, 'her old school beret dug out of the loft because she saw Faye Dunaway in *Bonnie and Clyde*.'[10]

At a time when many were tired of having to seem shocked, and wanted to assert new values and freedoms the film achieved widespread success. This image of an ultimately destructive ideal, has been revived in numerous fashion spreads, most notably Peter Lindbergh's atmospheric black and white photographs for British *Vogue* in May 1991, which provided added ambiguity by using female models to play both Bonnie and Clyde. In 1995 the *Independent* reported[11] that the wife of a judge murdered by the Mafia, had complained about the inclusion of gangster style designs in Dolce & Gabbana's collections of autumn/winter 1994/5. This exposed the stark difference between the reality of Mafia life and the glamorous visions created in its image.

When transposed to womenswear the gangster style takes on an erotic edge sparked by the contrasting masculine and feminine components it comprises and this juxtaposition of femininity and threatened aggression, of narcissism and violence, continues to resonate despite protests. Dolce & Gabbana's style has always drawn heavily upon this strong, Italian image. In 1992 Steven Meisel shot their advertising campaign: against an urban backdrop, a group of models strike defiant poses in monochromatic gangster

Violence and Provocation

chic. Their black leather caps and pointed, patent ankle boots give a camp air to their wide-lapelled 1930s-style coats. The tiny silk bustiers and smooth stockings project a feminine sexuality in contrast to the ultra-masculine cut of their white shirts and black ties. They stare out at the onlooker with taunting looks that reinforce the unity of their dress and gang-style stance. They are playing at being mobsters, the pinstripes and leather gloves a pastiche of male narcissism, the nostalgic gloss of their cut fusing the real and the fictional gangster, an iconic dress code ripe for consumption. The interchange between legitimate and illegitimate styles may be distasteful to some, but the reference-grabbing that has ensued from the postmodern fragmentation of divisions between previously clearly delineated areas of culture makes it inevitable.

Gangstas

> The functions of violence are also numerous – violence as release, violence as communication, violence as play, violence as self-affirmation, or self-defence, or self-discovery, or self-destruction, violence as a flight from reality, violence as the truest sanity in a particular situation.[12]

The hardcore gangsta rappers of the early to mid-1990s touched upon all these uses of violence. Their uncompromising stance and strident appearance spoke as eloquently of their anger and frustration, as their explicit lyrics.

Born out of the burgeoning black music scene in California, they represented a hardening of attitudes amongst young Black people, who, unwilling to wait any longer for a change in their situation through passive, political routes, sought to assert their strength through their music and visual style. There had been a resurgence in violent gang crime at the start of the 1990s, with its threat spreading out from the ghettoes of major American cities. Unlike the original gangsters that their name referred to, they subverted the casual sportswear that represented the healthy outdoors spirit of America, rather than the more traditional suiting of the older generation. Rap and hip-hop had already fetishised the status of branded sportswear, old skool rappers Run DMC's 'My Adidas', of 1986, had already provided an anthem to the supremacy of the trainer. Gangsta rap was never designed to be as palatable to the mainstream though, and added work-wear to the sartorial mix, as well as references to prison dress, in light denim shirts and baggy jeans worn low-slung to reveal the top of the boxer shorts.

At first simply providing an echo of the established New York rap scene, the West Coast gangstas quickly developed their own more confrontational style, where the authenticity of ghetto experience was a vital element and the anger and resentment it created spoke out against the contemporary 'peace and love', pan-Africanism of groups like De La Soul. This was music and fashion that flaunted references to shootings, drug dealing and sexual domination as a mark of power rather than degradation, where status and therefore value came from threat and menace. bell hooks commented, 'Rather than seeing it [gangsta rap] as a subversion or disruption of the norm, we would need to see it as an *embodiment* of the norm.'[13] Its

message of male domination and control, of using threat to make money was, she argued, an intrinsic element of American culture itself. However, appropriated by a marginalised group like black youth, it was viewed as dangerous and unfamiliar.

Artists such as NWA (Niggaz With Attitude) drew on their real experiences of gang life to express their contempt for white society. While many found the whole premise of gangsta rap offensive, others defended what it stood for. Andrew Ross wrote of the phenomenon

> After a quarter of a century of fronting black politicians and almost ceaseless economic warfare, it's no surprise that kids believe they can only locate sincerity in a musical genre top-heavy with humour and creativity, that delivers fantasies much closer to home than the distant dream world of affirmative action politics.[14]

The continual negative portrayal of young black men in the media had demonised them, and gangsta rappers played up to the stereotypes that a racist culture had shaped for them, revelling in talk of violence and gang warfare, eager to show journalists their gun collections, and flaunt their new-found wealth.

Since they came from poor communities, marginalised politically, they had formed their own group loyalties and had no desire to be assimilated into the mainstream. While earlier rappers like Public Enemy had used an aggressive stance and military-inspired dress to speak of black awareness and the message of Malcolm X, gangstas used hard black leather and Palladium boots to assert their own harsh lifestyle as it already existed rather than seeking change.

They owed their vision of black masculinity more to the tough, highly sexed heroes of the blaxploitation films of the early 1970s, like *Shaft* and *Sweet Sweetback's Baadasssss Song*, both of 1971, and the pimps and hustlers that inhabited the pages of Iceberg Slim's novels like his 1967 book *Pimp, A Story of My Life*. They were men who used crime and aggression to assert their position, and flamboyant styles that drew attention to the money they made by illicit means, defying rather than accepting the poverty of their origins. They took pride in their appearance, narcissism once again tempered by menace. If white culture had forced black masculinity to become performative, restricted by stereotypes of black men as sportsmen and dancers, then the icons of the 1970s like John Shaft and Superfly embraced the notion of maleness as spectacle, while clearly signalling their opposition to the mainstream. John Shaft, a private detective played by former model Richard Roundtree, dressed in a slick combination of polo neck, flares and leather trenchcoat from the opening sequence of the film. He presented an image that was coherent and sharp, combining an authoritative silhouette with a streetwise fashion sense. His strong visual image is contrasted with the shabby macs and unkempt appearance of the white gangsters he defeats in the course of the film.

The complaints levelled at gangsta rappers voiced concerns about their lifestyle as spelt out in their lyrics and the influence they might have on their fans, as young white devotees also began to pick up on gangsta style, a sure-fire way to antagonise their parents. The mood changed though after the Rodney King

case. King was a young black man who was filmed on CCTV being beaten by the police in Los Angeles in 1992. The acquittal of the policemen involved sparked riots in Los Angeles, and the bravado of the gangsta rappers suddenly seemed hollow at such a volatile time. Artists like Snoop Doggy Dog expressed the darkness of the mood in their songs, while continuing to use a combination of sports- and work-wear, highlighted with gold jewellery as their signature style. Snoop Doggy Dog projected 'an affectless masculinity, conceived under siege and resonating with the long history of presenting a neutral face, a mask of inscrutability, to the white gaze'.[15] While rappers have continued to use conspicuous consumption to challenge their detractors, the references to violence have declined. In 1997 the killings of two prominent rap artists, Tupac Shakur and Biggie Smalls, prompted a more sombre mood, and highlighted the dangers of living the gangsta lifestyle.

Skinheads

> The dramatically pared-down but always pedantically-styled combat dress of Dr Martens, Sta-Press, red socks, braces, Ben Sherman shirt and Crombie overcoat became the dominant terrace look. Out there in football thug land, clothes and violence have always been the twin routes to kudos.[16]

There had been fights on the football terraces in Britain in the 1920s and 1930s, but it was in the 1960s that the mods really cemented the relationship between team/gang loyalty, violence and style. As the hard mods evolved into skinheads at the end of that decade, the feeling of alienation of a generation of mainly white working-class youths found a vicious outlet in terrorising those who did not adhere to their identikit style.

Joe Hawkins, the anti-hero of Richard Allen's series of skinhead novels including *Skinhead, Suedehead and Skinhead Escapes* of the early 1970s, epitomised the cocky, brutal attitude and the obsessive attention to detail of the real subculture. The son of a docker, he loathed what he viewed as the passivity of his father's generation, which stood back and watched as traditional industries were eroded along with the role of the manual worker. Joe was sick of the bad housing, the poor lifestyle and the sense of hopelessness of his peers and, like the gangsta, strove to create a sense of identity 'under siege', a feeling of value that would unite him with fellow skinheads, while simultaneously believing himself to be individual and special. The clothing he adopted stood for a nostalgic (and largely imagined) working-class Britishness that deified work-wear and tough masculinity. The crucial element that added threat and menace to the image was the Dr Marten boots:

> Without his boots, [Joe] was part of the common-herd – like his dad, a working man devoid of identity. Joe was proud of *his* boots. Most of his mates wore new boots for a high price in a High Street shop. But not Joe's. His were genuine army disposal boots; thick-soled, studded, heavy to wear and heavy if slammed against the rib.[17]

The desire to 'cause mayhem' and make use of these boots, in combination with various other home-made weapons,

caused moral uproar. The newspapers were full of reports of skinhead violence and the style became synonymous with brutality. The battles between skinheads and mods at seaside towns on bank holiday weekends became a tradition that the police tried to stamp out by confiscating belts and bootlaces from skinheads as they arrived in these resorts, reasoning that they could not fight if their trousers were falling down and their boots falling off.

Despite their propensity to cause trouble, skinheads felt themselves to be victims, always at the bottom of the pile, part of a reviled lower class, bitter because of their lack of status, and dreaming of an imagined past when people could at least take pride in being British. Now they felt they were ignored by the dominant middle classes, expected to accept their lot without complaint. Three decades later, skinhead George Marshall expressed this feeling in his book *Skinhead Nation*, saying:

> While the lucky few can sit in wine bars wearing suits by Hans Van Kooten, dresses by Ann Demeulemeester and smiles by Persil Automatic, the rest of us are left to fight over the mass produced fodder that fills your High Street shops.[18]

This sense of exclusion even from quality consumer goods led to the fetishised nature of skinhead style, Jim Ferguson's 'Fashion Notebook' in Nick Knight's *Skinhead* book of 1982, provided a template for the revivalists of the period, as well as the first American skins in the 1980s.

Although certain American skinheads, like some groups in Britain, sought to assert a multi-racial image, the involvement of significant numbers of skinheads with right-wing organisations like the National Front in Britain, and their defence of a monolithic notion of national identity did not sit easily with the Two Tone dreams of ska-influenced groups like the Specials, in the late 1970s and early 1980s. The skinhead movement had evolved in Britain at a time of racial tension. The Race Relations Act of 1965 was extended in 1968 and sought to assert greater rights and equality for ethnic minorities and this antagonised right-wing white people. This was exacerbated by Conservative MP Enoch Powell's hostility towards black and Asian immigrants to Britain, expressed in his infamous 'rivers of blood' speech in 1968, in which he claimed that unless African, West Indian and Asian immigrants were repatriated there would be widespread violent rioting. Powell was sacked from the shadow cabinet for his views but his racist statements reinforced some skinheads' feelings of being under siege because of their race as well as their class status. This resentment was crystallised in the violent racism of late 1970s Oi! bands, like Skrewdriver whose white power sentiments gained sympathy among sections of the skinhead subculture on both sides of the Atlantic.

Skinheads had entered the American scene via punk and, as they were smaller in number, they tended to group together, keen to seem tougher than the punks and open to persuasion from right-wing organisations looking to find a younger audience. Other, earlier British subcultures had failed to take hold in America, partly because of the different mood in the US after the Second World War, and because more young people went to college, forming their own groups within that structure. As Jack B. Moore pointed out in

Violence and Provocation

Figure 11: Skinhead photographed outside the Last Resort, a skinhead shop in Petticoat Lane, London, 1981, photograph by Syd Shelton. Copyright Syd Shelton.

his book *Skinheads Shaved for Battle, A Cultural History of American Skinheads* of 1993, mods had seemed too effeminate, with their obsessive neatness, but skinheads touched a nerve, especially in the poor white suburbs of cities with a large black population, like Atlanta. There, young skinheads felt a similar sense of being outsiders, marginalised, with no future to look forward to. They saw being a skinhead as a lifestyle to be imitated and acted out. Fastidious attention to the details of the style was not as pronounced a feature of American skinhead culture, but once again the subculture became associated with outbreaks of gratuitous violence. Although less class based, their anger was focused on rejecting traditional authority, channelled through the pages of numerous fanzines that spoke of the right-wing Oi! bands imported from Britain, which often had links with the National Front in that country. The Ku Klux Klan began to take an interest in skinheads as potential foot soldiers for their racist manifesto. They were never large enough in number to cause the moral outcry that had occurred on the other side of the Atlantic, however, where members of Oi! group, Skrewdriver, were arrested for wearing a political uniform[19] that was allied with the skinhead look, and by the late 1980s skinheads were viewed with the same fear and loathing as the Ku Klux Klan had been in the 1950s. Jack B. Moore described the unfocused anger that he felt epitomised the subculture by writing, 'Skinheads appear to favour disorder. They are lords of misrule. Many seem not to have progressed much beyond the desire to break up society, without much desire to restructure it.'[20]

Skinheads dabbling in fascist insignia only hardened attitudes to the movement, whose shaven heads have been a symbol of aimless hate for 30 years. Attempts in the early 1990s to integrate elements of the style into mainstream fashion were largely unsuccessful; the skinhead is too virulent a folk devil to be comfortably glamorised within the mainstream. It is therefore ironic that the style has been successfully assimilated by Gay subculture in London, where khaki MA1 bomber jackets, Levi's jeans, Dr Marten boots and cropped hair were all adopted by Gay men in the late 1980s. The ultimate subversion of the skinhead's intolerant reputation, the style has become fetishised for its tough masculinity and uniformed control, the very elements that had made it so appealing to the working-class youths of London's East End.

Punks

In contrast to skinheads, punks in the mid-1970s were more concerned with visual than physical confrontation. Their style was about chaos and anarchy, attacking the establishment with images and words, eschewing the controlled exteriors of the other groups discussed in this chapter, which masked the actual violence of their lifestyles. Although punks also adopted swastikas this was more from a blatant desire to shock and confront than any real affiliation with right-wing organisations. This dress style reflected: 'a desire for intensity, a sense of frustration, and the use of clothes as a prime form of personal political expression. Black clothing in itself manages to signal both drama and introversion.[21]

This desire for intensity and immediacy of experience spoke of disgust with

contemporary popular culture as well as with the establishment. Music, fashion and existing subcultural styles, all seemed irrelevant to the lives of youths who wanted to kick back at the complacency of glam rock and the tired rebellion of ageing hippies. Punks expressed their boredom and contempt for morality through a compendium of references scoured from the underside of mainstream culture. Fascist imagery ensured their notoriety and rejection by the older generation. This disregard for the serious and offensive meaning of such symbols, the playful, ironic use of the most despised emblems of the century, led to the creation of an image of spectacular subversion that has reverberated down subsequent decades.

The appropriation of the paraphernalia of threat and violence was mirrored in the performance style of punks Sid Vicious and Iggy Pop, who would smash glass and cut themselves during performances, and was combined with a bricolage of bad taste and dark imagery. This nihilistic bravado of self-mutilation was aped in the multiple piercings of many punks. The style was self-absorbed, parading its self-inflicted wounds in front of a society it saw as bland and uncaring, while threatening the destruction of that society with its anarchic, cut-up graphics and antagonistic musical style.

Situationist-style tactics were used at punk concerts; groups aimed to repulse and antagonise the audience with aggressive performances rather than to seduce them into believing in the Spectacle. Malcolm McLaren, designer Vivienne Westwood's then partner and collaborator, was influenced by the ideas of the Situationist International of the late 1960s, which were espoused in theorist Guy Debord's book,

The Society of Spectacle of 1967. Debord discussed the dominating power of the mass media: 'The Spectacle is not a collection of images; rather, it is a social relationship between people that is mediated by images.'[22] McLaren employed the sloganeering and plagiarising techniques of the Situationists to attack the boredom and frustration of consumerism through his manipulation of punk's media coverage. McLaren, with his organisation Glitterbest, managed various rock bands, most notoriously the Sex Pistols and the New York Dolls, as well as contributing to Vivienne Westwood's creations. The theatrical interior of Westwood and McLaren's King's Road shop, the name of which changed to reflect their current design ethos, for

Figure 12: Punk girls at West Runton Pavilion, Cromer, Norfolk, c.1979, photograph by Syd Shelton. Copyright Syd Shelton.

example, Sex in 1974 and Seditionaries in 1976, provided a focal point and inspiration for young punks. It brought art school strategies of subversion into the previously calm world of retail, turning consumption into an anarchic act, loaded with menace and threat. Punk created another world, parallel to the 'norm' of the cities it inhabited, where skinny youths flaunted the violent secrets of sado-masochism in bondage suits and unravelling string jumpers, and swaggered with cocky delight at the outrage they inevitably provoked.

Whereas previous subcultures had usually cast women as marginal figures, with clothes that were imitations of their male peers, punk allowed young women a strong, if intimidating dress code. It flouted accepted notions of femininity, preferring to shock with ripped fishnet stockings, plastic mini-skirts and garishly unnatural make-up. As one commentator pointed out: 'By hi-jacking the imagery of sexual perversion, and inverting the meaning of bondage clothing, Westwood made young women's fashion threatening and overtly hostile for the first time.'[23] It was a look that combined the obvious sexuality of the dress of prostitutes with a violent retraction of the sexual invitation that the latter's clothes represent. While such imagery was disturbing, it did at least free women from the need to aspire to a particular fashionable ideal of beauty, or to attempt to fit their bodies into the current silhouette.

Westwood was clear as to the reasons for the unease such clothing caused: 'We were interested in what we thought was rebellious, in wanting to annoy English people – and the way to do that was through sex.'[24]

Despite the sexual liberation of the 1960s, much of England remained resolutely conservative in its attitude towards sex. Westwood's approach to design as a means to assert a personal political stance used this anxiety, exposing hidden desires, with pornographic imagery and slogans.

While punk may not have brought down the establishment it reviled, slipping instead into a pastiche of itself in the early 1980s, with mohican-haired punks as much a cliché of London's image as the red double-decker bus, it had a profound effect upon fashion. The do-it-yourself mentality launched a plethora of young designers as manufacturer-retailers of their own work sold from small outlets and market stalls, as well as influencing designers like John Galliano and Rei Kawakubo, who sought to push the boundaries of high fashion. It also fractured previous notions of the need for a pre-ordained idea of beauty and perfection. Punk entered fashion's vocabulary as a signifier of amoral revolt, and its legacy has been felt in the 1990s by generation X, Douglas Coupland's term (and also the name of Billy Idol's punk band), for the generation after the Baby-boomers – unmotivated and cynical twenty-somethings – who were depicted as 'slackers'. Generation X sought to distance themselves from the conspicuous consumption and flash styles of the previous decade, with punk a strong influence on their low-key style. Once again neo-punk brought about a turning in on the self, signalled by the upsurge in piercing and tattooing, on both the street and the catwalk, as well as inspiring designers and image-makers to seek new definitions of beauty which would reflect the frustrations of youth, rather than the ideals and morals of their parents.

Heroin Chic

At a press conference in May 1997 American president Bill Clinton drew attention to what he saw as a major problem of contemporary fashion: 'The glorification of heroin is not creative, it's destructive. It's not beautiful it is ugly. This is not about art, it's about life and death. And glorifying death is not good for any society.'[25] His words were prompted by the tragic death of fashion photographer Davide Sorrenti from a drug overdose at just 21 and the innumerable images of emaciated, dazed models, sprawled in seedy, anonymous rooms, that were so prominent in the 1990s. Clinton continued: 'As some of the people in these images start to die now, it becomes obvious that it is not true, you do not need to glamorise addiction to sell clothes.'[26]

The president's statement met with a mixed response from the fashion world. Some felt that he was voicing the fears of many within the fashion industry. British fashion journalist Brenda Polan wrote in the *Daily Mail*: 'A ragged cheer could be heard echoing around the fashion industry yesterday [when Clinton berated 'heroin chic']. President Clinton put his considerable weight behind an opinion held by many who work in fashion.'[27] Others, particularly those in the style press who were already moving on to new photographic and styling techniques, argued that the 'heroin chic' look was over anyway so it was too late to have any effect.

British photographer Corinne Day defended this style of imagery as more honest and realistic, as an attempt to move on from fashion's traditional representations of impossible beauty. Day was instrumental in pushing fashion away from relentless perfection, using more unconventional looking models and urban settings that she felt reflected young people's lives more honestly. In a photograph entitled simply 'Georgina, Brixton', of 1995, a model inhabits the claustrophobic interior of a sparse flat. The cheap, dirty carpet and bland decor are a far cry from the lush settings more familiar to the glossy magazine. The model wears scanty red underwear, its lines drawn out in rippling black lace. But this is no vision of eroticism and desire, her thin body is contorted, she seems unaware of the camera's exposing eye. The image refers to a souring of fashion's glamorous allure, to a search for greater realism in fashion imagery, but such photographs have also been interpreted by fashion commentators, as well as the American president, as representing the throes of a narcotics rush.

In the late nineteenth century the use of drugs, especially by bohemians, had grown to be associated with notions of weakness, and therefore femininity. In paintings of the period, drugs are often depicted in a context evoking visions of generalised exoticism assigned to the huge area defined by the West as the Orient. Earlier in the century artists like Delacroix showed North African women as lush and inviting, recumbent in jewel-toned loose tunics, smoking hookah pipes. Such images contrasted starkly with the restrictive formality of western attire and notions of respectability and were developed further in the mythology of the opium-eater, who was once again depicted in terms of 'otherness', as an exotic figure of relaxed morality. Degas' *Absinthe Drinker* of 1876 presented a very different vision of addictive substances. In

Figure 13: Antonio Berardi, autumn/winter 1997/8, photograph by Niall McInerney. Copyright Niall McInerney.

Violence and Provocation

this case the potent alcohol's sedating power is seen as stifling, turning the sitter into a numb doll, clad in melancholy layers, drained of colour. Her staring eyes seem to see nothing, she is denied a productive life, trapped by her desire for the immobilising pleasures of the thick almond-green liquid. Both her glazed expression and bedraggled surroundings have echoes in the imagery of the late twentieth century.

The absinthe drinker and the opium eater both embodied contemporary fears of degeneration. Opium was linked to the spectre of foreign infiltration, since its use centred on the Chinese communities in London and New York, and the drug became a symbol of cultural decline and deviance. Conan Doyle's description of an opium den in one of his Sherlock Holmes stories is telling: it 'drew voyeurs and slummers … There were those for whom the spectacle was entirely other, in whom no spark was struck by the fancied tableaux of bodies frozen in fantastic postures. [28]

The authorities were largely unmoved, however, until the late nineteenth/early twentieth century, when young aristocratic rakes began to experiment with drugs, drawn by the lure of exploring the city's underbelly. This, combined with the increase in drug use by soldiers on leave from the front during the First World War, prompted the gradual demonisation of various drugs which were previously easily available. In Britain, for example, morphine was sold at Harrods as late as 1916. Every society defines morality in reference to a concept of 'the norm', western society now shifted that norm, and certain drugs ceased to be classified as primarily medication. Their users were now viewed as deviant abusers. [29]

As society has further fragmented in the twentieth century overarching notions of morality have been exploded and sociologists have noted that various ideas of morality can be in operation simultaneously, with attitudes dependent upon the standpoint of a particular social group. In the late twentieth century the 'deviant' behaviour of the junkie had been brought into the confined world of fashion, its change in context disturbing readers' expectations that glossy magazines produce only easily read 'closed' images with secure meanings. Instead they have provided visions of uncertainty and loss of control. Lidz and Walker, who studied real heroin abuse in the late 1970s, and the moral attitudes it provoked commented:

> the 'rightness and wrongness' of various activities and participants in the deviance and control process depends on the social (and moral) perspective from which they are viewed. For instance, to some drug users, illicit drugs are morally good … while to various anti-drugs crusaders they are clearly evil.'[30]

The friction created by shifting ideas of morality and the contradictory viewpoints held by different social groups is epitomised by the conflicting reactions provoked by the late 1980s rave scene. The huge heroin scare of the 1980s had frightened many away from the drug and rave culture provided alternative narcotics that, to the younger generation at least, were perceived as less dangerous, less seedy. Ravers created an image of drugs like ecstasy as benign, producing only positive feelings of being 'loved-up', part of the nostalgic, brightly coloured world of the party, that drew on the dictums of

love and peace of the 1960s hippie. Angela McRobbie described this fantasy of harmless fun, saying, 'This is a drug culture which masquerades its innocence in the language of childhood.'[31]

In the 1990s, however, this escapism was undermined by the recession and the image of heroin also began to shift, as Dr Robert Millman of the narcotics treatment programme at New York University's Medical Center said:

> It used to be we would associate heroin use with poor people, losers, people who were going to get Aids. Middle-class people didn't want to get near it. Now, it has attained a certain chic, that's true. It has acquired an aura of romance, excitement and darkness.[32]

This fascination with darkness is crucial to the appeal of the drug, and also the appeal of the photographs associated with 'heroin chic.' The desire to experience danger, excess, if only voyeuristically through the visual image, has power in a society constantly seeking new thrills.

The increased access to heroin, because of the switch in its trade from Asia to established cocaine routes from Colombia, has meant that its use has seeped into all levels of society. This, combined with the rejection of the obvious glamour of the 1980s, has led to a section of the fashion industry using the look to create an ambiguous image of millennial anxiety and sleazy glamour.

Barbara Lippert New York advertising columnist, commented in 1997: 'In this media culture, there's been every sex act and every tattoo and every piercing possible and they have to keep getting more and more extreme, until they get to death … Now they've done death.'[33] Francesca Sorrenti, Davide Sorrenti's mother, herself a fashion photographer, made links with the reality of the lives of fashion insiders: 'Heroin chic isn't what we are projecting, it's what we are. Our business has become heroin chic. Someone taking pictures of that magnitude has to have experienced hard drugs.'[34]

Both the early 1990s grunge look and the revival of punk influences reflected a general dissolution, a feeling of hopelessness in a time of recession. They were also a result of the lack of optimism after a period of strident individualism and decline in any sense of collectivism. People were expected to be independent, individuals, but the break-up of traditional roles, at work and in the home generated a sense of ambiguity and ambivalence. This mood is comparable to the explosion of teenage angst that fuelled punk. While punk flaunted the unnatural in order to disrupt accepted moral codes and notions of stable identity, the young photographers and designers associated with heroin chic claimed their style was natural, that it reflected their real lives. However, its link to the imagery of heroin use throws this into question.

In his discussion of 1980s heroin abuse, Martin Chalmers[35] speaks of its use as a sign of repressed rage and defiance. Its imagery is perhaps therefore fatally appropriate to a generation of young people who felt displaced from the experiences of their parents, who had been able to count on greater stability in their lives. The early 1990s recession undermined both job and housing security and, coupled with growing disillusionment with government policies in Britain and America, a generation was created who felt alienated from a political system which seemed to have nothing to do with them and their concerns.

As ever, fashion was in tune with the *zeitgeist*; music, film and literature were also fascinated by the dark side of urban existence. Films like *Drugstore Cowboy*, of 1989, and *Trainspotting*, of 1996, inhabited the murky world of the junkie, recalling the 1981 cult film *Christiane F*, as did the novels of Irvine Welsh and Will Self. American rock band Nirvana embodied these concerns. As Jon Savage said in *The Face* in April 1997: 'Nirvana brought darkness into light but this is a dangerous occupation. People don't associate you with the therapeutic function of exposing the shadow; they associate you with that shadow.'[36]

The bruised and drug-hazed images that were so visible in the 1990s can be interpreted as angry rejections of fashion magazines's airbrushed notions of beauty, and call to mind Chalmers's analysis of those who choose to 'proclaim an excess of defiance to the healthy unmarked body and to good sense'.[37] They displayed a defiantly imperfect body and world view, as a reaction formation to the feeling of vulnerability and anxiety in a society that sets so much store by appearance. As Chalmers continued, 'Play with the body, as opposed to the labour of making it fit, has been at once a sign of oppression and of the subversion of that resistance.'[38]

When people feel that they have lost control of their lives, they often turn inwards, reclaiming the body as the only thing left that they can control and demonstrating this power through acts which are self-destructive and defiant. These so-called 'heroin chic' images short-circuit our expectations of the fashion image as representing submissive femininity. We seek validation from media representations, in images that are projections of desired selves. In these examples, though, we are denied our aspirational voyeurism and given only images of human frailty, which is profoundly jarring and unsettling.

The desire to project an image of decadence, of conspicuous waste and disregard for contemporary morality, is nothing new. In the 1970s designers like Halston and Yves Saint Laurent played with notions of pleasure, excess and death in their luxurious designs, shot in sleazily glamorous settings. They played with the same visions of ambiguous gender and sexuality that we see in the 1990s, and it is significant that they have been used by contemporary image-makers as a source

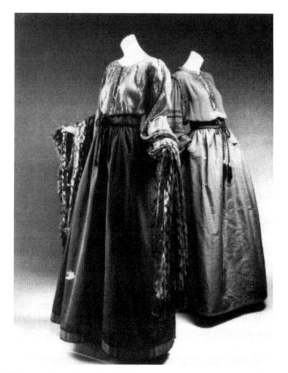

Figure 14: Yves Saint Laurent, evening ensembles, 1976/7, The Metropolitan Museum of Art, New York, Gift of Bernice Chrysler Garbisch, 1979 (1979.329.6a-d; 1979.329.7a-c). Copyright The Metropolitan Museum of Art, New York.

of inspiration. It is also worth noting that there was a similar cross-over between the fantasy of the images and the reality of the designers' lives. Both lived in decadent excess, Saint Laurent modelling himself on the nineteenth-century romantics, who also sought intensity through the emotional extremes of narcotics. Saint Laurent and Halston were part of the twilight world of hedonistic glamour that centred on nightclubs like New York's Studio 54. Their decadent image, woven with tales of excess, was epitomised in the launch party of Saint Laurent's heady oriental fragrance of 1978, Opium. Set on a Chinese junk in New York's East River the party dripped with references to the nineteenth-century opium-eater. It called to mind nineteenth-century aristocrats who went slumming in drug dens, expressing their '*nostalgie de la boue*', in defiance of contemporary morality. This sense of lazy glamour is lacking in the 1990s imagery that depicts a cold and impoverished drug culture, without the sense of distanced 'otherness'. However, some have viewed fashion in both eras as too self-absorbed and omnipotent, drunk on its own success.

High fashion has continued to toy with the etiolated, androgynous forms of heroin chic. When Calvin Klein employed the style in his advertising in 1995, the FBI began an investigation into his company, seeing not only potential drug abuse but also references to child pornography in the thin bodies of his very young models and tatty motel settings. Perhaps this is where the image is at its most controversial, when it is harnessed to blatant commercialism, used by designers to add a contemporary feel to sell their product. It is here that it gains greatest circulation too,

when it leaves the indulgent confines of the fashion world. It is when magazines like *Vogue* – which stands for the older generation's more traditional morality – use the style that there is greatest outcry. The youth magazines that hot-housed heroin chic represent the negotiation of new compromises in morality, where ideas of deviance become fluid as new identities are continually experimented with, pushing at boundaries of acceptability in representation and attempting to create an aesthetic that is truer to young people's experiences.

These negotiations were already in full swing in the 1960s, when drug use became the norm within youth and popular culture. Images by photographers like Bob Richardson projected a similar feel to those of Corinne Day, providing snapshots or stories of young people's lives, an intensification of their experiences. Christopher Booker felt that fashion itself expressed an 'exhibitionistic violence' during the 1960s, assaulting the on-looker with its harsh styles and the careless attitudes it reflected. He wrote of a culture that had become disinterested and cold saying that the 'hard uniforms were curiously impersonal, like the expressionless stare that so often went with them or the throwaway generic terms – "birds" or "dollies" – that were used to describe their wearers'.[39] His fears of a society that is brutalised and oblivious to the import of its words and actions, may undercut the usual image of the 1960s as a period of carefree fun, but his sentiments have been repeated in the criticism of contemporary fashion.

In Bob Richardson's photograph for *Nova* of 1972, the seedy hotel room familiar in 1990s fashion imagery has

become the site of what looks like an over-dose. The prostrate model conforms to many of the usual sexual tactics assigned to the fashion image: mouth half-open as if in sensual delight, slim body posed to increase the amount of flesh revealed. However, this easy reading has become dangerously subverted, the model appears dead, pills emptying from a bottle clasped in her hand, her body limp beside her open clutch bag, that reveals her pass-port and other personal effects, the enve-lope propped on the bedside table completing the image's dark narrative.

In the 1970s, French photographer Guy Bourdin brought danger and deathliness to notions of glamour. He used vivid colour photography that emphasised the artificiality of make-up and fashion, rather than attempting to make it seem 'natural'. In an advertisement for Charles Jourdan shoes of 1975, the product becomes secondary to the unsettling image he has created. The model's stiff legs and her barely concealed naked body seem dead, frozen in position. Her red toenails and strappy platform sandals provide a jarring note on her desensitised body. He has constructed a disquieting image that calls into question fashion's, and by extension western culture's, desire for the young, female body. Here that fetishised body shows its frailty, its mortality. Violence is hinted at but no fixed meanings are obtainable from the various signifiers that inhabit this troubled interior: what is the

Figure 15: Charles Jourdan advertising image, published as a promotional postcard 1975, photograph by Guy Bourdin. Copyright Samuel Bourdin.

significance of the woman frozen in a scream on the television screen? Who is the young child passing the door? Is he aware of scene he has witnessed? The viewer is denied the satisfaction of spectatorship: the comfort of being outside the image looking anonymously in is challenged, voyeurism is made uncomfortable. As in the 1990s pictures discussed earlier, we seem to be witnessing a private scene, itself ambiguous, which crystallises silent fears that reinforce the sense of lack pervading consumerism, instead of providing comforting visions that welcome our gaze.

The postures of 'anxiety, insecurity and sexual uncertainty'[40] that Dylan Jones saw in the photographs of the 1990s were rehearsed in the 1960s and 1970s, although the feeling of innocence that they project were lost in the nihilism of the end of the century. The continued references to heroin chic that we see in contemporary imagery, belie the claims that the trend is over. Actress Chloe Sevigny was shown in *The Face* in 1997 in a photograph by Juergen Teller, which is loaded with signifiers of the confusion surrounding identity and morality in the 1990s. She kneels uncertainly on the floor in front of the on-looker; the girlish innocence of the cluttered bedroom she inhabits is contrasted uncomfortably with her appearance. She wears a black, skinny-strapped leotard, her slouching body marked by clusters of sparkly silver decoration. The leotard has both the glitter of the showgirl costume and the masquerade quality of a child's dressing-up box. The ambiguity of the image is confrontational; meaning is sought from the collection of signifiers, but never satisfactorily found. Her tired face and puffy, dark-rimmed

eyes present an unsettling icon of contemporary popular culture. Sex, death and ambiguity are the key signifiers of the decade. As the interviewer said of Sevigny '[she] may personify our times, but don't ask her what she's supposed to represent'.[41]

Decadence and Decay

In the nineteenth century, theorists like Max Nordau explained the experimentation of bohemians who sought to create alternative lifestyles, and the abject poverty of city life, as a result of cultural degeneration. He read history in terms of a genealogy, with the progressive decline of the bloodline producing the symptoms of industrial decay and drug-hazed decadents: *'fin-de-siècle* society was intrinsically sick, diseased, pathological – its members were degenerating as the privileged became hopelessly weak and effete and the disadvantaged regressed down the evolutionary scale into animality.'[42]

The faults of such an argument are self-evident, yet twentieth-century moralists have again begun to use the term 'degeneration' to decry the contemporary scene. Contemporary catwalk excess has been viewed by some fashion writers as a symbol of the self-indulgence of the fashion industry and, implicitly, the wider culture. Fashion is perceived by some as having slipped into a decadent spiral of immorality, obsessed with its own ability to create as well as reflect the world around it, and with the need to shock, to push ever further at the boundaries of what is deemed acceptable. For Colin McDowell, fashion has 'ground to a halt in a morass of decadence – a tangible decay

of previous standards; the result of a creative degeneracy, caused by a lack of rigour and energy'.[43]

The desire to make sense of late twentieth-century concerns about the fragmentation of traditional belief systems and the frequent interpretation of imagery as reality have led to both commentators and the media seeing the violent and sexual content of fashion, film and television as symptomatic of millennial anxiety. The collective psychosis of the 1990s is seen as linked to emotions surrounding the turn of the century.

Fashion constantly pushes further, driven by the compulsion continuously to move on and create new, more striking images. The seedy excess of 'heroin chic' has been superseded by a feeling of decadence, a desire to create styles that are opulent and extravagant, which combine references to the high style of the 1980s with a continued fascination with decay and ambiguity. In Walter Benjamin's interpretation of the modern age as a vision of hell, fashion was placed in the prime role as the signifier of the ceaseless repetitiveness that he saw as its chief characteristic.

> The image of modernity as the time of Hell … deals not with the fact that 'always the same thing' happens … but the fact that on the face of that oversized head called earth precisely what is newest doesn't change; that this "newest" in all its pieces keeps remaining the same.[44]

The rebirth of couture in the 1990s was the result of capitalist zeal, rather than an actual increase in consumer demand for couture clothing itself. The new couturiers are freer than ever from the need to produce clothing that is wearable by the ever-smaller number of women who can actually afford to purchase such clothes. New to the various ateliers and craftspeople now at their beck and call, both John Galliano, at Christian Dior, and Alexander McQueen, at Givenchy, have heralded a revival in ornate styles that hark back to the complex fashions of the turn of the nineteenth century. In Galliano's autumn/winter 1998/9 collection for Dior, for example, references to the last *fin de siècle* dominated. One model wore a soft grey suit, severely tailored to create the statuesque silhouette of the 1890s. Trimmed with a curved puff of silver fur and dripping with multiple strands of diamonds, it

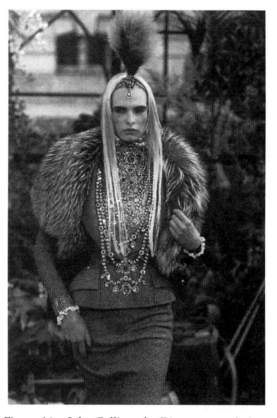

Figure 16: John Galliano for Dior, autumn/winter 1998/9, photograph by Niall McInerney. Copyright Niall McInerney.

recalled an era of decadent splendour. The model's neat hair was adorned with a green feather-plumed head-dress, adding to the emphasis on the vertical and bringing a bohemian note to the tailored control and sculpted torso of the outfit.

Some commentators have highlighted the fact that at the end of the nineteenth century tight lacing, which could be seen as signifying self-control, was in fact being worn at a time of loose morals and extravagance. However, it may in fact be interpreted as a signifier of a greater fetishisation of the body. An extreme fascination with the erotic potential of the controlled figure has become combined with an erotic vision that speaks of threat and domination. Perhaps the 1890s and, in turn the 1990s, see fashion trapped in the thrall of images of amorality and excess. These 1990s fashions are in part a reaction against the complaining morality of political correctness, in part a nihilistic desire for sensation, as garments present a visual and tactile feast of embroidery, real jewellery and furs. They tempt the onlooker, who usually has no means of possessing such riches, with their promise of power and cruelty.

Contemporary couture used the 1890s for inspiration as a conscious reference to this comparison, fulfilling the expectation that history will repeat itself. It is also subconsciously presenting intense visions of a cultural unease, presenting a plethora of imagery that draws upon a mixture of references to the beautiful and the deadly.

Since religious belief has also declined, the idea of creation of self by the individual enables an exaggerated sense of self-determinacy, witnessed in the strength of meaning within these fashions. Whereas in the early 1990s some had felt

that conspicuous consumption was no longer acceptable, luxury is now flaunted to confront the false modesty of the middle classes. As Mimi Spencer put it in March 1998, 'Lock up your morals the rich bitch is back.'[45]

Women are presented as monuments to the gothic, sexually provocative and threatening to the potential voyeur. In Alexander McQueen's designs for Givenchy autumn/winter 1997/8 one model was clad in a sinuous floor-length outfit that combined reference to the 1890s in its curving lines with a jet black geisha wig and Masai-style necklace that encircled the whole of the model's throat in dull gold rings. The gown consisted of a swooping over-dress of semi-transparent red, trimmed with a deep layer of lace that slipped down diagonally from the *décolletage* to reveal a black bustier. The friction created between the layers of fabric produced an illusionary striptease; the model was completely dressed and yet her gown seemed to be pulling away from her body to expose the moulded structure of her underwear. The styling of the outfit, with its mixed references and emphasis on the vertical, undercut this eroticism though, to produce an image of sexual strength rather than submission. The silhouette was reminiscent of the towering figures of the turn of the century, while the ominous spectacle that was recreated still held resonance at the end of the twentieth century, when male fears of women's potential to castrate, to strip them of their powers, seemed to be coming true. For Benjamin, the use of earlier styles of dress represented the need 'not [for] remembrance, but obliviousness to even the most recent past'.[46] They look familiar and assuage fears of forgetting, of loss, but

Violence and Provocation

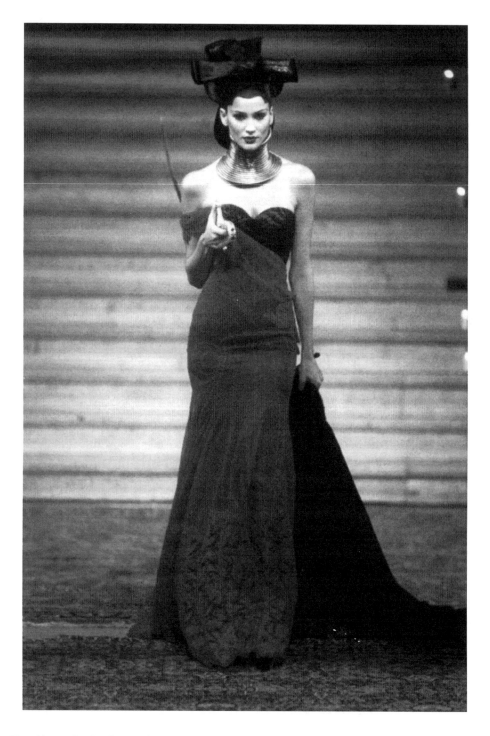

Figure 17: Alexander McQueen for Givenchy, autumn/winter 1997/8, photograph by Niall McInerney. Copyright Niall McInerney.

ultimately represent death rather than rebirth.

The connotations of the deadly, the repeated use of black and blood red, run deeper than just the clothing itself. The imagery of fashion has also become fascinated with the notion of threat, making visible the fears of the feminine by presenting women in terms of the horror film, fascinated yet repulsed. Fashion has become unable to tear its eyes away from the decorated corpses it has dreamt up. If modern fashion, in Benjamin's words, 'mock[ed] death', then postmodern fashion has gone further, taunting death with its nihilistic visions, flaunting its loss of moral restraint, its contempt for hypocritical bourgeois ideals and forcing a confrontation with inner fears.

The body has been contained in a rigid shell, 'the biological rigor mortis of eternal youth',[47] an hallucination of a world without ageing. 'Death and decay, no longer simply a part of organic life, are thrown up at the woman as a special punishment or fate. Her "continuous effort to be beautiful" is reminiscent of the repetitive punishment of hell.'[48] Fashionable decadence has touched on a nerve of western culture, the subconscious association that Freud described of excess signalling death.

The private and public spheres have merged, and the whole body is exposed, still bearing the imprint of the designer's vision by what he chooses to conceal, framing the naked flesh which is controlled by the fabric which surrounds it. This encourages us to consider new definitions of the body, to question the link between the organic and inorganic, since fashion seems to have fused the fissure between these seeming polarities,

as we judge all by the clothing, the image, rather than by the body which inhabits it.

For Otto Dix in the 1920s, fashion only thinly disguised the fallible, decaying body beneath. His paintings make explicit Benjamin's idea that fashion is 'the dialectical switching station between the woman and the commodity – desire and the dead body'.[49] The cold light of Dix's images showed a mistrust of this interchange between surface display and naked flesh.

McQueen explores this interface further, making the body into a memento mori. In one outfit of his autumn/winter 1996/7 collection, a model stalked the catwalk with a clawed skeletal hand seemingly gripping one side of her face, a representative for the dead. But unlike the mementos of the Middle Ages, there is little humble sense of mortality in this ensemble. The powerful feminine of his designs seems rather to flaunt her mortality, and revel in the fears it provokes. Defiant and strong, his work refuses to succumb to fashion's usual desire to erase the traces of decline, to smooth over and perfect any flaws; McQueen remembers Benjamin's injunction that the only sin is to surrender to fate.

Contemporary art projects a similar fascination with death and the desire to refute the morality of the living. If the decay and death of the body can be cheated, there is no reason to be restrained by the squeamish rulings of moralists, who want to avoid such confrontation of their deepest fears. British artist Damien Hirst's work contrives to dominate the natural in a similar way to some contemporary fashions, to forestall death, to preserve desires and emotions in tanks of formaldehyde.

For Belgian fashion designer Martin Margiela, the conflict between creating

Violence and Provocation

memorials to past clothing (or styles) and the need to speak of their inevitable decay is encapsulated in the garments displayed in a Rotterdam gallery in the summer of 1997, which were alive while simultaneously rotting. Working with a microbiologist to impregnate the fabric with bacteria, their lifespan was condensed into a few weeks, as the spores grew into constellations of soft mould before eating at the fabric that they lived on. Eighteen outfits were shown, one for each of Margiela's collections, a poignant *aide memoire* of his career to that date, as well as layered references to dress of the past. One mannequin was clothed in a heavy greatcoat that recalled the Napoleonic era in its wide lapels, double-breasted cut and big buttons.

Perhaps what Margiela's work contains, in its reworked, remoulded garments, are the 'dream fetishes', the 'fossilised traces of history' that Benjamin saw in the cultural detritus of the city. His designs contain not just the patina of age denied by so much of contemporary fashion, but the surviving objects of the past themselves. They fetishise the transience of fashion by continually referring to its cast-off past, making explicit fashion's distaste for the old, for anything that bears the mark of time, that betrays the lie of

Figure 18: Damien Hirst, *Isolated Elements Swimming in the Same Direction for the Purpose of Understanding*, Saatchi Collection, 1991, photograph by Anthony Oliver. Copyright Anthony Oliver.

Fashion, Desire and Anxiety

'newness' and innovation. He places old garments *sous rature*, under erasure, visible and yet erased by the outline of the new silhouette, thereby enhancing rather than denying their meaning.

As noted in Chapter 1, Rei Kawakubo, of Comme des Garçons, also distrusts the excesses of the decadents of couture. She imbues her designs with age, compounding the natural with the techno-logical to produce clothing which acknowledges human frailty and creates an aesthetic of decay. Such work may be a signifier of a type of fashion held back from the abyss of continual repetition, where the hell of (post)modern city life might exhibit mortality and a reunion with the realities of the decay of the body.

The fashion designs and images of the end of the 1990s presented a vision that acknowledged and made explicit both the violence of contemporary life and the emphasis this places upon our own phys-ical frailty. While the overt decadence of new couture, with its gothic styling, is a far cry from the subcultural styles exam-ined earlier in the chapter, both force us to accept the underside of city life and the desire to establish a defiant identity in the face of anxious times. Notions of moral acceptability have been pushed to breaking point by the experiments of

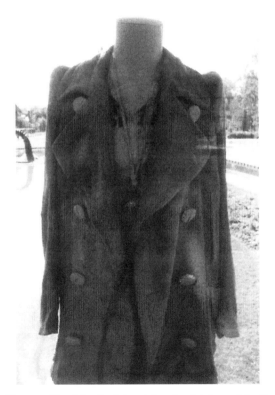

Figure 19: Martin Margiela, La Maison Martin Margiela: (9/4/1615) exhibition, Museum Boijmans Van Beuningen, Rotterdam, 11 June–17 August 1997, photograph by Caroline Evans. Copyright Caroline Evans.

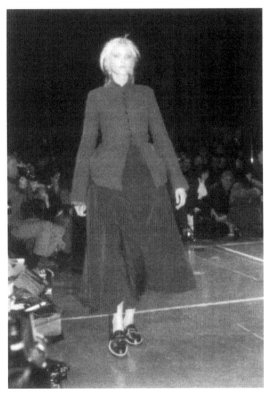

Figure 20: Comme des Garçons, autumn/winter 1994/5, photograph by Gilbert Benesty. Copyright Comme des Garçons.

Violence and Provocation

designers, photographers and those who inhabit the cities' crowded streets. Punk highlighted the hypocrisy of trying to conceal the fascination of violence and sex, forcing a confrontation with base instincts previously masked by modesty.

The thrill of the forbidden, the impulse to flaunt taboo images, dominated the fashions of the last quarter of the twentieth century, despite, or perhaps in response to, the moral unease they provoked.

Figure 21: Comme des Garçons, autumn/winter 1994/5, photograph by Gilbert Benesty. Copyright Comme des Garçons.

Figure 22: Comme des Garçons, autumn/winter 1994/5, photograph by Gilbert Benesty. Copyright Comme des Garçons.

Three: The Eroticised Body

The model stalks the catwalk, dark hair piled messily up on her head and tied with black ribbon, cigarette held to pouting red lips: she is seductively nonchalant. Her Dolce & Gabbana outfit is an abbreviation, somewhere between corset and mini-dress; it sculpts her body with voluptuous curves of shiny black fabric and clasps her figure with hook and eye fastenings. The boudoir styling is taken further with a froth of black lace standing out from the hem and a suggestively placed bunch of ribbons hanging between her legs. She wears over-long evening gloves that shrink down from her shoulders and wrinkle about her arms, her legs are covered by opaque black tights. Remarkably little of her flesh is revealed, only her shoulders and *décolletage*, outlined by the black structure of her corset-dress, but the effect is of erotic undress; it suggests both *fin-de-siècle* bordello and 1950s sex siren, Zola's Nana combined with Fellini starlet.

However, the context of the image, a catwalk show for autumn/winter 1991/2, alters the meaning of these references; the outfit's sculpted silhouette signifies neither courtesan nor showgirl. Instead it represents shifting attitudes towards women and the display of their bodies which had been crystallised in the mid-1980s by Madonna, who epitomised the ideal of strong, eroticised femininity. In Dolce & Gabbana or Jean Paul Gaultier corsetry, she subverted stereotypes of objectified femininity, using flaunted sexuality as an assertion of strength rather than submissive invitation. This offered women the opportunity to take pleasure in the sensuality of fashion and its display of the body.

However, despite the potential power to be gained from the eroticised body, its constant exposure blurred already hazy divisions between private and public, and, since it was always young, slim bodies that were displayed, reinforced restrictive notions of acceptable body size. The conscious adoption of eroticised dress as an emblem of empowerment also aggravated long-standing fears surrounding the nature of female sexuality and stereotypes of femininity as either acceptably modest and controlled, or unacceptably sexualised and uncontrollable. Fashion has made visible male, and to a lesser extent female, anxieties concerning the shifting role of women in late twentieth-century society and the way women should dress and be represented to reflect their developing social status.

The problems surrounding women's encroachment on the public sphere and the challenges this has inevitably posed to male authority have been constantly renegotiated during the twentieth century.

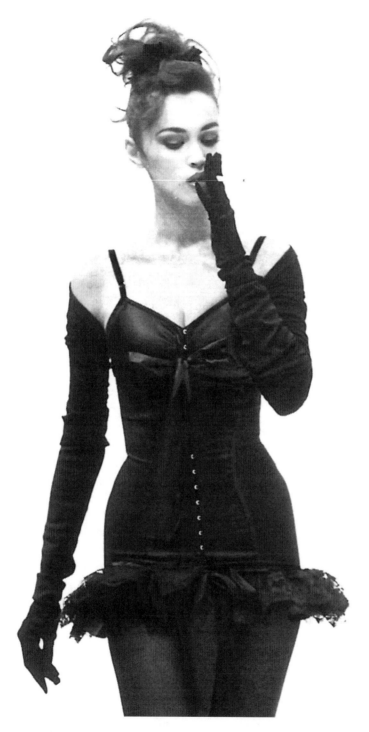

Figure 23: Dolce & Gabbana, autumn/winter 1991/2, photograph by Niall McInerney. Copyright Niall McInerney.

Greater female liberation led to the need for new definitions of identity, which frequently confused the impossible, idealised dichotomy of 'good' virginal femininity and 'bad' eroticised femininity. Martin Pumphrey wrote in 1993 of these negotiations in terms of changing lifestyle patterns in urban centres at the start of the century. Focusing on the 1920s New York flapper, who personified this new type of femininity, he wrote:

> The New Freedom was identified from the beginning as a product of modern city life and perceived as a threat to the traditional, patriarchal concept of the family, to the nineteenth century's (middle-class) ideal of the chaste, passive young woman and the self-denying wife and mother.[1]

The shimmering grown-up gymslip dresses of the 1920s, the wand-like silhouette, and the abbreviated hairstyles, symbolised a new mood of modernity that flourished in cities such as New York, London and Paris. While late nineteenth-century woman may have wished to be seen as 'new', calling for greater liberty and rights for her peers, and adapting the masculine shirt and tailored suit to her statuesque figure, it was the youthful exuberance of the 1920s flapper styles that represented the sense of unprecedented freedom and independence to the young women of the West.

The newly revealed 'natural' body, which couturiers like Paul Poiret had been streamlining in the early years of the century by discarding the corset and creating simpler, less restrictive garments, was celebrated by the flappers, whose appearance was revolutionary in both its style and its import. While it reflected the strength which women had gained in real terms from the successes of the suffrage movement, and their experiences in the workplace before and during the First World War, it also signified their growing presence in the public realm, which had previously been the male domain. Women were more visible: at nightclubs, on the streets of the cities, they danced, smoked, drank and drove, disregarding the Edwardian notion of femininity as a delicate flower to be cosseted and protected from the harsh realities of modern life.

As women came out from the privacy and seclusion of the home, existing ideas about public women, actresses and prostitutes, seen as lacking virtue and legitimate status, were transposed on to the emerging modern woman. She now inhabited many of the same urban spaces as they did. She also adopted the startling dress styles that had previously been the reserve of these public women, for whom newness, in fashions and in moral attitudes, was a stock in trade, a means of attracting and retaining attention. So, by embracing fashion as a force for liberation, women were also linking themselves to the quest for pleasure and seduction.

The modern woman was at once strengthened by a developing sense of her own sexuality and allure through notions of beauty as power, sensuality and independence, but also exposed to the conflicting anxieties surrounding this appeal to the senses, this need to create and perfect a modern physique. While the natural body became revered as authentic, to be toned and revealed in fashionably short skirts and figure-skimming bias-cuts, its naturalness was a fallacy. It was to be constructed as a cultural commodity, through the cosmetics and treatments of

The Eroticised Body

the burgeoning beauty industry, by the internalised corsetry of exercise and, as a quick route to the figure of slender youth, diet pills. This fashionable body was symbolic of discipline and wealth. It contained the familiar ideas of woman as both virgin and whore, clean and pure, yet manipulative and dangerously sexual beneath a facade of artificial charms.

Such conflicting ideas have been played out as the century has progressed, with men and women ambivalent in their response to the appeal of the sexualised woman, who was seen as powerful and cruel. The flapper was an early embodiment of these fears and desires; her style threatened the dominance of masculinity. Frederick Lewis Allen, looking back at the 1920s in 1931, recalled President Murphy of the University of Florida warning that, 'The low-cut gowns, the rolled hose and short skirts are born of the Devil and his angels, and are carrying the present and future generations to chaos and destruction.'[2]

Modern rationality was abandoned in the face of such supposedly loose morality. The woman of the 1920s subverted the image of the adolescent whom she resembled. She was not coy or demure but, rather, a knowing and rebellious youth, eager to try out the new experiences set before her and challenge existing rules of behaviour and deportment. Alienated from previous generations, she sought solace in the excitement of the city, both the real streets and clubs of the metropolis, and the fantasy environment of the luxurious and tempting fashion magazines. They offered freedom through sensuality and consumption, and yet were to ensnare her in eroticism, which would too often slip into resentment, threat and anxiety, conflicting themes that evolved over the century.

Underwear as Outerwear

In the final decades of the twentieth century, underwear as outerwear became a panacea for the fears surrounding sex and the body, haunted as it was by the threat of disease and violence, as well as being a site of empowerment for women who wanted to reclaim their sexuality and take pleasure in the potent appeal of erotic fashions. It has become a prominent example of the 'playfulness' of postmodern culture, 'dressing up in undress', a cliché of fashion story headlines, an escape from threatening realities.

As always, the undeniable appeal of the revealed or semi-nude body raises strongly contradictory reactions. Fashion writer Colin McDowell hinted at these in his comments on lingerie-inspired styles in 1995:

> the movement to figure consciousness that is now sweeping the fashion world is light years away from the vulgar S&M cartoon pastiche of sexiness which entertained some designers in the 1980s but had virtually no appeal for women.[3]

And here is the double bind: it is acceptable to wear underwear styles as long as they are delicate, feminine and not too revealing, styles which evoke images of the high-class models of the 1950s clad in neat, sophisticated waspies by couturiers Fath and Dior. However, garments which smack of explicit sexuality present greater problems as these relate directly to our hidden desires, to the act of sex itself, not things one should parade in public. The

message put across to women reflects the eternal conflict between the need to appear sexually attractive and being condemned for adopting too obvious an approach to achieve this goal.

The separation of fashionable styles for the 'public' women of the stage and screen, body-exposing costumes, shimmering fabrics and extravagant decoration, and the more sober lingerie fashions worn in 'everyday' life has been a staple of dress codes for centuries. The use of underwear as outerwear to subvert distinctions between public and private was popularised as early as the eighteenth century, by Marie Antoinette, painted by Elizabeth Vigée Le Brun in 1783 in the *déshabillé* of a chemise dress. Traditional Judeo-Christian thought stemming from the Old Testament description of the Fall, imposed a morality upon the exposure of the shameful naked body, which had to be swathed in the drapes of fabric, and concealed from lustful view. The lustful response to garments that simulate visions of undress and nudity has however ensured that fashion persists in reinventing their explicit appeal, to gain publicity, and to promote the latest body ideal.

To moralists in the twentieth century, as in earlier periods, such images denote the loss of all sense of boundary between the private and public, a condition that has led to a breakdown in values, the body, especially the female body, being held in contempt as a result of its constant exposure. Mario Perniola wrote in an essay entitled 'Between Clothing and Nudity' of 1989, that clothing creates 'being', with nudity representing a loss of this and that the danger of blurring this division, produces great unease. How is the wearer's status to be interpreted? Perniola wrote:

> Clothing gives human beings their anthropological, social and religious identity, in a word – their being. From this perspective, nudity is a negative state, a privation, loss, dispossession … being unclothed meant finding oneself in a degraded and shamed position, typical of prisoners, slaves or prostitutes, of those who are demented or cursed.[4]

The ambiguity of underwear as outerwear, caught forever between dress and undress, has a disturbing yet fascinating erotic effect, playing upon our fear of the uncertain. We are unsure how to respond to the sight of women seemingly dressed to go out and yet clad only in transparent fabrics or items of lingerie. Such styles are usually the preserve of the young, who are both more willing to expose their bodies and whose bodies are inevitably more in line with fashionable ideals of youthful slenderness. Each successive permutation of this trend is therefore regarded as 'new', and often as yet another example of declining standards in social behaviour.

In the 1980s younger women, many of whom felt alienated from second-wave feminism, which largely rejected fashion's allure, were particularly attracted to the idea that stylish dress could be empowering. Janet Radcliffe Richards discussed this in *The Sceptical Feminist, A Philosophical Enquiry* of 1980:

> The fact that some feminists seem to confuse feminism and puritanism, and convey that it is part of the women's movement to see sex and sensual pleasing as a frivolous waste of time, is probably one of the main things which puts people off feminism.[5]

The Eroticised Body

Richards believed that wearing sexually alluring, fashionable dress was something for women to take pleasure in, saying: 'why not wear pretty clothes? Why not, in suitable circumstances, dress in ways that are deliberately sexy?'[6]

The qualification of 'in suitable circumstances' demonstrates the hazy morality that surrounds attitudes towards sexually alluring dress like underwear as outerwear. Who is to say when such dress is 'suitable'? The idea that revealing clothing represents dubious morality is too firmly embedded in western cultural belief to have been completely erased by calls for women to empower themselves by reclaiming their bodies through what they wear. However, the media, especially the advertising industry was keen to promote the idea that images of scantily clad women could be represented as pleasurable for women and, increasingly, as an ironic and knowing appropriation of out-of-date stereotypes of women as sex objects. The controversial early 1990s Wonderbra poster campaigns, featuring model Eva Herzigova in black satin bra with the line 'Hello Boys' emblazoned above were an example of this. They were cheeky and playful yet required women to dress sexily or seem humourless and old-fashioned.

Earlier in the century concerns about the inflammatory properties of suggestively designed clothes had already led to a clause in the Hays Code of 1930 to combat the use of provocative costumes in Hollywood films.

Undressing scenes should be avoided, and never used save where essential to the plot.
Indecent or undue exposure is forbidden.
Dancing costumes intended to permit undue exposure or indecent movements are to be regarded as obscene.[7]

It went on to explain why these strictures were necessary, given the 'immoral effect' of nudity and semi-nudity on 'normal men and women', ending with the final injunction: 'Transparent or translucent materials and silhouette are frequently more suggestive than actual exposure.'[8] In the first half of the twentieth century, the cinema was one of the most accessible sources of information on fashionable styles and body image for many women in America and Europe. It enabled 90 minutes of legitimised voyeurism, frequently with fashion shows woven loosely into the plot line to further satiate the desire for beautiful clothes and stars that films already provided.

The 1930s saw the rise of the bias-cut column dress, pioneered by French couturier Madeleine Vionnet and worn by many stars, eager to assume the goddess-like image these gossamer slips of silk created. While these gowns draped the body in a classical swathe, the soft skin tones and light elasticity of the materials, cut to float provocatively around the figure, carried the imprint of the nudity they hinted at and further eroticised the figures of Hollywood icons like Jean Harlow and Carole Lombard, despite the moral climate. The slender female body, dressed and yet evoking the classical nude, was revered by designers like Madeleine Vionnet in a similar way to the Ancient Greeks' idolisation of athletic male youth. The effect was heightened by the symbolic relationship between the visual and tactile qualities of the fabrics and the yearned-for forbidden touch of the skin. Silk became a surrogate for the 'occulted body' beneath. Anne Hollander has noted Vionnet's and fellow

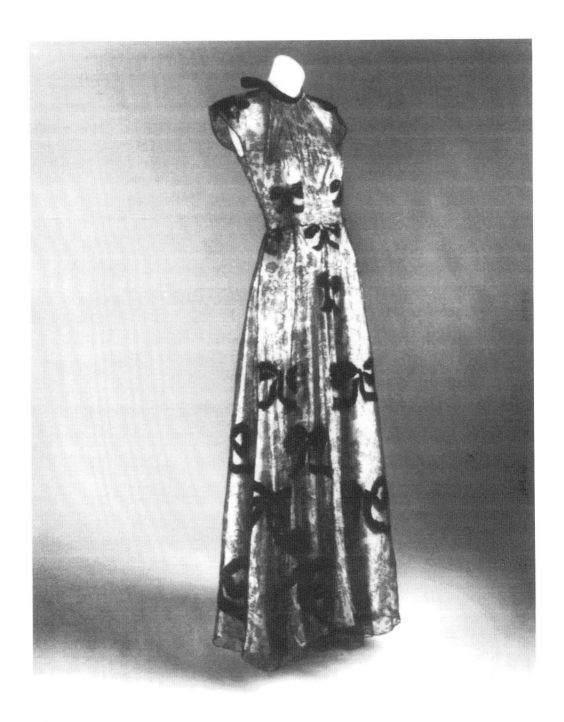

Figure 24: Madeleine Vionnet, black lace evening gown, 1939, The Metropolitan Museum of Art, New York. Gift of Mrs Harrison Williams, 1952 (CI 52.24.2a,b). Copyright The Metropolitan Museum of Art, New York.

The Eroticised Body

Parisian couturier Mme Grès's exploitation of this:

> [They] were the specialists in suggesting the pleasures of touch while maintaining the requisite linear slenderness and aura of refinement. These two used fabric in a sculptural way, as if it were an extension of mobile flesh, modelling directly on the body to make a complete plastic and tangible composition.[9]

In the 1950s, cinema continued to provide blueprints for the dubious morality of lingerie fashion. The proto-sex kitten played by Caroll Baker in little lacy nighties in *Baby Doll* of 1956, and Liz Taylor's assured manipulator, clad in a soft ivory-coloured, lace-trimmed slip in *Cat on a Hot Tin Roof* in 1958 – both represented models of sexuality which would be continually reworked in subsequent decades. The subverted nonchalance of their deliberate undress was instantly viewed as inflammatory; the League of Decency condemned *Baby Doll* on its release.

Thirty years later Italian designers Dolce & Gabbana were to base their careers on the appeal of this style. They consciously drew upon collective memories of Liz Taylor in the 1950s and of Fellini's voluptuous stars of the 1960s to add layers of tongue-in-cheek, pastiched eroticism to their creations. In the late 1980s and early 1990s, as discussed at the start of this chapter, they produced dresses in Sicilian black, which accentuated the female form, with softly corseted *décolletage* and visible underwear detailing. These were paraded by supermodels including Linda Evangelista, who 'played' at being Sophia Loren or Gina Lollabrigida, her powerful posture forbidding the touch that her clothing seemed to invite. As fashion designer Pam Hogg put it, 'You can look but don't touch – it's a sort of safe sex.'[10]

The craze for bra tops and bustiers permeated the period, a seductive juxtaposition to the sharp tailored suits, but equally eloquent of women's desire to gain power through confidence in their bodies. Madonna was the ultimate purveyor of this empowerment in pastel or gold pointed corsetry by Jean Paul Gaultier, who was influenced by the heavily cantilevered structures of 1950s bras by lingerie company Frederick's of Hollywood. It was a feminine suit of armour, to simultaneously seduce and threaten the onlooker, and copied on every dance floor in the western world.

However, the positivity of the 1980s was undermined by world recession, and growing fears of instability and decline, anxieties which led to a seeming compulsion for people to expose their innermost feelings in trying to make sense of the situation. On television chat shows and in the growing number of self-help guides, it became essential to unburden and examine all areas of your life. This media-fed desire to abandon secrecy stripped away boundaries in private life; the very notion of privacy came under suspicion as a potential smokescreen for nefarious practices.

Self-reflexivity became the dominant motif of various art forms during the decade. Artists and performers sought to analyse both their own motivations and the underlying meaning of their discipline. Frequently this took the form of obsessive self-scrutiny, as artists became the key subjects of their work, using their own identities as a medium to seek greater truths. British cultural critic Joan

Smith spoke of this in an article on women artists like Tracey Emin, who constantly use themselves as the subject of their work saying, 'we have come to expect access to the most intimate details of women's lives, to a degree that would have been unthinkable even two decades ago.'[11]

The dominance of transparent fashions has been a symptom of this. The wearer reveals her body as an emblem of her femininity, making the onlooker believe they know more than they really do about her. An outfit from Prada's second line, Miu Miu, of spring/summer 1997, reflects this. Layers of transparent white clothe and yet reveal the body, hinting at innocence and artlessness in their childish vest-and-gym-knickers shaping. However, the high fashion status of the label and the 'nude' coloured ankle boots belie such a straight-forward reading. The wearer is at once transparent in her intentions and yet knowing and opaque, her silhouette blurred, her femininity made hazy. She has gained another kind of power, to add to the erotic allure of the previous decade, the playful layered references in her dress a disingenuous nod at the desire for openness; however, we seem to know everything, yet nothing about her.

Eroticism

Fashion photography and design play an important role in displaying our desires, constructing complex images that encourage sensual visual consumption. Elizabeth Cowie wrote in an essay of 1992 that 'fantasy itself is characterised not by the achievement of wished-for objects but by the arranging of, a setting out of, the desire for certain objects',[12] and since the Second World War fashion has been reflecting our desires in increasingly tempting and explicitly erotic ways. The 'desire to desire' remains strong, and the fantasy element of most fashion imagery has become imperative to the creation of brand and designer identities. The saturated fashion marketplace has focused attention on the aura that surrounds a particular product or collection. The seduction of the potential consumer has shifted to a taunting, teasing playing with their yearning for the perfection of their own being through assimilating the ideals reflected in fashion photography and advertising.

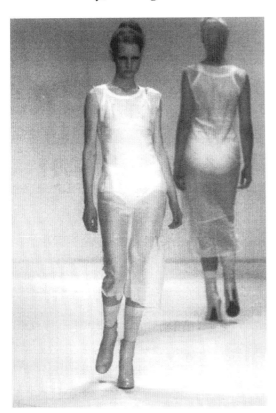

Figure 25: Miu Miu, spring/summer 1997, photograph by Niall McInerney. Copyright Niall McInerney.

The Eroticised Body

As Simone de Beauvoir wrote in 1949, there is both fascination with and lust for the sexualised woman, and yet stern condemnation of the public exposure of such desires. She saw that:

Man wishes her to be carnal, her beauty like that of fruits and flowers; but he would also have her smooth, hard, changeless as a pebble. The function of ornament is to make her share more intimately in nature and at the same time to remove her from the natural, it is to lend to palpitating life the rigor of artifice.[13]

The irrationality of this attitude is, de Beauvoir feels, compounded by the conflicting feelings of lust and threat aroused by the female form. She goes on to decry the contradictions inherent in the way a woman's body is culturally viewed, saying:

She knows that masculine morality, as it concerns her, is a vast hoax. Man pompously thunders forth his code of virtue and honour, but in secret he invites her to disobey it, and even counts on this disobedience.[14]

While, in the first half of the twentieth century, sex had been alluded to in the carefully posed images in fashion magazines, it was rarely made explicit. It was ruefully acknowledged that fashion was equated with pleasure, and therefore fantasy and desire, which made worshipping it something that was potentially dangerous, hinting as it did at being absorbed in sensual delight and narcissistic enjoyment, and therefore a peculiarly female weakness. However, the opening up of popular culture in the 1960s sexualised all areas of design and its representation. Eroticism became a playful way of flaunting new moral codes that mocked the hypocrisy of the establishment. It was also a refreshing alternative to the controlled grooming of 1950s couture, from Balenciaga and Dior, with a flirtatious, throwaway style that favoured the immediacy of ready-to-wear and the street as a replacement for the cool disdain of the salon.

In Britain the Profumo affair of 1963 highlighted the establishment's double standards. The details of Conservative politician John Profumo's deceptions surrounding his affair with Christine Keeler, who was also involved with a Russian diplomat, were endlessly debated. Sex and scandal were placed firmly on the agenda for the arts and media, eager to explore and exploit so salacious a subject. However, the fashion photography of the decade seems, in retrospect, to be very innocent in its use of sexuality; its key motifs were youth and fun, a naive conjuring of doll-like models in candy-coloured settings.

Twiggy epitomised this lightly worn sexuality, the eroticism of her childlike figure was underplayed as she jumped, danced and cycled her way through numerous images, always smiling, always carefree. Sex seemed uncomplicated and liberating, the revealed breasts of Rudi Gernreich's models, clad in topless bikinis for comfort and ease of movement, and his 'no bra bra' of 1965 emphasised the uncluttered approach to dressing, that favoured simple silhouettes and simple interpretations. They spoke of the rejection of oppressive morality, of free expression rather than the darker underside of erotic fantasies.

The camp sheen of futuristic man-made fabrics and then the soft romanticism of

Barbara Hulanicki's Biba empire, provided alternatives to this fresh-faced exuberance that exposed the artifice of the 'natural' look. Fashion though, was still a performance for the young, a marker of a swinging lifestyle, and the taint of decadence that was to overwhelm the imagery of the 1970s had no place in the mainstream of 'pop'.

However, the demarcation between what was acceptable, what forbidden, had been challenged, and was to be blurred further before the decade was out. The stylish pages of *Nova* magazine, hinted at things to come in their more knowing, adult use of erotic imagery. It did contain its share of shiny, happy models, and even photo-stories based on the cheeky lingerie-clad Vargas girls of the 1940s under the heading 'Meanwhile, exploitation can be fun' in Hans Feuer's pictures of 1972.

The idea of distracted eroticism, which showed glamour as an excessive facade, always on the brink of collapse, spread into fashion photography. One example, photographed by Duffy for *Nova* in 1966, shows two models stretched out on a rug strewn with silk cushions. Their sprawling legs form the dynamic of the image, cutting across the pattern of the rug at sharp angles which emphasise the erotic

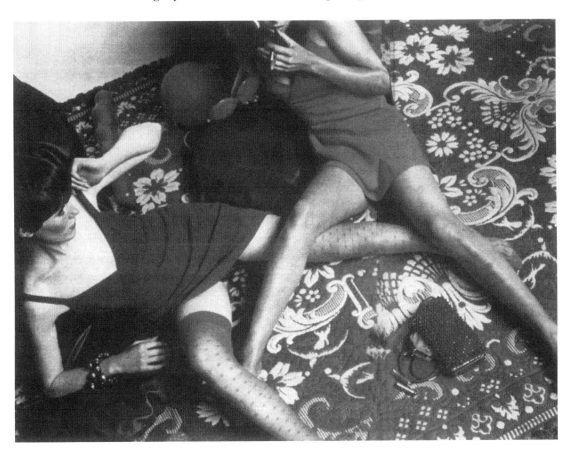

Figure 26: Photograph by Duffy, from *Nova*, November 1966. Copyright IPC magazines.

The Eroticised Body

potential of their position, and revealing flashes of brightly coloured underwear. The overstated use of colour coordination gives an oppressive feeling of controlled artifice, the hot orange and violet that spreads across all surfaces detracts from the jokiness of the phallic symbolism of slowly deflating balloons and unsheathed lipstick, held tentatively at the lips of one of the models. The loaded styling of the setting is emphasised further in the open, glass-beaded evening bags at the bottom of the picture. They provide a vignette of feminine accessories, cosmetics, mirror, unfastened purse strewn on the floor, worthy of any seventeenth-century *vanitas* painting.

As sex became more glamorous, it also became more threatening, touched by the growing excesses of 1970s fashion culture. A sense of decadent malaise permeated the fashion magazines in the 1970s. Fashion photographers, taking their cue from designers like Yves Saint Laurent, revelled in images that were an affront to bourgeois morality, blending 1940s sophistication with an air of sexual deviance. The multi-layered references of the settings, in crepuscular city streets and opulent hotel rooms, gave an impression of a kind of 'fashion *noir*'. Models exuded the same sense of fatal beauty embodied by the heroines of 1940s films, viewed as sexualised and dangerous, bringing with them confusion and potential destruction. The erotic nature of their being represents a deadly trick to lure and disarm. Glazed models became twilight vamps, and long-held fears concerning the sanity of women who gave themselves up to sensuality and eroticism were brought to the surface of glossy photographs.

French photographer Guy Bourdin fed on this heady atmosphere. During the 1970s the pages of French *Vogue* became an erotic interplay between his hyperreal colour images and the starker, more blatantly fetishistic styling of Helmut Newton's work. Both benefited from the immediacy of the image, which commanded an instant non-intellectual emotional response, an instant desire for the fantasy they provided, and yet an equally powerful sense of uncertainty in the face of such explicit artificiality. The models' cool gazes are tinged with the cruelty of self-absorption, the fallacy of their availability made obvious in the dissonant quality of the photographs. The fascination with such images is acute, since as Mike Gane points out:

> Woman is never so seductive as when she adores herself ... Around the mannequin is an intense narcissism, a paradigm of self-seduction. The woman becomes her own fetish and therefore, a fetish for the other.[15]

The 'other' comprises the male photographer as well as the magazine voyeur. Both of them seem to gain power from the inspection of such erotic images – they feed their own desires and fantasies – and yet lose power because the overriding impression of the 'falseness' of the scenarios and the excessive artificiality of the models' super glossy make-up and gestures short circuit a straightforwardly aspirational reading.

In Helmut Newton's photo-spreads for *Nova* magazine in 1971, the tension between model and photographer is revealed. In each picture Newton is shown in the act of photographing the model. The shoot, entitled 'Caught Underwears', recommends that when choosing lingerie for 'sex appeal ... think not so much of

yourself but himself'[16] and Newton's presence marks out his possession, if at first only visually, of both model and image. His face remains unknowable, hidden behind the camera, his black clothes making him a shadowy presence at the perimeters of the image, in contrast to the glowing semi-clad skin of the model, dressed in a series of pale underwear pieces. As the photo-story progresses over the magazine's pages, the erotic intimacy of the protagonists increases. The setting is claustrophobic; a small room papered in an overwhelming flock design that seems to push in from the walls. Each image is dominated by two elements: the rumpled white sheets of the double bed and the reflections caught in a large unframed mirror. The photo-story's dynamic is of scopophiliac desire, the interplay between photographer, as stand-in for the images' spectator and the model herself. In the final image of the sequence, the erotic promise is fulfilled; the model is seen lying on top of Newton, virtually concealing him from view. His hand though is clearly visible, reflected in the mirror's image, clutching the remote control of his camera, still photographing the unfolding scene. He thus manages to remain in control, coolly cataloguing his own seduction by the very fantasy that he has created. The photographs seem to have become an erotic end in themselves, a fetish for desires that can never be fully realised. The role of photographer blurs with that of the model, both the involved performer in the theatre of fashion and the distanced director of the act in progress.

Bourdin's advertising work was equally ambiguous and slipped from eroticism to violence in the deathly glamour it favoured. His infamous campaigns for Charles Jourdan shoes, as discussed in the previous chapter, enforced the pre-eminence of the image over the actual product. The object becomes a poor substitute for the powerful impact of the picture as a whole. Bourdin used the double-page spread to the full: models were chased across the New York dockside, chalk line bodies were scrawled on the neon-lit streets, the shoes an afterthought in kinetic images of boredom and lust, for the commodity itself and for the woman as commodity.

Even supposedly feminist magazines like *Cosmopolitan*, gave out mixed messages. At a time when women wanted to assert their equality, magazines were relying on increasingly sexually explicit advertising to maintain them financially so that forthright articles became overwhelmed by the seductive imagery of the advertisements. The question of whether such images were liberating and empowering women, or trapping them forever in the public realm, has continuing resonance. Kathy Myers comments on the contradictory messages they contain:

> The erotic photograph trades on a dubious tradition of sexual libertarianism, which invests that which is censored with the power to disrupt and liberate. Hence the 'erotic' – whether it alludes to sadism, nihilism or whatever – is acclaimed as a sexually liberating force.[17]

In the 1980s the rise of the image of the career woman and women's desire to reclaim stereotypes of sexuality, led them to adopt far more assertively erotic styles than had been mooted in the past. The figure-hugging sheath dresses of Azzedine Alaia, the voluptuous tailoring of Thierry Mugler

The Eroticised Body

and the Boucher print corsetry of Vivienne Westwood created women as amazons. In the popular style of see-through top and uplift bra, worn with mini-skirted suit or jeans, women of all classes were revealing their bodies more than ever before. The power derived from sexually provocative fashions was emphasised in magazines like *Elle,* which encapsulated the desire for glamour as well as equal rights. As Andrea Stuart noted in 1990, 'For younger women part of the value and pleasure of consumption is the space it provides for transgressing traditional boundaries of sexual difference and flouting anachronistic notions of femininity.'[18]

However, the mood was not entirely one of unconcerned bravado. The Aids scare increased fears of death and disease, the rigorously exercised body displayed by revealing fashions was as much a protective shield, a perfected exterior, which acted as a fetish to ward off anxieties surrounding death and disease. Perhaps the flaunting of sexuality in fashion was a surrogate for sex itself, which had become fraught with dangers. Erotic fashions were often blunted by the accessories used, denying the invitation that the clothing itself seemed to make. Heavy Dr Marten shoes and boots were a frequent accompaniment to sculpted day- and evening-wear for example.

Popular cultural icons like Madonna and Annie Lennox, provided role models for the subversion of sexual morality as a means of resistance to passive ideals of femininity. Shopping for fashion and beauty products was a major element in this aspirational search for new identities, and spread to wider sections of society, as the power of the designer name grew, adding cachet and desire to their

expanding ranges of clothes and cosmetics. The display of wealth and status of the 1980s woman was as erotically charged as in the past, the aerobicised, moulded body a symbol of allure and success. In February 1987 British *Vogue* advocated the use of an array of luxurious exfoliators and moisturisers to ensure that the body was made as smooth and flawless as possible in the season's revealing styles. The author of the article warned:

> While the government stamps health warnings on almost every form of carnal indulgence outside matrimony, fashion designers are busily undermining the new chastity with a new bareness in dresses which might easily be misinterpreted as little more than brazen sexual inventions.[19]

The accompanying photograph emphasised these tenets of expensive eroticism further, but they were not exclusive to the 1980s. The image used echoed earlier reincarnations of glamour. Cropped to focus on the tanned *décolletage;* the model loses all individuality, and becomes the voluptuous exemplar to which all women must aspire. Her torso is wrapped in ripples of rose pink ruched silk, a fake diamond- and pearl-drop necklace circling her throat. The image is of the eroticised body, but it is its interpretation as a symbol of a culture under siege from fears of death and disease that is different from earlier decades. Constructing the body as an untouchable protective shell averts the sense of the dangers of sexual contact. The 1990s have seen a continued fascination with the erotic, and fear of the sexualised woman has continued to rise to the surface. Both men's and women's fashion magazines

have used increasingly explicit imagery of nude and semi-clad models. The compulsion has been to explore the underside of eroticism, heavily tinged with sleazy glamour and threatened violence. Guy Bourdin and Helmut Newton have been looked to in a perverse nostalgia for decadent excess, rather than the breezy, uncomplicated sexuality of the 1960s.

Fetish

British *Elle's* tenth anniversary edition in November 1995 included a photo-story and article entitled 'Who's Shocking Who?', which examined the breakdown in moral barriers since the magazine started. The images were of models in designer fetish-wear, chained to chairs, enclosed in box-like spaces, the slippery shine of their rubber corsets, dresses and trousers offset with spike heels and padlock jewellery. Shot in black and white, the images are hard and chic, playing on the blurred definitions of sexuality in the 1990s. As the accompanying text points out, it is no longer viewed as 'deviant' or 'perverse' to wear PVC or rubber. High fashion has, in a sense, sanitised these fabrics, which have gradually been integrated into the mainstream. Fetish clothing, which was once appropriate only to the secret wardrobe of the hardcore S&M fan, is now a staple of both catwalk shows and high street chain store fashions, representing the erosion of the private sphere. The potent imagery of the scene has become a repeated motif in fashion photography, the glossy obsessions of Helmut Newton the source for later incarnations, like the ones used in *Elle* to demonstrate 'how far we have travelled in the past ten years'.[20]

The confrontational bricolage of punk style had broken the established code of sexual representation in the mid-1970s. Many had only seen latex clothes that hinted at bondage in the camp catsuits worn by Emma Peel in the 1960s television series *The Avengers,* or the futuristic costumes worn by Jane Fonda in *Barbarella* of 1968. This coy view was soon to be exploded. Vivienne Westwood and Malcolm McClaren revamped their King's Road boutique in 1974, creating a shady interior world that sold sado-masochistic clothing as a form of blatant resistance to accepted notions of modesty. The new name for the shop, 'Sex', was spelled out in tacky pink plastic, underlining the challenge to taste and their desire to smash through the taboo environment of so-called deviant sexuality.

Punk deliberately sought to cloud the meaning of clothing; the multiple references brought together in one outfit confused and challenged the onlooker, precluding a simple interpretation. The punk body was clothed in brutal pornographic styles ripped from the seedy environs of male-dominated Soho sex shops and flaunted in a bold statement of the power of the city street as an arena for the disenfranchised to express their revolt. Fetish-wear – latex mini-skirts, bondage buckles and zips, fishnet stockings and patent stilettos – was used as a call to arms by young women. They were not adopting these styles to be viewed as available or submissive – the traditional interpretation of such explicitly sexual attire – but to challenge the soft sentimentality usually assigned to female teenagers, who were expected to dream of romance rather than project hard-core eroticism. They were defiantly public in their challenge to

genteel morality. Parading the city dressed in the revealing styles more commonly associated with prostitutes, they threatened the careful balance between the concealed, forbidden world of the sexual and the openness and vulnerability of the streets. As Elizabeth Wilson has pointed out: '"Streetwalker" is an old term and street people a new … one, but both tell us that to spend too much time on the street – outdoors in the city – is to become morally suspect.'[21]

This moral uncertainty was stretched to breaking point; punk was loaded with pornographic content, yet it was itself openly bored with, and contemptuous of, sex, which was seen as a mechanical act, lacking emotion. These conflicting messages were presented as a means to transgress social codes and expose the false modesty of the mainstream. Sado-masochistic dress was used as a means to an anarchic end, rather than as part of a sexual ritual as it was by true sexual fetishists.

High fashion in the 1970s was also dabbling in fetishism, creating ultra-glossy images of bored-looking models indulging in S&M posturing. Helmut Newton's constant evocation of the dominatrix produced numerous images of women caught in provocative poses of erotic power. The set-ups evoke the mood of Catherine Deneuve's character in the film *Belle de Jour* of 1967. Clad in the controlled luxury of Yves Saint Laurent dress suits, she plays a frustrated *haute bourgeois* wife, who fantasises about brutal sexual rituals, and dabbles in high-class prostitution in an attempt to escape the stagnant, claustrophobic respectability of her 'real' life. The fashion magazine provides one 'safe' environment for such dangerous dreams to be experienced visually. Since the

fashion photograph is made primarily for the consumption of women, perhaps work like Newton's is selling the fantasy of sexual role-playing to an audience usually excluded from its consumption, since such erotic themes are normally reserved for the sole consumption of the male voyeur. However, their reading cannot be entirely positive, Caroline Evans and Minna Thornton commented in their book *Women and Fashion, A New Look* of 1989, 'The highly "set-up" quality of Newton's photographs speaks the photographer's dominance over the models for all their phallic pretensions.'[22]

This conflict between the streamlined phallic presence of the fetishised model and the knowledge of the photographer's control of the *mise-en-scène* is hard to resolve, even when the photographer is a woman. In Ellen von Unwerth's highly erotic image of Nadja Auerman for the cover of *The Face* in September 1994, the shadow of Newton's style adds to the sleazy glamour. Auerman is naked except for a black leather dog's collar around her neck and heavy, high-shine make-up. Further pictures inside the magazine continue her depiction as vampish and unreal, the parodic use of 1970s reference points adding to the confusing sense of her power as an emblem of eroticism, yet a slave to the poses and settings of the porn magazine.

In the mid-1980s Madonna had already shown the possibilities, and the problems of employing sexual and S&M imagery to emphasise female power. As bell hooks wrote:

[Madonna's image] evoked a sense of promise and possibility, a vision of freedom; feminist in that she was daring to transgress sexist boundaries; Bohemian in that she was an adventurer, a

risk taker; daring in that she presented a complex, non-static, ever-changing subjectivity. She was intense, into pleasure, yet disciplined.[23]

Madonna's reworking of numerous sexual stereotypes was intended to be empowering. S&M imagery in videos like 'Express Yourself', saw her playing both be-suited dominatrix and submissive screen star. Her apparent control of each persona underwrote the positivity of the reading. However, both her supporters and her critics were vocal in their condemnation of her book *Sex* published in 1992. The outcry caused by its explicit content was against the parading in the mainstream of the kind of imagery usually reserved for pornographic magazines.

While this was the same charge as that levelled at punk, the imagery in *Sex* used fetish-wear and S&M posturing in a very different way; to bell hooks it did not alter the sexual status quo, as punk had, but reinforced existing white, heterosexual ideas of sexuality. Rather than being used as a form of resistance, liberating women with an invitation to indulge in every fantasy, it revelled in hedonism for its own sake, recycling porn imagery instead of subverting it. The S&M imagery in *Sex* relies upon the same message of punishment that dominates its appropriation in the mainstream media, ignoring the more complex issues of consent and ritual which are so intrinsic to the scene itself.

For fetishists it is not the surface of the image that matters, or the fashion consciousness of their dress that is significant. It is the tactile quality of the slippery rubber and stiff latex that is important, the sense of restriction placed upon the body and the sexual tension caused by moving inside such a rigid shell. Real fetish-wear is remarkably unchanging in style. The same key garments continually reappear, almost invariably in black. Fashion, however, is far more experimental, using different colours of rubber, adding glitter or feathers to give varied textural effects, and streamlining garments to fit the current fashionable ideal. In many fashion garments that refer to S&M high-tech fibres are added to allow them to move and stretch with the body, enhancing its display while decreasing the restrictive nature of real fetish-wear and reinforcing the fashionable rather than the sexual purposes of the garments. There has also been a strong sense of camp in much of fashion's appropriation of fetish dress, using it as a playful celebration of artifice, a rallying cry against the serious suiting so popular in the 1980s. Both Thierry Mugler and Jean Paul Gaultier exemplified this tongue-in-cheek approach, the latter mixing rubber skirts and bras with tartans and cable knits in his autumn/winter 1987/8 collection – fetish-wear became just another element in his magpie world of juxtapositions. This emphasis on the surface effect, on the styling of the outfit and on bringing together such diverse references, revels in its own lack of coherent meaning. As Susan Sontag writes of this exuberant borrowing: '[Camp] is one way of seeing the world as an aesthetic phenomenon. That way, the way of camp, is not in terms of beauty, but in terms of the degree of artifice, of stylization.'[24]

Mainstream culture remained unused to seeing overtly sexual styles but they continued to cause moral unease. Fashion persists in flaunting fetish, wanting to add a pre-packaged sense of shock, as a direct way of grabbing the potential consumers'

The Eroticised Body

attention. Since the cross-over into high fashion clothing in the 1980s, when in photoshoots clothes by fetish firms like Ectomorph started to be mixed with designer rubber by more familiar names like Gaultier, this toying with the forbidden has become a recurrent theme. Linda Grant wrote in *The Guardian* in 1996 of the desire to find new ways to challenge the older generation's morality saying, 'How do you shock parents who danced naked at Woodstock except by laughing at their au naturel sexuality and their naive faith in peace and love?'[25]

Punk found the most immediate way to shock parents and grown-ups: through the violence implicit in pornography and explicit in sado-masochism. Since then

Figure 27: Jean Paul Gaultier, autumn / winter 1987/8, photograph by Niall McInerney. Copyright Niall McInerney.

such imagery has lost the rawness of its taboo status. As already noted in the previous section, fear of disease and decay became increasingly prominent in the last quarter of the twentieth century, the eroticised shine of rubber t-shirts and dresses became a protective exterior, as Body Map's designer Stevie Stewart remarked in 1996, 'People have spent so much time culturing and toning their bodies and this [fetish-wear] is a great way to show them off without revealing anything.'[26] Stewart's statement reinforces the real fashion fetishism of the late twentieth century: the obsessive desire to control and dominate the natural body, re-formed in the torture chamber of the gym and constantly, often brutally displayed on the catwalk of fashion magazine pages.

The Brutalised Body

'Beauty, I wish to praise thee!' George Grosz's bitterly condemnatory painting of 1919 is an example of defiled eroticism, lustful, yet loathing the power of women's sexuality. A dreary street cafe plays host to a group of city dwellers, the men are leering and predatory, the women seem besmirched by smudged cosmetics and noose-like fur stoles. The woman in the foreground of the painting is almost naked, her body stripped bare by the consuming gaze of the seemingly respectable men who sit behind her. As the ironic title implies, beauty is seen as a trap, the artifice of the public woman a mask for her decaying flesh, her base desires. The import of the image is clear: it depicts the duplicitous nature of women, contempt for the absorption in the made-up surface of the body, and the constant conflict

between fascination with and hatred of female flesh and the power it can wield.

Grosz's early twentieth-century painting of a female body that is both eroticised and brutalised illuminates attitudes expressed in 1990s fashion photography. While some sexually alluring images of women can be viewed as celebrating the body, and enabling liberating expression of power and desire, they can also constrain definitions of the body, their pervasive nature filling magazines and billboards with a claustrophobically narrow vision of constantly available voluptuous femininity. As Walter Benjamin pointed out, 'in fashion the phantasmagoria of commodities presses closest against the skin'.[27] This highlights the link between commodity and body fetishism, with both greedily held up for consumption.

The last 30 years of the twentieth century saw a rising number of fashion designers and photographers who produced work that challenged this persistently eroticised body image. In the work of photographers like Sean Ellis and designers like Alexander McQueen, the powerful eroticism of the female form can be seen as threatening the spectator, teetering on the brink of violence. Their work emphasises the dark side of sexual desire, revealing contemporary anxieties about the vulnerability of the body and the potential dangers of its possession, both visually and physically. They highlight western culture's obsessive voyeurism, with the female body under constant surveillance. We are supposedly liberated from traditional moral constraints, unfazed by images that expose and titillate; yet still haunted by fears that sex is sinful and the belief that those desires

should be rationalised and controlled. Fashion provides a major site for the examination of these themes of eroticism and suggestions of the fatal threat presented by sexualised femininity. Fashion is caught forever on the surface of the body, and yet compulsively reveals unconscious anxieties and yearnings for the flesh it so tantalisingly conceals.

Messages are no longer as clear and direct as they were at the start of the century. Both the natural body and its depiction can be altered and manipulated; the mixed emotions surrounding such imagery confuse the messages sent and received. The layers of reference concealed within images, reworkings of styles of the past, which link up with other areas of popular culture and design, make seeking a straightforward interpretation of the myriad of images an increasingly pointless process. Fashion photographs produce simulacra of the body, of beauty and even of death, removing the traces of mortality, ageing and decay, to become sites of conflict and ambiguity, rather than of resolution.

The model has become the emblem of this dislocation, revered for the youth and beauty that we strive for and yet reviled for her symbolic perfection. She is viewed as 'unreal', the channel for both desires for and disgust with the female body, feelings which can be explored in the realm of fashion, but which would be difficult to express in other ways. The boundaries of acceptability have been routinely stretched; it is the requirement for each new generation of designers and stylists to renegotiate the relationship between body, style and morality. In the 1990s this was a precarious balancing act between eroticism and violence. Models were

The Eroticised Body

shown in ever more brutal images that both flaunt and fear the anxieties of decay, disease and physical abuse.

Juergen Teller's photographs of the model Kristen McMenemy, taken in 1996, highlight this desire to go beyond the artifice of the fashion image and depict the body as fallible, open to pain and fatigue. They express the 1990s obsession with images that are 'real', that are harshly lit, exposing the skin as mottled and tired, showing up bruises and flaws rather than smoothing away any sign of the living/ dying flesh. While this realist style is in itself a convention, a particular way of viewing the world, focusing on the potential romance of the everyday, the mundane, Teller's photographs undoubtedly assert a different view of the previously unassailable supermodel body. The *Süddeutsche Zeitung* commissioned the pictures for the cover of its supplement on the theme of fashion and morality. Teller wanted to make a comment on the sanitised perfection of traditional fashion magazine covers, and the oppressive standards of beauty to which they adhere. He said of such cover images,

> To me, most of them look hideous. They don't show the human aspects of the girl. I don't understand the retouching. They look like aliens to me. They say Kristen McMenemy is a supermodel and that's how they show her. I just wanted to say, listen, this is her.[28]

McMenemy is presented to the onlooker as defiantly nude, a cigarette hanging from her full lips underlines the disregard for sanitised visions of glowing healthy bodies. She stands with eyebrows arched, taunting and challenging, her hands are on her hips mocking the careful poses of the model designed to display both fashion and sexual allure. She is caught in the flashlight's glare, defying the onlooker to inspect her nakedness. A heart has been drawn in lipstick between her breasts, the name 'Versace' scrawled in the middle. The eye is drawn to this focal point, forced to view her body in conjunction with the brand name, exposing the collapse of meaning between the model's body and the designer commodity. A red scar marks her stomach, the result of a too-hastily pulled up zip at an earlier catwalk show. The fashion references undercut her nakedness, defining her body in terms of the clothing it so clearly lacks.

The snapshot quality of the photograph reinforces the transience of both image and youthful body. The harsh lighting creates a realist feel that decries the usual flattering sheen of fashion imagery. We are refused the glossy perfection of many such pictures, unable to hide our voyeurism behind the veneer of glamour that provides distance between viewer and the viewed. McMenemy is aware of our prying eyes, defies us to eroticise her figure, flaunted for our inspection.

However, as stylist Venetia Scott said of this picture, 'Even if the image is quite brutal, you know she wasn't being victimised.'[29] Teller's work speaks of intimacy with models rather than tension. He is allowed into their private realm, constructing images that examine the way we usually look at models' bodies, demanding perfection, eroticism that enthrals and yet alienates us from the reality of the body and its inevitable decay.

Notes of a more dissonant eroticism in fashion representation had developed in the 1960s. Andy Warhol's Factory set represented a more disquieting vision of

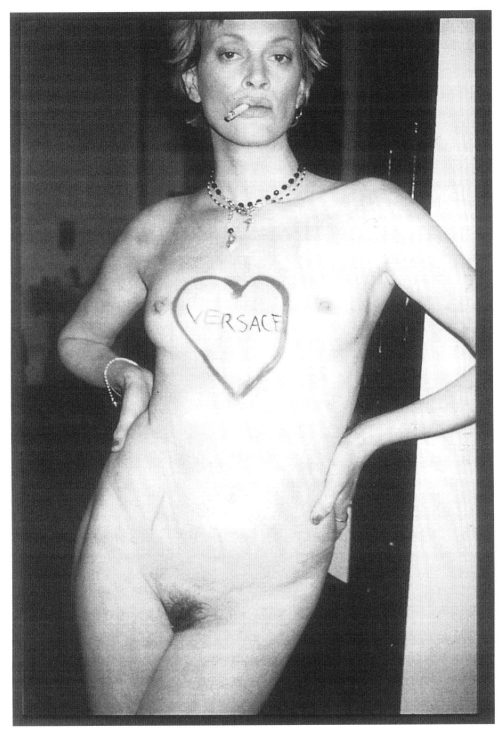

Figure 28: Kristen McMenemy, 1996, photograph by Juergen Teller. Copyright Juergen Teller.

The Eroticised Body

blurred gender identities and seedy, obsessive sexuality, which seemed to hover on the brink of neurosis. Author Elizabeth Wurtzel has spoken of the association of glamour with instability that was embodied in icons like Edie Sedgewick, who, she claimed, personified 'the triple-A admixture of amphetamines, anorexia and anaemia'.[30] This description is similar to the criticisms made of the waif models so popular at the start of the 1990s, whose appeal was based on the apparent weakness of their bodies and the translucency of their skin. These undertones of brutal sexuality and disruptive visions of the body, which rejected the perfected beauty of the traditional fashion model, were to become an increasingly significant strand in fashion representation. During the 1980s, clubland played host to performers like Leigh Bowery, who revelled in constantly recreating himself. His style was an embodiment of this resistance to sanitised depictions of the body. He used clothing and make-up as a means to construct visions of the extreme rather than to mimic or enhance ideas of the natural. His style was part of a growing shift towards using the body and images of the fashioned self as sites for the exploration of anxiety and anger. The pressure to conform to a standard ideal of sexual attractiveness weighed heavily upon conventions of fashion design and photography. Increasingly, though, fears of failing to meet such expectations became internalised, and fashion began to create more images that sidestepped notions of supposedly wholesome erotic display. Instead there was a preference for dwelling on less palatable visions of sexual desire, that depicted deathly undercurrents of violence and decay. The

myth of the eternally young, forever-perfect model was exposed as a lie, and spectators were forced to confront often disquieting images of their own mortality.

In Galliano's autumn/winter 1988/9 collection, the models were styled to emphasise their artificial status, with deathly, pallid make-up, lips and eyelids stained with dark shades that evoked the silent film stars of the 1920s. Their outfits were long and lean, but seemed to be pulled askew, with asymmetrical jackets creating a tension and friction against the body. They seemed powerful, combining strong imagery and masculine tailoring, their hair pulled neatly away from their faces; yet their 'phallic' strength is

Figure 29: John Galliano autumn/winter 1988/9, photograph by Niall McInerney. Copyright Niall McInerney.

disjointed by the forced 'otherness' of the styling.

The signifers of the organic have become consumed, the attempt to cheat death by clothing the body in cosmetic simulations of youth replaced with ghostly and jarring visions that speak of the vulnerability of the body. Benjamin's comment that 'fashion is the medium that "lures [sex] ever deeper into the inorganic world" – "the realm of dead things"',[31] emphasises the idea of clothing, make-up and accessories as artificial elements used to disguise the living flesh. The fashioned body is therefore one that is drawn ever further from the organic, its erotic allure enhanced by a series of masking feints.

The models' narcissism, that absorption in the outward appearance which both fascinates and repels, has been taken to an extreme in the inscrutable glazed mask they present to the onlooker. We clothe ourselves to conceal the reality of the organic body. The body has become at once erotic and yet generalised, referring always to countless other images. In the late twentieth century, this pre-packaged sexuality was constantly hovering on the brink of brutality, caught between a celebration of eroticism reclaimed and a spiteful rebuke to the belief placed in its power. As women moved more confidently into the public realm, fears about this shift in power structures have become internalised. Both men and women feel ambiguous about the perceived power of the female body in this context. Fashion pushes the limits of the body, never allowing for reconciliation between flesh and fabric. Basic fears concerning feminine sexuality and its inherent 'evil' have been brought dramatically to the surface, exhibited as spectacles of danger and seduction, with violence an ever-present reminder of the punishment for such display.

For Alexander McQueen this has meant a series of collections steeped in brutal sexuality. His first collection in 1993, saw models walk the runway in distressed white muslin, brown-red mud splattered across their breasts as though they were victims of some terrible violence, or surgery.

Themes of anxiety and distress continued to be combined with a latent sexuality in his work. In 'The Hunger' of spring/summer 1996, models were clad in attenuated suiting, which crept back from their bodies to expose clear moulded bodices with worm-like contortions

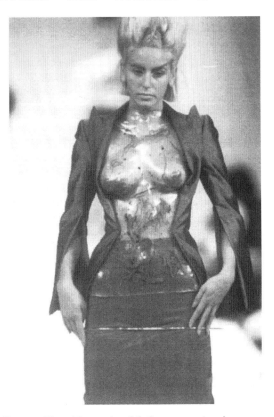

Figure 30: Alexander McQueen spring/summer 1996, photograph by Niall McInerney. Copyright Niall McInerney.

The Eroticised Body

writing across their skin. They seemed vampish and contemptuous of the attention they attracted. The look encapsulated the late twentieth-century fascination with a sleazy glamour that lives off its own deathly surface, turning its back on the bourgeois lie of 'natural' fashion and cosmetics, using deliberately shocking references as a form of resistance to the constant clarion call for health and beauty. This mixing of dark elements with images of eroticism can prove uncomfortable to witness. Ryan Gilbey wrote in *The Face*, in May 1997, of the growing movement of gothic and deathly themes in popular culture. He spoke of social and cultural desires for order and the conflicting emotions that they can provoke:

> Conservative society prides itself on being a place where darkness and ambiguity have been eradicated by common consent, but it follows that as any social order tries to become more sophisticated and 'civilised', so its more dubious and potentially disruptive undercurrents will flourish or be repressed.[32]

Deathly images represent the uncertainty surrounding sex, hidden fears writ large on the models' bodies. Drawing upon images from horror films of the monstrous feminine, like those seen in the *Alien* series, the models have become sacrifices to a collective neurosis of the body.

Rosetta Brooks writes of the unreality of the images created: 'Glamour is not the natural index of sexuality but is spectacularised as falsity. The glossiness and glamour seem to merge in the images as attributes of opacity and as points of closure, rather than as transparent openings upon the desired objects.'[33] Glamour acts as a distancing device in these images:

the woman becomes her own fetish, living off her own beauty. The deathly styling of much 1990s fashion photography draws on the work of Guy Bourdin in the 1970s, emphasising the self-destructive impulse of such self-absorption. Images of male models have also used visions of brutality. However, they lack the eroticised gloss of those of women, and circulate either around bravado and New-Laddism, or show men as 'murder victims', extinguished by some outside force, rather than feeding on their own flesh. Peter Robathan's photographs for *The Face* in January 1997 epitomise the former trend. They show male models drinking, staggering and fighting across pages, leering with cocky New Lad swagger. The backdrops to the images are bright and holographic, representing the nightclubs and pubs the models seem to trawl before ending the evening in an alcohol-hazed fight. In the last image one model stands over the other, stamping on his fingers, pulling at his face, threatening another punch with his clenched fist.

Such kinetic posturing is at odds with the more melancholic alienation of Juergen Teller's 1997 advertising campaign for fashion chain Jigsaw Menswear. Male models are shown lying face down on the pavement, stained with dark liquid or falling through space, as though dropping from the top of a building. The images draw upon the violence of the city, rather than the threat of the erotic, which permeates so much women's fashion imagery. Fears of the female body as phallic and the possibility, therefore, of male castration, present a far more alarming prospect.

Stylists have been exploring the boundaries of the artificial for some years, the

influence of Bourdin being combined with the punk ethos of chaos and destruction, which viewed the brutalised body as an index of inner torment and intensity of feeling. McQueen's work expresses abuse of the body, while showing unsavoury aspects of female existence. It reveals subjects that are usually concealed from the fashion consumer's view, disrupting the fantasy of perfection that usually dominates.

Sean Ellis's series of photographs entitled 'The Clinic', of 1997, inhabited this netherworld of deathly desire, with vampiric models overlaid with anatomical images showing muscles, and animal skulls. Under the line 'Welcome. We'll tear your soul apart' the photographs allowed the spectator to survey gothic visions of eroticism tinged with sadomasochistic pleasures. They highlighted the possibilities of the fashion photograph as an arena for female fantasies and fears to be explored and revealed. The powdered white skin of the models appears a thin disguise for the interior body revealed in the overlays; boundaries between flesh, muscle, blood seem to become blurred. In one picture two models' faces push diagonally into the centre of the frame. One has her head thrown back, apparently in an ecstasy of desire, as the other leans forward pressing the long silver spikes of her restrictive Shaune Leane facial jewellery into her partner's exposed neck. The viewer is excluded from this private game of fatal sexuality, the silvery glow of the plastic shower curtain backdrop and the unnatural blue of the women's hair further distancing them from the outside world. The eroticism of their pose does not seem to be staged for the pleasure of the onlooker, as in earlier fashion photography, but for their own enjoyment. The fetishized image of the model's body has become inverted; we are clearly excluded from the twilight world that the photographer has constructed around them.

Such images have the potential to enable a form of liberation from fashion's perfected bodies and this presents problems, both in terms of who controls and constructs the images and in the way they are received by the wider culture.

In Jana Sterbak's *Vanitas: Flesh Dress for an Albino Anorectic*, shown in the Tate Gallery's 1995 exhibition 'Rites of Passage', fashion's commodification of the body was exposed along with the frictions this creates when viewing the eroticised fashioned self. It consisted of a simple shift dress constructed of sewn cuts of meat. Its disturbing use of dead flesh, instead of fabric, flayed away the pretence of fashion, which is normally used to disguise the decaying natural body. It represented the cruelty inherent in the reverence for young flesh that dominates fashion. Sterbak's dress is raw and streaked with veins; it brings a cold reunion between inner and outer body, the brutality of its stitched-together silhouette a symbol of hidden fears.

In another piece by Sterbak, called *I Want You to Feel the Way I Do … (The Dress)*, the form of a dress was constructed from metal wire. Once plugged into an electrical socket, glaring light filaments burned out from its skeletal frame. It represented a 'meditation on attraction and repulsion, passion and jealousy',[34] inspired by the mythical story of Medea, who, abandoned by her husband for another woman, sent her rival a dress which devoured her in flames when she

The Eroticised Body

Figure 31: Shaune Leane facial jewellery for Alexander McQueen, photograph by Sean Ellis, from *The Face*, March 1997. Copyright Sean Ellis.

put it on. This vision of woman consumed by sexual jealousy, reveals the perceived dangers of the carnal self and the potentially fatal violence and revenge it unleashes.

In a photograph taken by Rankin for *Dazed & Confused* from June 1997, this mythical vision of the instability of the woman who has given herself up to base desires is once again evoked. Clad in a clingy Alexander McQueen ensemble the model seems to be in the thrall of erotic delight. She pulls at her dress, gathering it up on her body, clutching at the fabric. Her head turns from the camera, dark red lips apart, eyes closed, and the zip of her top slipping down below her throat. Flames lick up the hem of her skirt, setting light to her top, creeping up towards her face; she is oblivious to the threat, abandoned to the ecstasy of the fire. The image is an emblem of anxiety, highlighting the underlying fear that giving in to erotic desire will lead to danger and death.

Fear of real women is displaced on to the models who inhabit the visual representations of popular culture; the world of the image is used to explore and expurgate subconscious concerns surrounding the body and sexuality. In some examples a warning of potential tragedy is given. They imply a resentful backlash against the power and advances that women have made over the century, and unease about images that seem to exclude the spectator from the erotic fantasy they have constructed. They recall deep-seated fears of the potential for uncontrollable instability in female sexuality, already revealed in other areas of popular culture. Women are made glamorous and fascinating by their open sexuality, yet condemned for using it as a seductive weapon. However,

there is the disquieting feeling that these images present a realm of forbidden pleasures, which defiantly refuse perfection and idealisation. Flaws and decay are displayed as the battlescars of mortality, erotic but disrupting the dream of hygienic, sanitised sex in a culture that worships unblemished youth. The body represents a site of conflict, where frustration and anger is inscribed on the skin in contradictory images of anguish and pleasure, the flesh symbolically punished for the desires it provokes.

Flesh

As the twentieth century has progressed, we have all come to have too much invested in fashion's fantasy world of perfection to be able to ignore the modern demand that we 'create' our own bodies. As women have gained more power in education, politics and the workplace, they have also learnt to fight the female body, to present a firm, toned exterior that conforms to sexual stereotypes while resisting the maternal silhouette that had been the defining feature of femininity in the previous century. Fashion's ideal of beauty is not the celebration of the natural, but the test of women's ability to defy it. It demands the ability to fit into the prevailing aesthetic, as Rosalind Coward has pointed out: 'One thing that fashion is quite categorically *not* is an expression of individuality.'[35] Fashion is rather a form of seductive and beautiful coercion into believing in the miracle of perfection that awaits those faithful to its decrees.

Fashion colludes in society's obsession with thinness; the whole process of making and marketing a collection is based upon

The Eroticised Body

the production of clothing in the smallest sizes. This then requires models to be very slim to fit into the samples which are used for catwalk shows and photo-shoots, which then create media images that reinforce the received wisdom that clothing looks best on thin women. The fantasy created in fashion photographs emphasises that you need continually to maintain your body in line with the ideal model silhouette, as the only means to wear the latest, most desirable fashions. An illusion of choice is maintained by the constant shifting of styles and fashionable faces that populate the advertising and magazines that surround us, but it is only ever an illusion. The proportions of the models may alter slightly but the ideal of thinness has remained.

The modernist body was streamlined and fragile, belying the strength that women have gained. The trend was emphasised in the 1930s, when bias-cut gowns exposed the natural body to scrutiny and necessitated exercise, diet or slimming pills for many women to achieve the desired line. In the second half of the twentieth century it became increasingly acceptable for women to use any method to reconstruct themselves according to fashion's dictates, even the violence of plastic surgery was glamorised. Plastic surgery has been marketed as the ultimate freedom to defy the limitations of the prosaic natural body, and literally create your own image, albeit by evoking the ideals of fashion and media bodies. The possibility that you can alter your physical being, freed from the moral dictates of religious belief in the sanctity of God's creations, has stretched out from the fashion pages, where such extreme ways of changing appearance have been accepted for half a century. Joanna Briscoe has

spoken of the 'melting' of the physical limits of the body: 'Body obsession has reached epidemic proportions. The body is mutable, no longer a given configuration of flesh, features and genes, but the chosen canvas of the decade, the clay of a booming [plastic surgery] industry.'[36]

Models' bodies are pushed beyond even the boundaries of surgery, by computer manipulation of the images they inhabit. Magazine cover shots are routinely retouched using software like *Photoshop* to smooth the model's skin, brighten the whites of her eyes, enhance her breasts and lengthen her legs. This does not forestall our need to believe in them. We seek to emulate their increasingly impossible realities and produce our own hyperreal forms, ready for the spectacle of fashionable dress. The postmodernist body therefore becomes a pastiche, a composite of references to images from fashion, film and popular culture, further and further removed from the real body that is rejected for its banality, its lumpen and inevitable decay. British photographer Nick Knight has explored the possibilities of computer-enhanced imagery. In a photograph he took for *Visionaire* in 1997, with Alexander McQueen as art director, he pushed fashion imagery further into the realm of fantasy, layering together diverse references to create a surreal vision of late twentieth-century beauty. The model, Devon, is shown against a stark white backdrop. Her dark hair, tinged blue by the lighting, is knotted into a geisha style. Her dress echoes this in palest pink oriental silk, decorated with glistening flowers. Her face is surrounded by the halo of her collar, which is reinforced to stand up in a circle, framing her head. The style recalls

Figure 32: Jenny Saville, Trace, 1993, Saatchi collection, photograph by Anthony Oliver. Copyright Anthony Oliver.

The Eroticised Body

images of the singer Bjork in its coupling of delicacy and eeriness; Devon's forehead appears to have been sliced open, tiny pink blossoms push out from the incision, which is held together by a large silver safety pin. The punk aggression of the pin, the obvious artificiality of the image is at odds with the organic purity of the flowers and the fragile femininity of the model. The limits of her real body have been erased, technology has replaced the boundaries of the flesh to create a composite 'fashion' body, a fantasy valued for its impossibility.

Baudrillard has asserted that, 'You are responsible for your own body and must invest in it and make it yield benefits – not in accordance with the order of enjoyment – but with the *signs* reflected and mediated by mass models, and in accordance with an organisation chart of prestige.'[37] The body is 'wrapped' in a narcissistic shell that produces a homogenised vision of culturally fetishised seduction. Its every part is a sign of exchange-value, esteemed for its closeness to prevailing ideals, its readiness to be visually consumed and appreciated as a triumph over the lost natural body.

The sexualised and brutalised visions of fashion discussed earlier in the chapter evoke the conflict between the need to achieve this signification around the body and the anguish and frustration that such impossible ideals can trigger. As fashion has permeated all but the very poorest sections of society, everyone is under pressure to desire to consume and conform to fashion's push for 'neo-narcissism'. This involves people being absorbed not in their actual body image, but that which can construct in reference to the images that surround them. We are then valued in accordance with our ability to achieve this.

In the 1990s concerns about the impact of the continual pressures around the size and shape of your body has led to moral outcry and debate focusing upon fashion's perceived responsibility for the situation. Psychiatrist Oliver James has spoken of the destructive way in which images of beautiful, slim models are used to induce a perpetual sense of dissatisfaction, a feeling that we must continually consume more to emulate them. He cites advanced capitalism as the motor of this push to encourage more and more expenditure, to prop up industries through the purchase of various luxury goods. He says, 'If reality falls short of our high hopes, we blame the system or ourselves, but either way, rates of violence and depression rise.'[38]

Despite the advances that women have made in the last 30 years of the twentieth century, they still bear the brunt of problems concerning the representation of the body and the meanings that surround such imagery. The sight of very thin models prompts accusations that fashion magazines encourage the rise in instances of anorexia among young women, who turn against their own bodies as symbols of their frustration at the pressures placed upon them. In June 1996, the watch manufacturers Omega threatened to pull their advertising out of British *Vogue* in protest at the very thin models used, which, they claimed, could push girls towards anorexia. *The Independent* newspaper reported the ensuing media furore, saying, 'On the pages of *Vogue*, the emaciated figures of [models] … are made appealing by the glamour of fashion photography. But blown up, in less flattering newsprint, they are a horrible testimony to the unrealistic ideals being pressed on women.'[39]

It may be disingenuous to suggest that such images are rarely seen outside the rarefied pages of the fashion magazine as fashion advertising is, after all, featured in newspapers, which also follow the current aesthetic in their own fashion stories. These concerns have echoed down the decade.

There was a tangible unease in fashion during the early 1990s, prompted by the economic recession that saw numerous fashion designers go out of business and seemed to herald the imminent demise of couture. Fashion became a confused mix of hollowly up-beat nostalgic reference points and grunge-inspired angst. The waif model, best personified by Kate Moss, summed up the friction between relief at shedding the heavily artificial glamour of the 1980s and anxiety about the future. The push to counter the dominance of fashion by the frail and the thin has to contend not just with sartorial prejudice against fatness. As Naomi Wolf discussed in her 1990 book, *The Beauty Myth*, fatness has been characterised within western society as 'expendable female filth; virtually cancerous matter, an inert or treacherous infiltration into the body of nauseating bulk waste'.[40] Such negative characteristics evoke our obsession with mechanical efficiency that extends to the perception of the body as a machine that must be stripped of supposedly 'unnecessary' weight. They also demonstrate our rejection of the complex maternal and sensual signifiers that the rounded female body represents. These are signs that suggest comfort, softness, dependency and feminine power, submission to the natural predispositions of the body that women are taught to reject in favour of impossible, eternal, youthful slimness. We are all encouraged to become physically unchanging, never ageing, yet always representing the 'newest' fashionable image of beauty. The tokenistic use of 'larger' models did little to explode this ideal. British *Vogue* may have included a sensual photo story by Nick Knight which used size 16 model Sara Morrison in June 1997, but the editor Alexandra Shulman was quick to assert that, although this was 'a kind of celebration of the flesh … [it was] strictly a one-off'.[41] The rapid disappearance of Morrison from the fashion pages hinted that the photographs had been successful in creating publicity for *Vogue*, rather than in asserting the beauty of larger bodies. Another larger-size model, Sophie Dahl, has been more visible in international fashion magazines, but her voluptuous flesh is rarely depicted as 'normal'. She is usually portrayed in an uneasy series of cartoon like pictures, often semi-clad, posing either as a saucy seaside postcard pin-up, or as a dangerous vamp. These images are pastiches of earlier female stereotypes with Dahl adopting various ironic guises that recall film star pin-ups like Diana Dors, who was popular in the 1950s – the last decade to idealise more rounded figures. However, while the 1950s films may have seen more voluptuous icons like Dors and Marilyn Monroe as the epitome of sensuality, high fashion continued to revere the svelte, using the etiolated lines of models like Carmen Dell'Orefice to epitomise the elite couture body. Fashion has far more exacting standards than cinema. Models are judged on the perfection and symmetry of their faces and bodies alone, unlike actresses who, while also valued for their looks, need to be able to project character and enable audiences to have empathy with them.

Both men and women have problems with viewing larger sizes positively, even if these are closer to the actual bodies that the majority of people inhabit, since fashion has reinforced the ideal of thinness for most of the twentieth century. The Body Shop's advertising campaign of 1997 which used the slogan 'There are 3 million women who don't look like supermodels and only 8 who do', highlighted the discrepancy between what we accept in our everyday lives and what we expect from the visual image. Designers may be starting to make larger sizes, but the fashion store environment, filled with mirrors that encourage shoppers to compare themselves with the images of models that promote the designers' wares, make them intimidating to women who feel excluded from the lifestyle that they convey.

Artist Jenny Saville creates images that challenge this narrow view of acceptable bodies. Her paintings show large, naked women looming down from the canvas, the perspective enforcing a sense of their power. One still bears the imprint of her underwear, her flesh marked with its outline, dividing her body into the zones decreed by western dress. Another is inked with lines like those drawn by plastic surgeons to guide their scalpels. Both images question the acceptance of viewing the body as a sum of parts, open to scrutiny, vulnerable to the cut of fashion and, by extension, society's criticism of its size and form. In 1998 Saville worked with fashion photographer Glen Luchford, to produce photographs of herself pressed against glass, her face and body seemingly pushed beyond its limits, squashed into odd shapes and distortions.

Fashion designer Rei Kawakubo has also challenged the dimensions of the body. Her collection for Comme des Garçons of 1997 included soft gingham dresses padded to create lumps in unexpected places, at the shoulder or in the small of the back so that they seemed both unnatural, yet strangely serene and organic. Fashion commentators were once again shocked by this deliberate avoidance of the conventions of beauty. But for Kawakubo they were part of a continuing exploration of fashion as a means of questioning western ideas of a slim, sexualised female form that began with her oversized, wrapped designs of the early 1980s. She routinely avoided restricting the figure with severe tailoring and the demanding, eroticised short skirts and

Figure 33: Comme des Garçons spring/summer 1997, photograph by Niall McInerney. Copyright Niall McInerney.

fitted tops so popular during that decade. Both Saville and Kawakubo want to explode the arguments surrounding the size of the flesh. They attempt to use plastic surgery's message that the limits of our bodies are no longer fixed in a liberating way, and use their work to push out into negative space, to embrace diversity rather than homogeneity of the flesh.

Skin

> If one is to be treated as a thing, one would rather be treated as a rare and pretty thing than as a disgusting or dangerous one. But that is still to be treated as a thing.[42]

Just as potent a fetish as the volume of flesh on the fashionable body has been the colour of the skin that covers it. Phyllis Rose, speaking of Josephine Baker, the ultimate black showgirl and totem of the 'exotic' of the pre-war period, highlights the problems of representation for those outside the supposed 'norms' constructed by the dominant, racist white culture. black, Asian and Far Eastern women have routinely been cast in the role of exotic, mysterious muse, a rare interruption in the parade of pale faces that populate the world of fashion. Almost always seen through the filter of white western fantasies of the eroticised 'other', their cultures have been merged into a generalised sense of sexual potential and the frisson of danger in the unfamiliar.

The traditions of viewing non-western cultures as less advanced, more passive and lazily sensual are ingrained in a history of imperialist arrogance. In the nineteenth century writers like Gustave Flaubert were intoxicated by their voyages to the Orient (a term used to cover much of the Far and Middle East, as well as North Africa), and wrote stories heavily laden with sexual import. Edward Said has pointed out that, as Europe became increasingly taken over by *embourgeoisement*, sex became hidden from the respectable view by layers of moral opprobrium, and male travellers transferred their frustrations and fantasies to the Orient, which to them seemed to offer the escapism of a luxuriant, sexual licence. In Said's words: 'the Orient seems still to suggest not only fecundity but sexual promise (and threat), untiring sensuality, unlimited desire, deep generative energies.'[43]

European fashion's history is dappled with references to other cultures. The start of the twentieth century saw a riot of Orientalism. Poiret, the master of the style, was closely associated with Parisian avant-garde artists, including Matisse, who sought to explore the Orient with his paintings of recumbent odalisques and Moroccan town life. They bridged the gap between Orientalism and modernism because, 'They broke with the official art by which they were formed, but without embracing functionalism or rejecting the body and the decorative.'[44] Poiret created gowns liberally decorated with swirls of embroidery and luxuriant jewellery and headdresses, all speaking of decadence and excess, combining references from his studies of the Orient with the wealthy status symbols of Parisian couture. However the bodies which he celebrated were notably always those of white women. The exoticised outfit became a new 'skin', a costume that appropriated for the over-exposed white body connotations of mystery and eroticism. It appealed

The Eroticised Body

to the jaded western palette, spoiled by the luxuries that pass across fashion magazines' pages, and constantly seeking a new thrill. Just like the tradition of exoticism itself, fashion 'grew up rich and a little bored'.[45] Exoticism does not fear other cultures as the racist does, but views them as a series of beautiful fantasies to tease and enjoy.

Fashion continually plays with this exotic 'skin', toying with the sexually charged images of the geisha, the Moroccan peasant girl, the Masai warrior. There is a sense that such images refer to something more authentic, closer to the 'natural' body lost in the West beneath the stratum of fashionable artifice. The line is constantly blurring between genuine multiculturalism, where all references are used with a sense of equality and context, and brutal assimilation of stereotypical representations of the 'other'. The latter reinforces the sense of westernness, with whiteness being 'everything and nothing',[46] a 'norm' around which all other cultures become defined.

Yves Saint Laurent's Ballet Russes-inspired collection of 1976 restated couture's love of the fantasy of the exotic, and the 'dressing up' quality of cross-cultural references. The theme has never really disappeared. Although the white spell had been broken during the 1960s when David Bailey photographed Donyale Luna for British *Vogue*, with Beverley Johnson appearing on the cover of American *Vogue* in 1974, the most famous images of Saint Laurent's taffeta-clad *nouveau*-peasant girls are of white models, who continued to dominate fashion imagery. While Galliano's African-inspired beaded 'corsets' for Dior in 1997 were modelled by black models, the photographs Peter Lindbergh took of the collection, showing black models in sculpted evening dresses, defined by the brightly coloured rows of beads, posed in a stark studio set-up, called to mind the nineteenth-century anthropological photographs 'collected' of other races, to catalogue and collate. They show pride in African culture, but still leave a feeling of the fraught morality of such references within the elitist confines of couture.

While the 1970s saw the rise of several black and Asian models, they were still used primarily for photo shoots with 'exotic' themes, chosen by white fashion image-makers for their ability to add an extra frisson to the prevailing ideals of the time. Linda Grant wrote in *The Guardian* in 1997 that:

No one is more of a thing than a super-model, a piece of moving meat to hang clothes on, and none more so than black models. Every few years the business has its fling with ethnicity, scavenging across the globe for what it likes to call inspiration and the rest of us would call plagiarism or even downright theft.[47]

Such criticism exposes the problematic representations in fashion both of models from ethnic minorities and non-western cultures. The history of their representation within white culture is too fraught with racist notions of superiority to allow entirely positive readings to come easily. In high fashion there are few well-known black models, and those who do succeed are often chosen for their light skins and slim white European features. Naomi Campbell spoke out about this, saying, 'There is prejudice and it's a problem ... I can't go along any more with brushing it under the carpet.'[48]

Figure 34: Rifat Ozbek, spring/summer 1993, photograph by Niall McInerney. Copyright Niall McInerney.

The Eroticised Body

There continues to be a feeling that black faces will not sell magazines or beauty products in the way that white ones will. While black models have been used more for diffusion ranges like Ralph Lauren's Polo Sport, which has one of the rare black, male models on the scene, Tyson Beckford, as its 'face', there is greater reluctance to reflect the multicultural mix of western society in main-line ranges. This reflects both the notions that sports-wear, so imaginatively used within the black American culture that popularised its widespread adoption, adds an authentic note to a designer's image, and also the wider problems relating to representation. It is not just a matter of dubious attitudes and practices within the fashion industry, but rather a problem of the wider racist society.

There needs to be recognition of diversity, rather than the tokenistic use of a black or Asian model, and understanding and reflection of the notions of beauty within those cultures, not a blandly white European homogeneity of facial and body types as the dominant ideal. While such steps are essential to a truly multicultural fashion vision, they bring their own problems. Lack of representation in fashion leads to a sense of invisibility and valuelessness in a society that is bombarded by negative images of non-white races, frequently linked to newspaper stories that focus primarily on black and Asian youths in relation to crime and racial tensions. However, it is this very lack of role models in the fashion and beauty press for young women that some researchers see as having spared them from the intense feelings of inadequacy that many white girls feel about their bodies when compared to those of models. A survey of black teenagers by the University of Arizona in 1994 found that they did not feel that there was this burden of having to aspire to such ideals, but rather, 'Crucial to the black teenager's view of their bodies was the sense that beauty came from within, that it was linked to confidence, pride and "attitude".'[49] This reinforces the idea that it is real diversity, in body shape, size and skin colour that fashion should strive to incorporate. However, the commercial concerns of the industry mean that it continues to be more lucrative to persuade everyone that there is a pre-packaged lifestyle-ideal waiting for them to fit into, a fantasy of sensuality and happiness based on the consumer's ability to conform.

The twentieth century has seen increasing use of erotic and sexual imagery within fashion. As more and more women are exposed to the glare of fashion's spotlight the contradictory feelings it provokes are starkly illuminated. Undoubtedly, the power of women's sexuality and beauty is something positive and pleasurable. It enables women to express their own desires through consumption and adornment, but the pervasive visions of beauty are streamlined by the media and fashion industries to exclude groups who, because of their race, body size, class or, indeed, lack of money, are not able to feel fully included within the fantasy world that fashion has constructed. Perhaps, in an increasingly fragmented world, we cling to these stereotypes as a dream of stability, since, despite the rapidity of the fashion seasons, there is an underlying feeling that everything and nothing actually changes. While taboos surrounding the exposure of the body are eroded, there must be a continued questioning of stereotypes and exclusions in fashion images and, importantly, in western culture as a whole.

Four: Gender and Subversion

The model's body is androgynously slim. Her right hand is clasped above her waist, pulling up her hot pink cashmere vest to reveal her flat stomach and narrow hips. The model may be boyishly slender, her pedal-pushers may seem childishly short, but they are made of fuschia silk and combined with the skinny stripe of pink strappy sandal above her painted toenails, they are undeniably feminine. The soft blue-green of the picture's backdrop only serves to emphasise the bright hues of her outfit further. Her garments are narrow and abbreviated creating dissonance, each is a little too small, not quite able to cover her frame, vest too short, pedal-pushers cropped on the knee. The image is sharp across her midriff but starts to go hazy at the edges. The clipped minimalism of her outfit is set against contradictory blurring of the glass in her left hand and the unidentifiable object at her feet. Marcus Tomlinson's photograph for *Frank* magazine of April 1998 constructs an interesting vision of *fin-de-siècle* femininity. It is at once brazenly girlish, reflecting the late nineties fashion for nail varnish and cute, pink, too-small T-shirts, yet the emphasis on androgyny indicates uncertainty. At the end of the twentieth century, despite, or perhaps because of over 100 years of debate about sexual equality, gender identities continued to shift and blur; with

fashion representing the subversion of both masculinity and femininity. In Elaine Showalter's book *Sexual Anarchy, Gender and Culture at the Fin de Siècle*, of 1992, she comments:

> In periods of cultural insecurity, when there are fears of regression and degeneration, the longing for strict border controls around the definition of gender, as well as race, class, and nationality, becomes especially intense.[1]

Showalter's analysis draws interesting conclusions about the similarities in concerns at the end of both the 19th and 20th centuries, with gender definitions drawn along increasingly blurred lines that reflect cultural uncertainties surrounding male and female roles. The impossibility of resurrecting mythical notions of 'masculine' and 'feminine' as stable, binary definitions has been reinforced by a century of flouting and subverting such monolithic constructions.

The long-held stereotype of the feminist woman, ridiculed in *Punch* since the Bloomerists of the 1850s dared to suggest that perhaps women need not simper in frills as a constant reminder of their decorative role, reflected cultural unease about assertive femininity. While the guffaws of moralists, horrified by the sight of American women in bifurcated garments chased

Figure 35: Warehouse pedal-pushers, Rebecca Moses cashmere vest, Gina couture sandals, photograph by Marcus Tomlinson, from *Frank*, April 1998. Copyright Marcus Tomlinson.

away that particular innovation in the mid-nineteenth century, there was a continuing sense of alarm at the visible manifestations of independence among women. By the 1920s the facade of femininity had cracked under the weight of bejewelled androgyny and yet a shadow of doubt still hovered over any woman wearing 'masculine' styles for anything other than sport and certain work activities. After all, women surely dressed to attract men, and how could they possibly do that in trousers?

In 1949 Richard Curle wrote in disgust of women who sought to rebel against restrictive notions of acceptable femininity:

> Then, of course, there is the soured type of spinster who despises clothes because they have never got her anywhere, and the masculine type of woman whose satisfaction comes from apeing [sic] men and who wears high collars and stiff jackets. They are both, in their varying degrees pathological types...Dress for them may be called a symbol of defeat.[2]

This damning indictment of women who chose to ignore traditional strictures on femininity, rings through the decade after the Second World War. Women may have shown independence and valour during the war but they were expected to slip softly back into the domestic realm, clad in the dramatically feminine sculpting of New Look fashion, once the men returned home.

In the late sixties and early seventies the feminist movement, along with the Gay Liberation movement and the black civil rights movement drove stakes into the heart of traditional moral opinion on representation. The simple dichotomy of masculine/feminine had gradually been eroded during the twentieth century, undermined by the shifting power structures of industrialised society and the crumbling of empires. The notion of a stable masculine 'norm', that underpinned so many cultural ideas in the West, was dismantled by the shifting definitions of femininity, no longer seen as an 'opposite' that would remain poles apart from the ideals of strength, independence and rationality, previously viewed as the sole prerogative of men.

In spring 1971, American-based designer Rudi Gernreich showed a collection of separates inspired by the women's liberation movement. The military styling, with patch pockets, dog tags and sturdy knee-boots, was simple and utilitarian, and the toy rifles that the models carried made clear the collection's message. The shorts and tunics may have been fashionably abbreviated, but they were designed to be representative of the war against inequality that had reached critical mass in the late 1960s. There was a rash of demonstrations and organised protests against, among other things, the gender stereotypes that the fashion and beauty industries – that Gernreich himself was a part of – played so important a role in perpetuating.

Of course, if women could subvert so-called masculine traits by adapting and adopting masculine fashions, then it was also possible for men to procure feminine styles for themselves, and, as the century progressed, the cries of 'gender confusion' by media and academic commentators became increasingly loud. Once the traditional moulds were broken they could not be patched back together, and the masquerade of fashion enabled those alienated from such stereotypes to dress up and invent their own gender identity.

New Woman

Fashion designer Elizabeth Hawes, writing in 1939, despaired at women's reluctance to adopt what she saw as the obvious functional ease of trousers. She wrote in her book *Men Can Take It*:

> I can go right on saying that women should wear trousers to work and it won't make any difference. If Greta Garbo said it or Chanel, or God, that wouldn't make any difference either. Women aren't ready to wear trousers to work. When they are ready they will. It took a world war to get women out of corsets. It will probably take another to get them into trousers.[3]

Elizabeth Hawes, herself left-wing and feminist in her beliefs, was right in highlighting women's lack of readiness to adopt trousers unquestioningly. Trousers symbolised male authority and any woman adopting them was therefore viewed as over-assertive and unfeminine. For this reason trousers, since the first radicals adopted them in the socialist communities of the mid-nineteenth century, had been tarred with the brush of feminism, the ultimate insult from the mouths of reactionaries the world over. It was to take more than God or a world war to make them a ubiquitous item in women's wardrobes, a fundamental cultural shift was necessary in social attitudes towards femininity and women's place in society, and this was not forthcoming in the 1930s.

Although stars, like Garbo, Dietrich and Hepburn had all been wearing slouchy pleat-front trousers in films and, perhaps even more persuasively in their supposed 'private lives' depicted in backstage publicity shots, most women lacked confidence to wear the ultimate masculine garment without the protective shield of Hollywood allure. For film stars, masculine dress could lend a frisson of mystery and exotic androgyny to their star persona, or, as in the case of Katharine Hepburn, an air of patrician nonchalance and chic. Couturiers like Chanel and Vionnet had been advocating soft pyjama-style trousers for evening wear since the 1920s, but only the most daringly fashionable were willing to forsake the gilded femininity of formal evening dress in their favour. Although the average woman was more likely to have worn trousers during the 1930s than in any earlier decade, there was a lingering doubt over their acceptability. As Katina Bill has pointed out: 'When they were worn, trousers and shorts were associated with a limited range of activities, namely holidays, especially at or by the sea, and sports, especially cycling, hiking, and riding.'[4]

Immediately after the Second World War Paris strove to reaffirm its position as the sole arbiter of style, usurping the more funcional American look that had gained so much ground during the decade epitomised by Claire McCardell and Bonny Cashin's easy-going, practical fashions. The 'Théâtre de la mode' of 1945, an exhibition of miniature Parisian couture styles comprised of tiny models and surrealist sets, went a long way to reconstruct the fantasy and romance of French fashion, its doll-like models wearing nipped-in waists and flounce skirts, but it was Dior's collection of 1947 that set the seal on couture dominance. It also resurrected the overt femininity that was so tightly bound up with traditional couture, which relied upon women seeing themselves as decorative objects. The challenges to this image of women that had been

made by female couturiers Vionnet and Chanel in the 1930s were overthrown by the extravagant Victorianism of Dior's vision. The corset was reinterpreted as a sculpted jacket and waspie-waist that emphasised the hips. Once again, the maternal aspects of the body were revered, subconsciously mirroring the push to get women back into the roles of wife and mother to raise the post-war generation and nurture the returning troops.

Film director Franco Zefferelli tells an anecdote in his autobiography that illustrates the contrast between the more streamlined functional silhouette of much inter-war fashion and the extravagant impracticality of the New Look. While walking through the Paris streets in the late 1940s with Coco Chanel, he recounted the couturier's reaction to seeing two young women dressed in Dior's latest fashions. Chanel began to berate Dior's hourglass styles, claiming that the women he dressed were 'fools', made to look like 'transvestites' and as the young women hurried to get away from her tirade, Chanel screeched:

> See, they can barely walk. I made clothes for the new woman. She could move and live naturally in my clothes. Now look what those creatures [male couturiers] have done. They don't know women, they've never had a woman.[5]

Chanel then relished the discomfort of one of the women who, dropping her tiny handbag was unable to retrieve it because of the tightness of her waspie, the bulk of her full skirt and the height of her spindly high heels.

In America the conflicting pressures on women during the period were represented in popular culture as well as a rash of pseudo-medical analyses of women's psychology. Psychologists perceived women as having more power and status than ever before, yet they were still in the thrall of fashion and beauty. The glamorously deadly neuroses of the heroines of films like *Leave Her to Heaven* of 1945 and *The Lady of Shanghai* of 1948, echoed this paradox, since they showed women to be beautiful and desirable and yet ultimately unstable and dangerous. Women were pushed to be groomed and seductive, yet punished for narcissism, and their irrationality was an enduring theme that was examined in various forms in the forties and fifties.

In Eric Dingwall's book *The American Woman, A Historical Study* of 1956 he reported that,

> It is … repeatedly said that there is 'something wrong' with the American woman, that she plays a dominant role in the social structure of the United States and that, having gained so much, she is nevertheless profoundly dissatisfied, frustrated, resentful and neurotic.[6]

Texts like this, Ferdinand Lundberg and Marynia Farnham's *Modern Woman, The Lost Sex* of 1947 and Albert Ellis's *The American Sexual Tragedy* of 1954, dissected women as being afraid of sex, using clothes as 'a weapon *against* men'.[7] Writers depicted women's fragile egos employing the artificial shell of glamour to taunt both themselves and the opposite sex; trapped in the torment of achieving physical perfection and beauty yet thriving on fashion's sensuality and allure. The blatant misogyny of many such texts demonstrated deep-seated anxieties surrounding femininity and the advances women were making in contemporary society. Attitudes towards women in general and notions of

femininity were shifting, but only very slowly. Attitudes to women who spoke out for their rights, or who dared to adopt 'masculine' attire were extremely suspicious and, in Lundberg and Farnham's discussion, such women are condemned in terms that deny even the pretence of scientific objectivity: 'The feminist formula was to convert themselves as much as possible into men. To act like men. And thus to recapture libidinal satisfaction. That formula did not work.'[8] No irony was seen in bracketing together the 'Woman of Fashion' and the feminist since both were viewed as 'neurotic ... We allude, in the 'Woman of Fashion', very clearly to the frequently seen overdressed, over-perfumed, over-bedizened person, the ever-current version of the 'glamour girl'.'[9]

Each stood accused of subverting 'natural' femininity, one with her trousers and practical clothing, the other with her 'excessive' use of the accoutrements of fashion. Few paused to question exactly what this supposed 'natural' femininity was, or who set its parameters. It was enough to know that, as Elaine Showalter pointed out some 30 years later, 'women ... are typically situated on the side of irrationality, silence, nature and body, while men are situated on the side of reason, discourse, culture and mind.'[10]

It is little wonder that feminists of the early 1970s rejected the traditions of femininity so firmly, and saw fashion as a trap for women. The stereotypes of feminists as man-haters in sexless clothing were revived for another generation of women who were not willing to conform. Although bras were probably not literally burned, the idea that femininity was a social construction of a patriarchal society become one to be debated and renegotiated. Many second-wave feminists fought shy of discussing fashion directly, eager to dissociate themselves from its corrupted allure. It was seen as enforcing a demoralising image that women had to try to live up to, distracting them from more meaningful goals. Germaine Greer argued in *The Female Eunuch* in 1971, 'The spirit of competition must be kept up, as more women struggle towards the top drawer, so that the fashion industry can rely upon an expanding market.'[11]

Earlier feminists had worried that masculine style dress was not the means of asserting female power, in 1949 Simone de Beauvoir had written that, 'One does not acquire virile attributes by rejecting feminine attributes.'[12] However, discarding the paraphernalia of femininity seemed liberating to some more radical feminists in the 1970s, since it was viewed as having been imposed upon women, and as preventing them from being able to compete on an equal footing with men. The conflict, for feminists, was between the desire to wear functional, non-restricting clothing that was neither manufactured in an exploitative way nor designed to turn women into sexual objects, and the continuing allure of fashionable dress as pleasurable and desirable. The power of fashion remained undiminished. Yves Saint Laurent's cool adaptation of the masculine tuxedo for women in the sophisticated lines of *le smoking* for his *pret-à-porter* Rive Gauche collection debuted in 1966 and quickly became the epitome of chic for women who wanted to appear glamorous as well as strong and independent. Trousers for women could still cause controversy in some places (a woman was reputedly banned from the

Plaza hotel restaurant in New York for wearing an Yves Saint Laurent *smoking*) but dress codes were relaxing. They were breaking down under the onslaught of popular culture, which, alongside attacks from the feminist movement, fractured the upper-class composure of couture.

Feminists' sense of unease about the fashion industry remained, since it was seen as an especially pernicious aspect of consumer culture that encouraged feelings of inadequacy in women in order to encourage them to keep buying into its fantasy world of luxury. At a radical feminist conference held in London in 1981, one speaker developed the equation: 'Fashion = control = violence against women.'[13]

While most feminists continued to wear clothing that paid at least lip-service to current fashions, this did nothing to stave off the caricature image of dungarees and heavy boots, which was employed in the press as a shorthand for both feminists and lesbians. This was largely an attempt to trivialise the women's liberation movement, and distance such women visually from the mass of women, even if the reality was that there was no feminist 'uniform' worn by all. Some did choose to discard obvious signs of 'sexualised' dress, like high-heeled shoes or short skirts, and turned instead to thrift shop nostalgia in the seventies and early eighties as a means to avoid the oppressive fashion cycle of seasonal dressing.

The lure of fashion was hard to fight though, and many felt torn between what they felt was rational in dress, and the desire for more extravagant pleasures. Susan Brownmiller in 1984 agonised at length over her choice to wear trousers rather than skirts, upbraiding friends who had slipped back into feminine dresses, while clearly hankering after their 'softening effects', saying:

> I suppose it is too much to ask of women to give up their chief outward expression of the feminine difference, their continuing reassurance to men and themselves that a male is a male because a female dresses and looks and acts like another sort of creature.[14]

As feminist ideas filtered into the mainstream the choice became less stark. If women had (relatively) more material power, they could assert this through more traditionally feminine dress, not just through appropriated masculine garments. By the 1980s women could wear trousers in most social settings and in many workplaces without being viewed askance, and fashion increasingly presented a dressing-up box of self-conscious 'images' to be adopted and discarded at whim.

Katharine Hamnett, one of the most prominent names in fashion at the time, and one of the few to admit to being a feminist (a term still seen as the natural enemy of fashion), showed the way forward in her collection of 1986. Entitled 'Power Dressing', it heralded the fashion idea the decade would be remembered by, with its smart skirt suits that turned office dress into a statement of feminine control and, significantly, sexuality. Worn with high heels or flat lace-ups, it was translated into a thousand versions from high street stores like Britain's Warehouse and Jigsaw to the brass-buttoned glitz of the revived Chanel suit, to the hourglass double-breasted cheekiness of Gaultier's suits. Evans and Thornton describe the effect of one of the latter: '[the] clothes suggest the anonymity of uniform but the

combination of austerity with elegance indicates the dandy. The style conveys an aloof autonomy.'[15]

Just as the bourgeois male dandy of the early nineteenth century transgressed his allotted role through the impeccable sobriety of the presentation of his dress, asserting his own power and influence over the dominant class, so this feminine dandy propounded the strength of the eighties career woman, and added a vital new ingredient to the puritanical restraint of the dandy: sex appeal. The phallic power of the streamlined, tailored silhouette and the perfectly groomed hair and make-up were at once alluring and threatening; the skirts may have been short, but the message was far from submissive. As Elizabeth Wilson said in the mid-1980s, 'Fashion is one among many forms of aesthetic creativity which make possible the exploration of alternatives.'[16]

Although women had still not achieved complete equality, there was an acknowledged feeling of real advancement, and fashion seemed to be a potential means to subvert and challenge women's allotted role. Natasha Walter may be over-optimistic in her book *The New Feminism* of 1998, seeing fashion as an almost entirely benign phenomena, but as she says, '... ordinary women are now much more in control of fashion codes, able to use or reject 'conventional feminine attire' without feeling like dupes or revolutionaries.'[17] Greater confidence in the use of fashion and style allows women the pleasure to indulge in the sensual artifice of appearance, but its very artificiality means that fashion remains ambiguous, its daring speaking of, in Elizabeth Wilson's words, 'dread as well as desire; the shell of chic, the aura of glamour, always hide[s] a wound'.[18] Fashion's contradictory nature means that the powerful images it conjures speak of fear as well as pleasure.

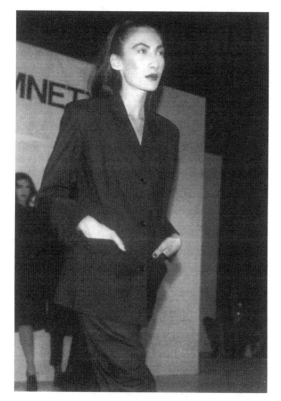

Figure 36: Katherine Hamnett, Power Dressing collection, spring/summer 1986, photograph by Niall McInerney. Copyright Niall McInerney.

Dressing Up: Woman

'Honey, you're born naked, and the rest is drag.' (Ru Paul)[19]

The notion that while sex is a biological given, gender is a social construction nurtured in us from childhood, was propounded in *The Second Sex* in 1949 by Simone de Beauvoir and developed by Robert J. Stoller in *Sex and Gender, On the*

Development of Masculinity and Femininity in 1968. This idea opened up the possibility of fashion as the most instant means of asserting or subverting the once stable masculine/feminine divide. The idea of gender as binary opposition was no longer viable, and the suggestion that gender is a constructed has enabled radical possibilities for playing with ideas of identity. The images of fashion and art that had been forming ideas of femininity were created through the filter of a patriarchal society that had a vested interest in presenting women as soft and submissive. The progressive fragmentation of this structure during the twentieth century speeded up after the Second World War, splintered by the feminist and Gay Liberation movements in the sixties, both envisioning more fluid ideas of sexuality and gender.

At the end of the Blumarine fashion show in Milan in March 1994, the traditional bridal gown was sent out for the finale of the collection. The way it was presented was less conventional though; model Claudia Schiffer, wearing a white lacy mini-dress, was escorted by Nadja Auerman, in a white tuxedo. With their matching glittering coronets perched precariously on their long blonde hair, black high-heeled shoes, and heavily made-up faces, they were playing with the stereotypes of both femininity and lesbianism. Schiffer's coyly pretty wedding dress represented the fantasy that is the feminine, her opaque black tights and Mary Jane shoes seemed incongruous, a 'wrong' note in the vision of pale tulle, that acted as a distancing device, drawing attention to the constructed nature of the archetype she represented. Auerman's 'demi-drag' made a nod to the contemporary vogue

for so-called lipstick lesbianism. It represented the blurring of sexual and gender boundaries; it was a feint, teasingly ambiguous, deliberately evasive.

Both models were famous for their curvaceous, feminine bodies. Here both seem to be in drag, Schiffer's overstated masquerade of femininity makes her seem hyperreal, a simulacrum of the ideal woman. Auerman is also a pastiche, a sexualised androgyne, her fluid evening suit a disguise that cannot fully conceal her feminine body, her smudged eye make-up drawing attention to the artificiality of her costume.

Fashion had been growing more playful in its appropriation of references to gay culture since the 1980s. As fashion shows became more grandiose, more theatrical, they drew upon the tenets of camp, revelling in the freedom to exaggerate and dramatise femininity in a manner that was self-conscious in its postmodernity. The role of fashion as entertainment, reinforced by Versace with his flamboyant shows that made the supermodels into icons and attracted a large contingent of film stars to his front row, had brought overstatement and parody to the industry. Pastiche had become a major motif; designers were increasingly looking to the past for inspiration, not just for styles, but also for references to, for example, Hollywood icons, to provide their collections with instantly recognisable glamour. This overlaying of references was also an aspect of the supermodel phenomenon, Claudia Schiffer 'did' Brigitte Bardot, Linda Evangelista 'did' everyone from Sophia Loren to Marilyn Monroe, in the same way that drag queens 'did' femininity, paying homage to the same stars. It was no longer necessary to pretend that

Figure 37: Blumarine, autumn/winter 1994/5, photograph by Niall McInerney. Copyright Niall McInerney.

fashion, or for that matter femininity, was natural. The ebullient mood of much 1980s fashion, combined with the growing power of many women meant that glamour was a self-reflexive game to play. 'There may also be a lesson for feminism in homosexual culture' wrote Natasha Walter in 1995, ' that the arts of self-decoration and posing need not be seen as the attributes of a victim, but can be allied to serious, power-seeking and humorous pleasure-seeking.'[20] Madonna was an eager communicant, perceiving that ultra femininity could be intimidating as well as seductive. Emulation became an increasingly significant part of her own star persona, reinforcing the fluidity of gender identities, and taking control of their construction. Her 1990 video for the song 'Vogue', paid tribute to the Gay subcultural roots of this spectacle. She used dancers from the New York ghettoes that had hot-housed 'Vogueing' itself. In Jenny Livingston's film *Paris is Burning*, of 1990, the director showed these schools of young black men who were obsessed with fashion, grouped together to take part in imaginary catwalk shows, competing for the most authentic enactment of a particular fashion look. They subverted the often macho performance of rap, hip-hop and other black subcultures, by theatricalising the feminine rather than the masculine.

They recognised that the essence of fashion is the fantasy of escape. At both ends of fashion's spectrum, couture and subcultural style, there is space for experimentation, for transgression and revolt. In both, those who feel alienated from the mainstream can use visual codes as fantasy and provocation, where appearance is power and style the currency.

Drag, with its obsession with the details of traditional femininity, the make-up, grooming and accessories, the gestures of the models that populate the glossy world of *Vogue,* also highlights the contradictory nature of fashion. While it allows for the possibility of new moralities, for the formulation of new identities, it is also conservative, reinforcing ideas of femininity at the same time as highlighting their fakery.

Club culture was an inspirational site for this same-sex drag. In the early 1990s, recession meant that real life was frequently harsh and unrelenting: the nightclubs in big cities like Kinky Gerlinky and Billion Dollar Babes in London, were attracting a mixed crowd, with drag queens setting the agenda for the dressing-up-box style. While at the start of the decade there had been a push towards eco-friendly New Age fashions, exemplified in Rifat Ozbek's white and silver collection of 1990, fashion history can never be so neatly boxed into ten-year periods, and the hedonistic feel of late eighties style spilled over into many designers' work. In 1991 Galliano drew directly upon drag style, with models dressed in marabou-trimmed bras and lacy knickers, their elaborate hair-dos and false eyelashes bringing the nostalgia for the 1970s disco look into the mix. Some commentators were concerned about the implications of this trend, perhaps fearing that such overt styles were retrogressive, pushing women back into the mould of glamorised sex object. Lisa Armstrong wrote at the time,

It's sad news for women. The womanly ideal is one of the strongest ideals in fashion. But do we really want to go around in six-inch heels with padded

hips and tits hanging out? If you think about it carefully, it's alarming.[21]

The playful element of this look, and the sense in which it became merely one shade in the expanding palette of femininity, rather than a single didactic mode to be adopted by all, perhaps prevented it from being entirely backward looking. It was certainly a more self-conscious and humorous adaptation of the *femme fatale* than that which had been popular in the mid-1970s. Exemplified by the coldly glossy vamps who adorned the covers of Roxy Music albums of the period, the 1970s look spectacularised femininity, yet

Figure 38: John Galliano, spring/summer 1992, photograph by Niall McInerney. Copyright Niall McInerney.

seemed to exclude the possibility of any female pleasure from the performance. The models become the sum of their airbrushed parts: the bruised glitter of eyeshadow eyes, juicy red doll mouths, and flowing hair. Like Guy Bourdin's fashion noir images, the artificiality of their glamour became repressive, out of their control.

Angela Carter wrote of these conflicting ideas of femininity in 1975. She referred to the great impact that Andy Warhol's celebration of drag queens had and asked whether after the unease surrounding traditional visions of femininity of the sixties:

> the only people we could go to to find out what it [femininity] had looked like were the dedicated male impersonators who had kept the concept alive in the sequined gowns, their spike-heeled shoes and their peony lipstick? Probably.[22]

Fears about this influence of gay fashion designers in the creation of notions of femininity were long standing, and reflected wider cultural fears of gayness itself. In 1953 Edmund Bergler had written:

> It seems to me that inventions of this sort [i.e. exaggerated fashions] should be credited to the homosexual's hidden enmity against the female customer, a defensive enmity which originated in the unsolved homosexual conflict with the infantile image of the Giantess of his individual nursery.[23]

The spectre of the phallic mother, nurturing yet castrating, is a powerful and destructive vision, that reflects the hidden anxieties of many men, not specifically

those who are Gay. The fascination and repulsion felt towards women who flaunt femininity as a masquerade is deep-seated in western culture. In the 1947 film *The Secret Life of Walter Mitty*, Danny Kaye plays a weak day-dreamer dominated by the women in his life. At one point he fantasises that he is a milliner, with a fake foreign accent and camp, overstated gestures. Reflecting social mistrust of both homosexuality and femininity, which were both judged to be inauthentic in their emphasis on style and surface, he sings of his outlandish creations,

> And why do I sew each new chapeau in the style they must look positively grim in? Strictly between us, entre nous, I hate women.[24]

For many men and women there is a feeling that women who use femininity as an over-statement, who deliberately ignore pressure to look 'natural' and modest are suspicious because they seem to be dressing up for themselves rather than to attract men. Many men feel threatened by the overt acknowledgement of female sexual power. Richard Curle wrote in 1949 of scarlet lips and nails as 'tribal marks', saying of those who in his opinion use too much make-up, '... the appeal of that minority is about as limited as is the appeal of the fictional 'vamp' lying curled up on a tiger skin. The average man either fights shy of them or treats them as a joke.'[25] In his confidence, Curle forgets that it may not be the 'average man' that such women wish to appeal to. The vamp's continuing allure and iconic status, in both fashion and film, would suggest that this particular variety of same-sex drag has a very significant power, precisely because of the conflicting responses of desire and anxiety that it provokes.

In the 1990s the revival of couture as a spectacle relied upon the gay subcultural sensibility of drag. The art of creating a strong character of towering femininity through exaggerated dress and excessive adornment, and the fetishistic use of previous iconic styles, has been prevalent in the work of both John Galliano for Givenchy and even more so at Dior, and also of Alexander McQueen at Givenchy. Their statuesque designs speak of both dominance and romance, and use clothing as a means of constructing and remaking identities, as part of a wardrobe of femininities available at the end of the century. Fear of exaggeration, of drawing too much attention to oneself that is so important a part of respectable bourgeois culture, has become a moral restraint to be defied rather than reinforced by couture fashion, now so self-reflexive in its parodies of its own past and the feminine images it has created.

Dressing Up: Man

Since masculinity is held up as a signal of the 'norm' in Western culture, any deviation from conventional male attire is viewed with great unease. Exaggeration within the dress of those men who wish to step outside these somewhat rigid definitions has a long history, and exaggeration itself need only be slight to provoke moral anxiety. This is perhaps because to question masculinity within a strictly patriarchal society threatens the existing balance of power. Traditionally, men who blurred definitions of masculinity by expressing an overt interest in fashion were viewed suspiciously within western culture. They undermined stable ideas of men as workers and providers and slipped

instead into the 'feminine' realm of sensuality and adornment.

During the eighteenth and nineteenth centuries, groups of men like the Macaronis and Swells in England, the *Incroyables* in France, and the Dudes in America, sought to distinguish themselves through exaggerated and elaborate dress. They threw open the masquerade of masculinity, showing it to be another cultural construction rather than a given.

Masculinity was so firm a foundation of contemporary social and political institutions in the eighteenth and nineteenth centuries, that any transgression was seen to be a betrayal of manhood, and a threat to the status of the country. Although masculinity was equated with 'culture' and femininity with 'nature', there was a very real fear of 'unnatural' masculinity. While it was accepted that gentlemen needed to demonstrate good etiquette and social poise, there was great unease that this could tip over into effeminate vanity. Any hint of exaggeration was deeply mistrusted because it was seen to indicate a subversive nature. A careful balance had to be struck between being overdressed for a particular occasion and underdressed, since slovenly costume was viewed as a symptom of indolence and immoral conduct. In the nineteenth century, European empires grew and the thrusting explorer, soldier or industrialist was worshipped. These elements were reflected in the proliferation of uniforms in male dress during that period. While there were deviations in the style and cut of men's attire during the period, the repressive silhouette of the three-piece suit was ever present.

The dandy of the early nineteenth century, as personified by Beau Brummell in London, subverted these meanings of masculine sobriety. Instead of using overt exaggeration and elaboration to signal difference as the eighteenth century Macaroni had done, the dandy revered plainness and neatness in dress. Every detail of the dandy's dress must be perfect: dark fine wool coat, starched white linen shirt and cravat, buff breeches or pantaloons, hessian boots and soft yellow leather gloves. Dandies represented exaggerated sobriety rather than flamboyance in their dress. Fashionable young men were absorbed by inconspicuous consumption, which required close attention to, and knowledge of the quality of fabric and cut. The dandy's over-emphasis on the exterior was felt to break the Puritan ethic of humility. The sober tones of his dress only served to complicate the signals it gave off. Dandies seemed respectable yet were obviously outside the accepted ideas of masculinity. Beau Brummell, who defined the dandy, was from a trade or service background and used fetishised neatness and plainness as symbols of restrained good taste and control. His dress exemplified the ease with which the non-aristocrat could pass for his betters. His was an austere aesthetic that the upper classes followed and it relied upon self-respect rather than respect from others based on rank. Dandies were sexually ambiguous, more interested in the approval of other dandies than the attention of women. Thomas Carlyle mocked them as part of a pseudo-religion, playing upon religious severity and stress on a strict ritual of cleaning and washing – seemingly virtuous yet founded upon vanity. He wrote:

And now, for all this perennial Martyrdom, and Poesy, and even

Figure 39: George Bryan 'Beau' Brummell, 1805, engraving by John Cook, National Portrait Gallery, London. By courtesy of the National Portrait Gallery, London.

Gender and Subversion

Prophecy, what is it that the Dandy asks in return? Solely, we may say, that you would recognise his existence; would admit him to be a living object; or failing this, a visual object, or thing that will reflect rays of light.[26]

Oscar Wilde's late nineteenth-century dandy was a more flamboyant and sexualised creature, who rejected the Puritanical strictness of Brummell's era. The aesthetes' love of style for its own sake was a direct attack upon conventional masculine models, and reinforced Carlyle's concerns. Dress was yet to be acknowledged as a means of resistance, a visual insult to stifling norms. During the last years of the nineteenth century the concepts of both homosexuality and feminism were crystallised, and although they were unrelated, they were viewed as a joint assault on contemporary manhood: 'The challenge to young men of the turn of the century was not only to adapt successfully to the pressures of modern urban life, but to adjust to these changing standards of femininity.'[27]

The line between acceptance and rejection of the 'norm' was and remains thin. Certain acts of flamboyance are countenanced within male dress codes, context and tradition is paramount. Post-war youth cultures successfully lifted the mask of masculinity, by revealing that the uniformity and anonymity of the suit was itself a construction, that it was a costume which was consumed like any other, and had been perfected to the point of inscrutability by the ruling classes, who visually asserted their power through their 'respectable' dress, setting an example that the lower classes were to aspire to in their 'Sunday Best'. In the twentieth century, the groomed image of the bowler-hatted city gent sits on the 'right' side of 'gentlemanly' while the mod's obsession with detail smacks of vanity and a lack of concern for the things that are deemed to matter. Masculinity rests upon unwritten acceptance of paying attention to dress only within certain arenas, where it can be read as a sign of duty, discipline and devotion to a just cause. Concentration on style within youth cultures seems to speak of concerns with leisure, and loyalty to groups of friends, rather than to the wider concerns with which men are meant to align themselves. The mods '... seemed to consciously invert the values associated with smart dress, to deliberately challenge the assumptions, to falsify the expectations derived from such sources'.[28]

Mods' Italian-style suits, individually tailored and smartly accessorised, were intended to impress upon the onlooker the mod's imagined status, rather than his actual social position. Neatness was a symbol of middle-class morality, yet the mod was usually working class and keen to subvert his immaculate image with gestures of insouciance and defiance. Groups like the mods and Teddy Boys before them, took the leap of imagination to construct their own status and visual code, through a spectacularised version of the dress of their supposed 'betters'. Teenagers had increased spending power by the 1950s and their role models were from the glittering world of rock' n' roll. The fashion agenda was set by those who were supposed to blindly follow, as in the days of the original dandy. Masculinity, so long the 'norm' was fragmenting more than ever. The imagined images of maleness, drawn from ideas of power and status, as

well as the fictional and visual representations of the 'hero' had constituted, as Graham Dawson noted:

> An *imagined identity* [which] is something that has been 'made up' in the positive sense of active creation ... It organizes a form that a masculine self can assume in the world (its bodily appearance and dress, its conduct and mode of relating), as well as its values and aspirations, its tastes and desires.[29]

The new role models of the post-Second World War period also challenged moralists keen to reassert the respectable heroes of sport, the military or politics. Writing just before the Second World War, designer Elizabeth Hawes had despaired of men ever dressing in a way that allowed for more individuality and self-expression. She acknowledged that men's business suits were functional and easy to mass-produce, but she felt that men could wear lighter clothes in summer and brighter clothes for parties. However, she recognised that the average man was highly suspicious of any significant change in dress, fearing above all that he might be made to look ridiculous, and the easiest way to look foolish was to show too much regard for fashion. Hawes echoed the opinion of many when she wrote:

> With all my desire to see men comfortable, I would like everyone to understand from the beginning that the very last thing I should like to see is the introduction of Fashion into men's clothing. Fashion ... is fast becoming one of the greater ills of our time.[30]

Fashion brought with it not only the devil of consumerism, but also the threat to stability contained in the notion that masculinity was off-the-peg in the same way that vain femininity was. As the century progressed this challenge to masculinity became more acute, having to search for new constructions in response to feminist, gay rights and black civil rights criticism of its bias towards white, heterosexual, middle-class ideals. Shifts in work patterns have also undermined the stoic strength of tradition. The workplace has been opened up to women and to people of other ethnic groups. Work itself has changed, shifting away from the heavy industries towards those based on technology and public services, requiring different and less physical skills as well as different attitudes.

By the end of the 1960s, the subverted suiting of the mods was being overtaken by the decadent styles of the hippies and the psychedelic unisex of stars like Jimi Hendrix and the Rolling Stones. Mick Jagger's dishevelled bohemian style was portrayed in the 1968 film *Performance* and was disturbing not only because of the star's careless narcissism, but the drug-induced haziness of the masculinity that he embodied. He was heterosexual, yet flaunted long hair, and a skinny androgynous body. He was shown in Cecil Beaton's photograph taken on the set of *Performance* thrown back among a confusion of glittering, jewel-coloured cushions and throws, a studded leather wristband the only (albeit rebellious) emblem of masculinity.

The notion that straight men might wear frilled and colourful clothes was decried in the press. In Britain, David Bowie's mercurial image proved the definitive icon of malleable gender identity, inspiring the sparkling hedonism of glam rock. The confused messages given out by such

Gender and Subversion

ensembles were to cause unease on both sides of the Atlantic. In *The Morality Gap* of 1976, Mark Evans claimed that such images had promoted a 'warped and perverse culture'. He saw the use of such unisex styles as an example of how: 'in recent months, rock audiences have become so accustomed to the sick, the bizarre, the violent and the obscene, that promoters are forced to seek new depths of depravity in order to hit the Top 40'.[31] He expresses the long held fear that such transgressive dress will only lead to worse affronts to morality, that visual difference is one step away from physical protest against the status quo. Since fashion and youth culture continually need to push boundaries further, each challenge to masculinity compels the next subversion and blurred gender divisions can never be clarified again. What Evans failed to realise was that antagonising the establishment was a means to assert difference as something positive rather than frightening. Germaine Greer wrote of such young men: 'Their [long] hair was a sign that they did not accept the morality of the crop-haired generation of bureaucrats which sired them.'[32]

By the 1980s the notion that masculinity was as much a masquerade as femininity was represented in the flamboyant costumes of clubland once more. The New Romantics theatricalised cross-dressing for men and women. They wore elaborate combinations of real and imagined past styles, painting their faces to enhance fantasy and artifice, their escape from the natural. Vivienne Westwood's Pirates collection of 1980 epitomised this postmodern pastiche of the past as gender playfulness rather than restrictive traditions. The unisex designs combined references to real seventeenth century dress in

the convex seamed breeches and square-toed boots, with the glamour of the Hollywood pirate, dishevelled and battle-torn, in bright red and gold layers. The so-called 'gender-bending' of pop stars like Boy George, who drew upon this eclectic dress code, was sufficiently mainstream by 1985 for mass-market cosmetics line Boots No.7 to use a male model in full, pearlised make-up for its advertising campaign, with the line 'Looks better on a girl', the ironic pay-off.

The realisation in the 1980s that there is no single stereotype of gayness had enabled gay style to be used in more areas of fashion. Also, focus on the male body and voyeuristic depictions of it reinforced

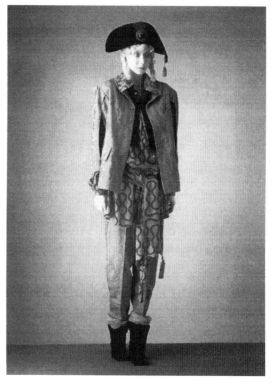

Figure 40: Vivienne Westwood, Pirates collection, (London, World's End), 1980, Victoria & Albert Museum, London (T.334-I-1983). Courtesy of Victoria & Albert Museum Picture Library.

the attack on a single view of the masculine. The exaggerated style of the Buffalo Boy, and Herb Ritts' and Bruce Weber's objectification of the male body, showed that men were increasingly required to consume to maintain a sense of their masculinity. Advertisements reinforced people's need to acquire the right 'look' to meet contemporary expectations. Ray Petri's styling of the Buffalo look was important because it encapsulated the contemporary approach to masculinity, bringing together cult icons of 'classic' maleness, using for example, cowboy, Native American and boxing motifs, which had strong associations with childhood dressing-up games as well as their cultural resonances. It also constructed the club uniform of customised MA1 jacket, Levi's 501 jeans, Dr Marten's shoes and white T-shirts, garments which again present a heady cocktail of functional anonymity, in their military/workwear history, stylish transcendence of 'mere' fashion and acknowledgement of current gay subcultural dress. The images he created with Marc Lebon and Jamie Morgan for magazines like *i-D* and *The Face* were highly influential, opening up the market for later men's magazines like *Arena* in 1986. All focused on the same concerns of tough, sports-inspired style, with the emphasis on the 'design classic', creating new options for masculinity. As Jamie Morgan wrote of Petri's style, 'His images were strong and sensitive – they showed you didn't have to drink beer and beat people up to be tough. He gave men a sense of pride in the way they dress which was hugely influential.'[33]

This look certainly had more impact than the more extreme experiments of the time. Female designers like Katharine Hamnett,

who produced fluid parachute silk shirts and trousers in the mid-eighties, and Vivienne Westwood, who favoured rich fabrics and decoration in her designs, offered more sensual and playful types of menswear, but it was Jean Paul Gaultier whose gender games became the most notorious. His male sarong skirts and knee-length kilts of the mid-eighties were seen to be too direct a challenge to masculine power. His approach highlighted the role-playing that is the basis of the masculine (as well as the feminine). By exposing masculinity as artifice, the lie that masculinity is natural and fixed collapsed under his stylised examination. However, it was his faux gangster-style double-breasted suits that were the dominant look of the aspirational male, and only the bravest would attempt one of his beaded matador boleros. Public unease meant that the male skirt was the reserve of the nightclub fantasy. In 1995 a man lost his case against Hackney Council in London, which had banned him from wearing a skirt to work; this challenge to the official 'norm' had proved too disquieting.

In order to maintain the status quo, the dress codes assigned to the masculine must not be subverted in a manner that cuts through the discipline and lack of emotion implicit in traditional styles, in particular at work. It is notable that this is also the last place in which women are often made to wear skirts, a throwback to older ordering systems. Employers are reluctant to admit that fundamental changes in gender definition and women's status have taken place.

Menswear in the 1990s has seen the continued opening up of options for men, particularly with the growth in club-orientated labels like W<. Walter Van

Bierendonck's diffusion range includes both the usual layered sports-led styles that black youth culture popularised in the previous decade and post-Gaultier fetish-wear. Latex T-shirts in vibrant colours that turn men into postmodern cartoon heroes are shown at spectacular fashion shows, teeming with drag queens, carousel horses and swirling lights, which close the gap with womenswear presentation.

While many men would perhaps prefer the more restrained quirkiness of Paul Smith's tailoring, or the subtle textures of Dries Van Noten, that such a variety of style is now on offer to men demonstrates

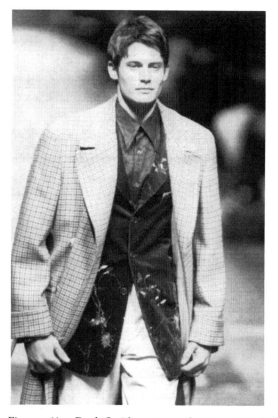

Figure 41: Paul Smith, autumn/winter 1998/9, photograph by Niall McInerney. Copyright Niall McInerney.

the blurred lines of gender in the 1990s. The skinny models used by many designers from Gucci to Dolce & Gabbana, may make many uneasy about masculinity's lost confidence, but it is also a sign that, in Anne Hollander's words, 'Both sexes play changing games today, because for the first time in centuries men are learning clothing habits from women, instead of the other way around.'[34]

Although there may be more scope in women's dress for subversive signals, since femininity is not traditionally so important in the power structure, both the presentation and design of menswear became more spectacular in the last 30 years of the twentieth century. Ambiguity causes insecurity because definite understanding cannot easily be reached. This detracts from the neutral status usually accorded to the masculine. In the second half of the twentieth century it was recognised that society is multicultural, that there is increasing equality of the sexes and sexualities. This acknowledgement forced masculinity to take part in the gender debate rather than to define it, and this in turn naturally led to anger from traditionalists, who longed for a monolithic past that never really existed.

Unisex

Unisex dress that disguises gender distinctions and presents a masquerade of equality for all, has been a recurring utopian dream. In the twentieth century the fragmentation of traditional lines of status and power has led to periods when solace has been sought through this denial of difference. The diversity of contemporary culture and the break-up of existing

ideas of gender, race and sexuality led to confusion surrounding definitions of identity. Some youth cultures, like hippies in the sixties and ravers in the late eighties and early nineties, adopted unisex dress that implied reconciliation between various groups, each seeking equal representation.

Uncertainty surrounding gender identities has frequently been accompanied by a more functional way of dressing. This breaks through the exclusivity of high fashion leading to a desire for clothing that is easy to wear and relatively cheap. As Gille Lipovetsky has pointed out,

> The movement toward equality has eliminated signs of ostentatious difference...it has facilitated the promotion of 'authenticity' and 'truth' as values attributed to the object. The celebration of functional beauty owes little to the diverse social strategies of distinction; it is rooted in the techniques of mass production.[35]

In the 1990s, casual-wear continued to have not only a unisex feel, but also a growing homogeneity. At the beginning of the decade, economic recession led to a collapse in confidence and the flaunting of expensive fashionable dress became both unfeasible and distasteful. Many turned away from fashion, seeing it as the ultimate symbol of the uncaring, self-indulgent consumerism that they blamed for the

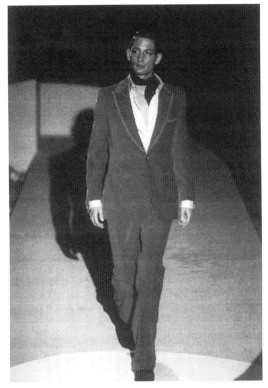

Figure 42: Gucci, autumn/winter 1996/7, photograph by Niall McInerney. Copyright Niall McInerney.

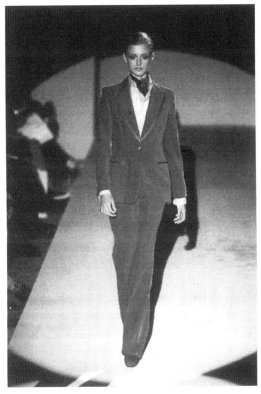

Figure 43: Gucci, autumn/winter 1996/7, photograph by Niall McInerney. Copyright Niall McInerney.

Gender and Subversion

current financial crisis. Designers turned to the bland, unisex ease of the diffusion range as a means to stay afloat. Although few of these ranges were completely unisex, most played down gender difference and focused on simple, functional dress that was given a veneer of edgy, streetwise chic through the cachet of the designer's label, and eye-catching advertising campaigns. Prada, which had promoted industrial nylon to high fashion status, pioneered this escape into simplicity. However, it was the American designers, in particular Calvin Klein, who, in the face of chaotic reality, mastered the retreat into anonymous homogeneity. Steve Daly wrote of Klein's work in *The Face* in 1995: 'Most of his products are, after all, on just the right side of generic ... And yet we keep coming back for anything bearing The Name, always rendered in that immaculately tasteful, almost faceless typeface.'[36] The clothes seemed familiar and yet new. Steeped in references to authentic work-wear, they were advertised with attention-grabbing images of 'real' models, who seemed to be caught against a succession of seedy backdrops in increasingly compromising poses. These gave a feeling of uneasy teenage sexuality, like that in Larry Clark's film *Kids* of 1995. Klein's provocative promotional techniques drew recriminations from the American president, and were branded 'adverteasing' by Hillary Clinton. This just added to the aura of subversiveness that was appropriated for Klein's clothing. There was a clear indication that the clothing would not define its wearer, but allow them to be an individual; their own, fashionable persona would lend the same edginess to the clothes as Klein's attitude-driven advertising.

This defying of constructed definitions by wearing simple basics was a favourite theme, picked up on by brands at all levels of fashion, from Calvin Klein, to Gap and Muji. It combined the inverted status value of the 'classic' that had grown in appeal during the 1980s, as an alternative to the myriad options fashion offered, with the desire to avoid restricting definitions that was a feature of contemporary youth culture.

As gender debates raged and sex was under siege from moralists, warning of death and disease, refuge was found in the childlike visual style of rave, which hid from the adult world in fairground fantasies of nostalgia and escape. According to Caroline Evans, ravers devised '... new as yet unrecognised, forms of resistance, such as the tactic of making themselves invisible, both through the ordinariness of their bland and baggy fashions, and through the fly-by-night nature of the rave'.[37] Ravers adopted the oversized t-shirts and bright colours of the Ibizan holidays that had crystallised the style. The remote, transient setting of many raves heightened the feeling of fluidity and this increasingly influential subculture grew to encompass many forms of music, from ragga to industrial techno, all coming under the hazy categorisation of 'dance'. The Ecstasy-fuelled intimacy of the culture, was reinforced by the 'Smiley' logo that was appropriated in the late 1980s as the motif of rave. Clothing erred on the side of unisex for much of the early period of the movement, again a symptom of the masking of difference, the blurring of the actual diversity of music, styles and beliefs of the party-goers.

Clothing was as playful as the mood of rave, with neon colours, swirling patterns

and babies' dummies all part of the hedonistic release from the need to be grown-up, to make choices, and fit into a neat category. Rave had its own fashions, from baggy flares to Timberland boots to T-shirts with retro-cartoon characters printed on them and deliberately provocative brand names. In his short story, 'Heart of the Bass', Kevin Williamson writes of an encounter between two characters, highlighting both this use of teasing logos, and the hidden sexuality of the subculture, which, to the distanced onlooker, seemed to be devoid of sexual encounters, 'Sleepy Sue has gouched off into limboland beside him so he slides his hand up her T-shirt and makes the word FUCT ripple around like shimmering waves on a lycra shore.'[38] As rave developed and evolved, its seeming lack of any agenda antagonised those who felt that subcultures should be defiant and political. But rave used child-like imagery as a delighted affront to such seriousness, in resistance to the compulsion to care about the world of the establishment that seemed to have so little meaning or knowledge of the concerns of the younger generation.

In the 1990s rave lost some of its unisex ambiguity. Girls wore body-hugging lycra, derived from the skimpy shine of aerobics outfits, the ultimate feminine sports-wear, and, importantly, from the more sexually provocative fashions of black club-culture, which were prominent in the mix of 'dance' music. Twinned with hotpants and bra tops from the contemporary seventies disco revival, it was a heady combination.

Rave moved away from the utopian dream of unisex, like their subcultural cousins, the hippies, whose 'peace and love' ethos of the late 1960s had been a reference for the former's own 'loved-up' mood. The hippies had advocated similarly genderless casual wear, in its style, 'a beautiful explosion of sexually ambiguous silks and beads'.[39] The potential difficulties of such homogeneity were glossed over. Although promising equality, unisex dress has always been essentially masculine in style.

This unisex dream of togetherness was echoed in the work of Rudi Gernreich who designed brightly coloured, flowing kaftans, to be worn by anyone of any age in 1970, and predicted that everyone would be wearing unisex clothes by 1980. However, men shied away from what they perceived as the feminine overtones of his designs, preferring the safely masculine 'unisex' of denim, worn with long hair as a concession to counterculture sensibilities. Indeed, when Yves Saint Laurent launched a 'genderless' scent, Eau Libre in 1975, it was firmly rejected by consumers. It was not until the 1990s that the public was ready to be persuaded by Calvin Klein's CK One, and its inclusive marketing. By then the fragmentation of gender divisions, and the desire for simplicity as a cocoon from the confusion of the contemporary world meant that the perfume, like the 'New Unisex' was hailed as 'honest', although Klein's description of CK One as 'disguising differences'[40] highlights the fatal flaw in unisex theorising: It can only ever be a disguise, a veil to conceal diversity as something troubling, rather than positive. Confusion about gender is inevitable in a period that has seen such upheaval in traditional constructions and ideals, yet, as Naomi Schor points out, 'Denied sexual difference shades into sexual indifference and following the same slippery path, into a

paradoxical reinstatement of the very differences the strategy was designed to denaturalize.'[41]

Androgyny

... [T]he One which contains the Two; namely, the male (andro-) and the female (*gyne*).[42]

While unisex seeks to mask the body in supposedly genderless clothes, androgyny seeks to unite male and female, masculine and feminine in one body. The resulting hermaphrodite vision represents a return to a 'sense of a primordial cosmic unity',[43] a point of union which would assuage gender confusion and anxiety, by evoking a mythical pure state of being before the Fall. It is apposite then that the late twentieth century has been so preoccupied with androgynous fashions, which reflect the attempt to reconcile the gender differences that had been thrown into such cold relief by contemporary debates.

Since the 1920s androgyny has been associated with the search for greater independence for women, the merging of genders signifying a desire to inscribe masculine power upon the female body. The mystery and seductive potential of the androgynous body, slim and youthful yet knowing and self-aware, was emblematic of the inter-war period and of the search for the 'modern' woman, who could encapsulate the shift towards a public dynamic femininity. The boyish silhouette spoke of adolescence, both in its push for freedom and its ambiguous status between definitions. This fascinating uncertainty was embodied in the star personae of Greta Garbo and Marlene Dietrich, who added the exoticism of European accents to their shimmering Hollywood appearances. Their frequently mannish costumes heightened the glow of their softly lit feminine faces, hinting at uncharted sexualities beneath the disguising fashions that adorned their bodies. Sybil DelGaudio wrote of the ambiguity of Dietrich's image in 1993:

In highlighting difference, incongruity becomes another way of suggesting that things are not as they seem. Cross-dressing disguises one's sexual identity and presents an outer appearance that does not match the inner reality of one's sexual self.[44]

It was not just that these actresses adopted male dress, it was that they seemed to combine both masculine and feminine within their screen identities, appearing strong and assertive yet vulnerable and seductive. The conflicting emotions that they represented are part of the spell cast by the androgyne on modern fashion. They are also part of the uncertainty that surrounds such imagery.

During the 1960s the same narrow silhouette was evoked, again to denote freedoms gained and the rejection of a preceding claustrophobic femininity. For some second-wave feminists the race towards androgyny seemed liberating, offering the opportunity to surmount the problematic differences between men and women and move on to a higher plain of gender reconciliation. However, the fantasy of 'wholeness' ignored the roots of the androgynous body, which had always imagined the union of the sexes via the classical Greek adoration of the athletic male youth. Since the earliest times the

images of the androgyne had shown only male genitalia, and the flat, waistless figure of the masculine adolescent.

Kari Weil writes of women's adoption of this image as a symptom of their constant 'mimicry' when constructing identity, adopting and assimilating the current ideal through dress, make-up and gesture. She writes: 'Through mimicry women take control of the role they must play by a deliberate act, and thereby enact and affirm the disjunction between that role and themselves.'[45] The problem is that the 'role' of androgyny requires the mimicking of a masculine image, albeit one which is softened by the ambiguities of youthfulness. The disparity between the boyish dress worn and the feminine contours of the body beneath sharply reveals the act of fashion as one of disguise, giving an air of both mystery and disquiet. Journalist Joyce Maynard wrote in her memoirs about the image created by the ambiguous styles popular in 1969, saying:

> 'Purple tights are meant for spindle legs; boy's sleeveless undershirts are embroidered for girls who want to look like boys – girls with sad eyes and trembling lips who dress and move and talk ... with what's become a favourite noun, the highest compliment – vulnerability.[46]

This sits ill with the notion that women might acquire power through androgyny and suggests a backdrop of anxiety to women's growing freedoms. While blurred gender lines may suggest a progressive disregard for stifling traditions, 'That androgyny has often functioned as a conservative, if not a misogynistic, ideal is evident in the long and learned tradition of dual sexed beings.'[47] Feminists like Weil were increasingly dubious about the denial of gender difference, at first seeking rather to assert an essentialist view of femaleness, and then attempting to recognise masculine, feminine and androgynous as possible choices within the spectrum of role-playing identities.

During the 1970s photographer Helmut Newton eroticised the delicate androgyne of the previous decade, shooting her in the hazy twilight of city streets in Yves Saint Laurent *le smoking*, drawing on the mystery and exoticism of Dietrich's image. The sharp black tailoring of Saint Laurent's trouser suits were juxtaposed with fluid transparent blouses, the sensuality of the image contained suggestions of both power and desire, and represented a more adult interpretation of androgyny than the child-like images constructed in the sixties. Increasingly then, androgyny became part of a selection of identities, a range of disguises constructed by fashion that masked and made pleasurable, if only for a fleeting moment, the issues surrounding gender at the end of the twentieth century.

The 1990s saw men and women being drawn into the play of androgyny, at first by wearing their hair long and adopting more unisex styles, but by the end of the decade the image had become leaner, and more edgy. Men looked back to the ambiguous icons of the seventies, like David Bowie, as well as more contemporary figures like Jarvis Cocker of Pulp. They flaunted an androgynous image as a distancing device, like the women of the sixties, they seemed awkwardly adolescent in thrift shop style too-tight T-shirts and low-slung trousers, reflecting similar anxieties about their own gender identity, delaying adulthood and the implied need

to obtain a more clearly defined 'fixed' identity, from which they feel alienated.

For women androgyny still presented a contradictory selection of signifiers. The strong, nonchalant designs of Anne Demeulemeester project a confident disregard for definitions. Other images are less assured though, with the fashion for hipsters, which demand a flatly masculine frame, embodying the problematised aesthetic of the androgyne. Alexander McQueen first exposed the stomach down to below the hip bone in the gaunt tailoring of the 'bumster' trousers that he designed in 1993. Other designers moderated the style, by raising the 'waistline' to

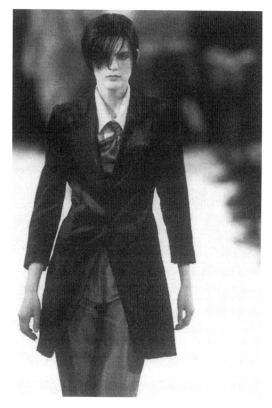

Figure 45: Anne Demeulemeester, autumn/winter 1995/6, photograph by Niall McInerney. Copyright Niall McInerney.

sit on the hipbone, thus reviving the sixties hipster, along with that decade's exclusion of the fuller stomach as a symbol of maternity. Once again adulthood was denied, the slim body needed to carry this style excluded many women from the androgynous ideal. The pervasive nature of this teenage silhouette was echoed by the 'waif' model of the early part of the decade and required younger and younger girls to portray its ideals in the glossy pages of fashion magazines. Katie Ford of Ford Models Inc., in New York said in 1998, 'A lot of models are probably the youngest I can ever remember ... Designers are looking for a very young look now. They want girls with a very straight shape – you don't have that in your 20s.'[48]

The seeming anonymity that unisex and androgyny provide ultimately serves only to highlight the differences between genders. While the twentieth century saw the overthrow of many stereotypes about the way men and women should dress, and behave, tensions still existed, and it is hard to conceive of an unproblematic image of masculinity, femininity or, indeed, androgyny. Fashion is intimately implicated in this re-negotiation of identities, tied forever as it is to the body, revealing our desires and anxieties in an often provocative way. Identity and morality are increasingly fluid, shifting self-consciously to create and then dismantle existing norms. Fashion, as the most instant and changeable aspect of visual culture, provides a microcosm of fragmentary ideals, shedding sometimes uncomfortably harsh light on the contradictions of western culture, and its uneasy relationship with the body that it at once desires and reviles.

Conclusion

Fashion is always the product of the culture that spawns it, embodying the concerns of the wider society in its myriad styles. Inherently contradictory, fashion constructs a realm which is ambiguous, able to bear the weight of the varied meanings which flicker across the body of the wearer. The contradictory nature of fashion relates to our unease about the body and its representation, we are fascinated by and yet uncertain of the responses dress provokes: its juxtapositions can be protective, shielding the wearer from those outside their group, who are unable to read the complex signifiers that are pulled around the body. It can also expose the wearer, excavating hidden desires and fears, and unsettling the onlooker with ambivalent messages that confront taboos and challenge notions of the acceptable. The constant shifting of fashion, its rapid turnover of styles, allows the fluid definitions of gender, sexuality, ethnicity, status and class that populate a culture in transition, to be captured and revealed. Fashion needs constantly to stay ahead, to entice the consumer with the temptations of the new, to distract a culture satiated with imagery by creating visions that experiment with and challenge conventional morality.

Dress indicates both conscious and subconscious attitudes to morality, showing the ideas and ideals of the designer and the wearer, and, by extension, the culture itself. The examples that are discussed in this book reveal these deeper, underlying desires and anxieties, reinforcing the importance of fashion imagery, as well as actual dress, in shaping and, indeed, fracturing notions of acceptability. The period between the 1970s and 1990s has witnessed an intensification of this process, as fashion has reflected the rapid change in cultural values in response to the breakdown of faith in political, religious and media institutions. Diverse groups have sought to assert their own values and desires, through sartorial codes, as well as political action. The hierarchy of fashion itself had been undermined in the sixties, as couture gave up its dictatorship and distinctions between different types of dress blurred. The varied influences that fashion now draws upon reflect both the sensuality of luxury and wealth, and the confrontational rawness of brutality and violence. Fashion is no longer concerned with producing only images of perfection that smooth out the reality of the body and the harshness of western capitalist culture. It now encompasses references to death and decay, uncertainty and yearning, in its allusions to the detritus of the city, illuminating the shifting moralities of contemporary existence.

Notes

INTRODUCTION

1. Stivers, R., *The Culture of Cynicism, American Morality in Decline*, Oxford: Blackwell, 1994, p.x

CHAPTER 1

1. Harrison, M., *Appearances*, London: Jonathan Cape, 1991, p. 266.
2. Nava, M., *Changing Cultures, Feminism, Youth and Consumerism*, London: Sage, 1992, p. 167.
3. Pumphrey, M., 'The Flapper, the Housewife and the Making of Modernity', *Cultural Studies*, vol. 1, no. 2, 1987, p. 186.
4. Barnett, H.G., *Innovation, The Basis of Cultural Change*, New York: McGraw-Hill, 1953, p. 139.
5. Mosely, C., *The Letters of Nancy Mitford, Love from Nancy*, London: Hodder & Stoughton, 1993, p. 197.
6. Hopkins, H., *The New Look, A Social History of the Forties and Fifties in Britain*, London: Secker & Warburg, 1963, p. 95.
7. Quoted in Rawsthorn, A., *Yves Saint Laurent, A Biography*, London: Harper Collins, 1996, p. 112.
8. Reed, J.R., *Decadent Style*, Athens, Ohio: Ohio University Press, 1985, p. 1.
9. Norman, P., *The Age of Parody, Dispatches From the Eighties*, London: Hamish Hamilton, 1990, p. 5.
10. Debord, G., *The Society of the Spectacle*, New York: Zone, 1994, p. 153.
11. Tulloch, L., *Fabulous Nobodies*, London: Picador, 1989, p. 16.
12. Faludi, S., *Backlash, The Undeclared War Against Women*, London: Vintage, 1992, p. 208.
13. Langley, W., 'Farewell to High Fashion?', *Evening Standard*, 22.1.93, p. 10.
14. Bradberry, G., 'The Man who Combined Beauty with Vulgarity', *The Times*, 16.7.97, p. 16.
15. For a fuller account of the appropriation of such brands see: Godfrey, J., Procope, D. & Templer, K., 'Ruder than the Rest', *The Face*, vol. 2, no. 30, March 1991, pp. 72–85.
16. Letts, Q., 'Flash is Back!', *Evening Standard*, 15.9.97, p. 11.
17. Polan, B., 'J'Accuse', *Daily Mail*, 19.7.97.
18. Wilson, E., 'These New Components of the Spectacle: Fashion and Postmodernism', Rattanasi, A. & Boyne, R. (eds), *Postmodernism and Society*, London: Macmillan, 1990, p. 209.
19. Simmel, G., 'Fashion', in Levine D.N. (ed.), *Georg Simmel On Individuality and Social Forms*, Chicago: University of Chicago Press, 1971, p. 297.
20. Meikle, W., *Towards a Sane Feminism*, London: Grant Richards, 1916, p. 67.
21. Ibid., p. 62.
22. Vreeland, D., *D.V.*, New York: Alfred A. Knopf, 1984, p. 129.
23. Dariaux, G.A., *Elegance, A Complete Guide for Every Woman who Wants to be Well and Properly Dressed on All Occasions*, London: Frederick Muller, 1964, p. 16.
24. Friedan, B., *The Feminine Mystique*, London: Penguin, 1983, p. 200–1.
25. Arnold, E., *Eve Arnold, In Retrospect*, London: Sinclair-Stevenson, 1996, p. 4.

26. The furs used in Alexander McQueen's designs for Givenchy were, at least, made from recycled pelts.

27. Quoted in, Gaudoin, T., 'Could it be Furever?', *Elle*, December 1995, p. 78.

28. Collard, A. with Contrucci, J., *Rape of the Wild, Man's Violence Against Animals and the Earth*, London; The Women's Press, 1988, p. 55.

29. Bell, Q., *On Human Finery*, London: Allison & Busby, 1992, p. 31.

30. Quoted in, Sherwood, J., 'All the Fun of the Fur', *The Independent on Sunday, Real Life*, 14.9.97, p. 9.

31. For an account of economic issues surrounding the wearing of fur see Emberley, J.V., *Venus and Furs, The Cultural Politics of Fur*, I.B. Tauris, 1998.

32. Coupland, D., *Generation X, Tales for an Accelerated Generation*, London: Abacus, 1997, p. 92.

33. Coward, R., *Female Desire: Women's Sexuality Today*, London: Paladin, 1984, p. 31.

34. Davis, F., *Fashion, Culture & Identity*, Chicago: Chicago University Press, 1994, p. 63.

35. Dent Candee, M. (ed.), *Current Biography, Who's News and Why, 1954*, New York: The H.W. Wilson Company, 1954, p. 423.

36. Steiner, R.L. & Weiss, J., 'Veblen Revised in the Light of Counter-Snobbery', *Journal of Aesthetics and Art Criticism*, vol. 9, no. 3, March 1951, p. 263.

37. Ibid., p. 265.

38. Quoted in, Gaines, S., *Halston, The Untold Story*, New York: G.P. Putnam's Sons, 1991, p. 15.

39. Thornton, P., 'CKDKNYOK?', *The Face*, vol. 2, no. 87, December 1995, p. 145.

40. Bourdieu, P., *Distinction, A Social Critique of the Judgement of Taste*, London: Routledge, 1996, p. 281.

41. Armstrong, L., 'The New Snobbery', *Vogue*, April 1995, p. 172.

42. Spindler, A.M., 'Tracing the Look of Alienation', *New York Times*, 24.3.98.

43. Mower, S., 'Margiela does Hérmès', *Harper's Bazaar*, June 1998, p. 147.

44. Martin, R., 'Destitution and Deconstruction: The Riches of Poverty in the Fashions of the 1990s', in *Textile and Text*, vol. 15, no. 2, 1992, p. 4.

45. Carter, A., 'The Recession Style', in *Nothing Sacred, Selected Writings*, London: Virago, 1992, p. 92.

46. Koda, H., 'Rei Kawakubo and the Aesthetic of Poverty', *Dress*, vol.11, 1985, p. 8.

47. Yohji Yamamoto, in *Notebook on Cities and Clothes*, dir. Wim Wenders, 1989.

48. Wilson, E., 'Fashion and the Postmodern Body', in Wilson, E. & Ash, J., *Chic Thrills, A Fashion Reader*, London: Pandora, 1992, p. 4.

49. McCracken, G., '" Ever Dearer in Our Thoughts", Patina and the Representation of Status Before and After the Eighteenth Century', *Culture and Consumption*, Bloomington: Indiana University Press, 1990, p. 32.

50. Dior, C., *Christian Dior's Little Dictionary of Fashion, A Guide to Dress Sense for Every Woman*, London: Cassell, 1954, p. 6–7.

51. Ibid., p. 15.

52. Montague, K., 'The Aesthetics of Hygiene: Aesthetic Dress, Modernity & the Body as Sign', *Journal of Design History*, vol. 7, no. 2, 1994, p. 97.

53. Witzenmann, H., *The Origin and Overcoming of the Materialistic World-Outlook, The Natural-Scientific Attitude of Consciousness as World Danger and Hope for the Future*, London: Living Art Publishing, 1976, p. 1.

54. König, R., *The Restless Image, A Sociology of Fashion*, London: George Unwin, 1973, p. 207.

55. Soper, K., 'Nature/"Nature"', in Robertson, G. et al. (eds), *FutureNatural, Nature, Science, Culture*, London: Routledge, 1996, p. 25.

56. Lipovetsky, G., *The Empire of Fashion, Dressing Modern Democracy*, Princeton, N J: Princeton University Press, 1994, p. 248.

57. McRobbie, A., 'A New Kind of Rag Trade?', in Ross, A. *No Sweat, Fashion, Free*

Trade and the Rights of Garment Workers, London: Verso, 1997, p. 276.

CHAPTER 2

1. Stivers, R., *The Culture of Cynicism, American Morality in Decline,* Oxford: Blackwell, 1994, p. 155.
2. Easton Ellis, B., *American Psycho,* London: Picador, 1991, p. 9.
3. Ibid., p. 399.
4. Margaret Thatcher, quoted in Coren, V., 'Why Thatcher is Wrong about the Nation's Young', *Evening Standard,* 25.5.96, p. 25.
5. Gerrard, N., 'In Front of the Children', in French, K. (ed.), *Screen Violence,* London: Bloomsbury, 1996, p. 88.
6. Durkheim, E., *Suicide, A Study in Sociology,* London: Routledge & Kegan Paul, 1970, p. 256.
7. Bruzzi, S., *Undressing Cinema, Clothing and Identity in the Movies,* London: Routledge, 1997, p .70.
8. Quoted in Perry, G., 'Fear and Clothing', *The Sunday Times Magazine,* 14.4.96, p. 78.
9. Fraser, J., *Violence in the Arts,* Cambridge: Cambridge University Press, 1974, p. 16,
10. Carter, A., 'Notes from a Theory of Sixties Style', in *Nothing Sacred, Selected Writings,* Virago, 1992, p. 86.
11. Hume, M., 'A History of Controversy on the Catwalk', *The Independent, Section 2,* 10.2.95, p. 2.
12. Fraser, *Violence in the Arts,* p. 9.
13. Hooks, B., *Outlaw Culture, Resisting Representations,* London: Routledge, 1994, p. 117.
14. Ross, A., 'The Gangsta and the Diva', in Golden, T., (ed.), *Black Male, Representations of Black Masculinity in Contemporary American Art,* New York: Whitney Museum of American Art, 1994, p. 165.
15. Ross, A., 'The Gangsta and the Diva', *The Nation,* 22–9.8.94, p. 191.
16. Elms, R., 'The Golden Age of Football Violence', *The Face,* no. 73, May 1986.
17. Allen, R., *The Complete Richard Allen, vol. 1,* Argyll: S.T. Publishing, 1992, p. 14.
18. Marshall, G., *Skinhead Nation,* Argyll: S.T.Publishing, 1996, p. 63.
19. Ian Donaldson and four other members of the group were convicted in 1977, for their creation of what was deemed to be an illegal political uniform, of 'black trousers, white power t-shirts, and black bomber jackets with Nazi insignia.' See J.B. Moore's *Skinheads Shaved for Battle. A Cultural History of American Skinheads,* Bowling Green Ohio: Bowling Green State University Popular Press, 1993, p. 57.
20. Moore, *Skinheads Shaved for Battle,* p. 101.
21. Kohn, M., 'The Best Uniforms', in McRobbie, A. (ed.), *Zootsuits and Second-Hand Dresses, An Anthology of Fashion & Music,* London: Macmillan, 1989, p. 147.
22. Debord, G., *The Society of the Spectacle,* New York: Zone, 1994, p. 12.
23. Valenti, C.C., 'Torpedoes, Tarts and the Birth of the Amazon', in Jones, T. (ed), *The I-D Bible, Part Two,* London: Terry Jones & Tony Elliott (eds), 1988, p. 48.
24. Brampton, S., 'The Prime of Miss Vivienne Westwood', *Elle,* September 1988, p. 204.
25. President Clinton quoted in Harvey, M., 'Drug Chic Gets a Shock', *The Daily Mail,* 23.5.97, p. 16.
26. President Clinton quoted in Helmore, E. & Pryor, N., 'Clinton Rages at Fashion Industry over Sick Taste in Heroin Chic', *Evening Standard,* 22.5.97, p. 3.
27. Polan, B., 'Commentary', *Daily Mail,* 23.5.97, p. 17.
28. Kohn, M., *Narcomania,* London: Faber & Faber, 1987, p. 9.
29. The legislation was passed under the Defence of the Realm Regulation 40B in July 1916. Although it did not cover heroin or cannabis, it established the principle of prohibition. For a full account of the impact and significance of this legislation see Marek Kohn's excellent account of the period in *Dope Girls, The Birth of the British Drugs Underground,* London: Lawrence & Wishart, 1992.

30. Lidz, C.W. & Walker, A., *Heroin, Deviance & Morality*, London: Sage, 1980, p. 21.
31. McRobbie, A., *Postmodernism & Popular Culture*, London: Routledge, 1994, p. 169.
32. Dr Robert Millman quoted in Usborne, D., 'Cheap, Strong and Chic: Heroin is Back with a Bang', *The Independent on Sunday*, 25.5.97, p. 13.
33. Helmore, & Pryor, 'Clinton Rages at Fashion Industry', p. 3.
34. Ibid., p. 3.
35. Chalmers, M., 'Heroin, the Needle and the Politics of the Body', in McRobbie, *Zootsuits and Second-Hand Dresses*.
36. Savage, J., 'Brother Beyond', *The Face*, vol. 3, no. 2, March 1997, p. 207.
37. Chalmers, 'Heroin, the Needle and the Politics of the Body', p. 152.
38. Ibid., p. 152.
39. Booker, C., *The Neophiliacs*, London: Collins, 1969, p. 264.
40. Jones, D., 'Chasing Dragons', *The Independent on Sunday, Sunday Review*, 1.6.97, p. 7.
41. Patterson, S., 'Cosmic Girl', *The Face*, vol. 3, no. 1, February 1997, p. 52.
42. Smith, D., 'Introduction' to Nietzsche, F., *On the Genealogy of Morals*, Oxford: Oxford University Press, 1996, p. xii.
43. McDowell, C., 'Depravity Bites', *The Guardian, Weekend*, 9.8.97, p. 36.
44. Buck-Morss, S., *The Dialectics of Seeing, Walter Benjaimin and the Arcades* Project, Cambridge, MA: MIT Press, 1997, p. 97.
45. Spencer, M., 'Return of the Rich Bitch', *Evening Standard*, 24.3.97, p. 23.
46. Buck-Morss, op. cit., p. 98.
47. Ibid., p. 99.
48. Ibid., p. 99.
49. Ibid., p. 107.

CHAPTER 3

1. Pumphrey, M., 'The Flapper, the Housewife, and the Making of Modernity', *Cultural Studies*, vol. 1, no. 2, 1987, p. 184.
2. Quoted in Allen, F.L., *Only Yesterday, An Informal History of the Nineteen-Twenties*, New York: Harper & Brothers, 1931, p. 92.
3. McDowell, C., 'Breathtaking', *The Sunday Times, Style*, 5.2.1995, p. 20.
4. Perniola, M., 'Between Clothing and Nudity', in Feher, M., with Naddaff, R. and Tazi, N. (eds), *Fragments for a History of the Human Body, Part 2*, New York: Zone, 1989, p. 237.
5. Radcliffe Richards, J., *The Sceptical Feminist, A Philosophical Enquiry*, Middlesex: Penguin, 1994, p. 249.
6. Ibid., p. 241.
7. MPPDA Production Code, 1930, in Steinberg, C., *Reel Facts, The Movie Book of Records*, London: Penguin, 1981, p. 550.
8. Ibid., p. 558.
9. Hollander, A., *Sex and Suits, The Evolution of Modern Dress*, New York: Kodansha, 1995, p. 135.
10. Quoted in Turner, L., 'Indecent Exposure', *ES Magazine*, December 1991, p. 52.
11. Smith, J., 'What's the problem with Women?', *The Guardian*, Section 2, 20.2.98, p. 3.
12. Cowie, E., 'Pornography and Fantasy, Psychoanalytic Perspectives', in Segal, L. and McIntosh, M. (eds), *Sex Exposed, Sexuality and the Pornography Debate*, London: Virago, 1992, p. 136.
13. De Beauvoir, S., *The Second Sex*, London: Vintage, 1997, p. 190.
14. Ibid., p. 624.
15. Gane, M., *Baudrillard's Bestiary, Baudrillard and Culture*, London: Routledge, 1991, p. 111.
16. *Nova*, August 1971, p. 59.
17. Myers, K., 'Fashion 'n' Passion: A Working Paper', in McRobbie, A. (ed.), *Zootsuits and Second-Hand Dresses, An Anthology of Fashion and Music*, London: Macmillan, 1989, p. 192.
18. Stuart, A., 'Feminism: Dead or Alive?', in Rutherford, J. (ed.), *Identity, Community, Culture, Difference*, London: Lawrence & Wishart, 1990, p. 33.
19. Bennett, C., 'High Exposure', *Vogue*, February 1987, p. 154.

20. Mower, S., 'Who's Shocking Who?' *Elle*, November 1995, p. 246.

21. Wilson, E., 'Outsiders', *The Guardian Weekend*, 26.11.94, p. 65.

22. Evans, C. and Thornton, M., *Women and Fashion, A New Look*, London: Quartet, 1989, p. 83.

23. hooks, b., *Outlaw Culture*, London: Routledge, 1994, p. 11.

24. Sontag, S., 'Notes on Camp', in *Against Interpretation*, London: Vintage, 1994, p. 277.

25. Grant, L., 'Cut and Thrust', *The Guardian, Section 2*, 5.2.96, p. 7.

26. Quoted in Nilgin, Y., 'Outward Bound', British *Elle*, August 1990, p. 108.

27. Buck-Morss, S., *The Dialectics of Seeing, Walter Benjamin and the Arcades Project*, Cambridge, MA: MIT, 1997, p. 97.

28. Quoted in Frankel, S., 'The First Time I looked through a Camera, I Knew that Was What I Wanted to Do', *The Guardian, Section 2*, 3.6.98, p. 10.

29. Quoted in Windlin, C. (ed.), *Juergen Teller*, Cologne: Taschen, 1996, p. 8.

30. Freedland, J., 'Sex and the Psycho Girl', British *Elle*, February 1995, p. 38.

31. Buck-Morss, *The Dialectics of Seeing*, p. 107.

32. Gilbey, R., 'Doom Generation: New Tales from the Dark Side', *The Face*, May 1997, p. 122.

33. Brooks, R., 'Sighs and Whispers in Bloomingdales: A Review of a Bloomingdales Mail-Order Catalogue for the Lingerie Department', in McRobbie, A. (ed.), *Zootsuits and Second-Hand Dresses*, p. 186.

34. *Rites of Passage, Gallery Guide*, London: Tate Gallery 1995.

35. Coward, R., *Female Desire: Women's Sexuality Today*, London: Paladin, 1984, p. 29.

36. Briscoe, J., 'The Skull Beneath the Skin', *The Guardian, Section 2*, 18.2.97, p. 2.

37. Baudrillard, J., *Symbolic Exchange and Death*, London: Sage, 1995, p. 111.

38. James, O., 'The Happiness Gap', *The Guardian, Section 2*, 15.9.97, p. 2.

39. Fowler, R., 'How to End the Fashion Famine', *The Independent*, 1.6.96, p. 17.

40. Wolf, N., *The Beauty Myth*, London: Vintage, 1990, p. 191.

41. Quoted in Spencer, M., 'Big, Beautiful, but Will it stay in Vogue?', *Evening Standard*, 22.5.97.

42. Rose, P., *Jazz Cleopatra, Josephine Baker in her Time*, London: Vintage, 1989, p. 44.

43. Said, E., *Orientalism, Western Conceptions of the Orient*, London: Penguin, 1995, p. 188.

44. Wollen, P., *Raiding the Icebox, Reflections on Twentieth-Century Culture*, London: Verso, 1993, p. 17–18.

45. Rose, P., *Jazz Cleopatra*, p. 44.

46. Dyer, R., *The Matter of Images, Essays on Representation*, London: Routledge, 1993, p. 142.

47. Grant, L., 'The Old Colour of Money', *The Guardian, Section 2*, 15.4.97, p. 8.

48. Quoted in Chunn, L., 'Not a Simple Black and White Case', *Evening Standard*, 10.4.97, p. 12.

49. Grant, L., 'Why Fay Doesn't Want to Look like Naomi …', *The Independent on Sunday, Real Life*, 25.9,94, p. 23.

CHAPTER 4

1. Showalter, E., *Sexual Anarchy, Gender and Culture at the Fin de Siècle*, London:Virago, 1992, p.4

2. Curle, R., *Women, An Analytical Study*, London:Watts & Co, 1949, p.103

3. Hawes, E., *Men Can Take It*, New York: Random House, 1939, p.2

4. Bill, K., 'Attitudes Towards Women's Trousers: Britain in the 1930s', *Journal of Design History*, vol.6, no.1, 1993, p.47

5. Zefferelli, F., *Franco Zefferelli, The Autobiography*, London: Arena, 1987, p.100
My thanks to Adrian Garvey for drawing this extract to my attention.

6. Dingwall, F.J., *The American Woman, A Historical Study*, London: Gerald Duckworth, 1956, p.vii

7. Ellis, A., *The American Sexual Tragedy*, New York: Twayne, 1954, p.48

8. Lundberg, F., & Farnham, M.F., *Modern Woman, The Lost Sex*, New York: Harper & Brothers, 1947, p.222

9. Ibid., p.223

10. Showalter, E., *The Female Malady, Women, Madness, and English Culture, 1830–1980*, London: Virago, 1985, p.3-4

11. Greer, G., *The Female Eunuch*, London: Granada, 1971, p.58

12. de Beauvoir, S., *The Second Sex*, London: Vintage, 1997, p.692

13. Quoted in Walter, N., *The New Feminism*, London: Little, Brown & Company, 1998, p.84

14. Brownmiller, S., *Femininity*, London: Hamish Hamilton, 1984, p.79

15. Evans, C. & Thornton, M., *Women & Fashion, A New Look*, London: Quartet, 1989, p.94

16. Wilson, E., *Adorned in Dreams, Fashion & Modernity*, London: Virago, 1987, p.245

17. Walter, *The New Feminism*, p.95

18. Wilson, *Adorned in Dreams, Fashion & Modernity*, p.246

19. Ru Paul quoted in, Pike, L., 'Life is a Drag', *Elle*, March 1992, p.38

20. Walter, N., 'Who's Afraid of the Catwalk?', *The Independent*, 6.3.95, p.15

21. Quoted in Pike, L., 'Life is a Drag', *Elle*, March 1992, p.38

22. Carter, A., 'The Wound in the Face', *Nothing Sacred, Selected Writings*, London: Virago, 1992, p.97

23. Bergler, E., *Fashion & the Unconscious*, New York: Robert Brunner, 1953, p.8

24. Songwords by Sylvia Fine, from *The Secret Life of Walter Mitty*, dir. Norman Z. McLeod, 1947

25. Curle, *Women*, p.102

26. Carlyle, T., *Sartor Resartus*, Oxford: Oxford University Press, 1987, p.207

27. Barraclough Paoletti, J., 'Ridicule and Role Models as Factors in American Men's Fashion Change, 1880–1910', *Costume* no.19, 1985, p.126

28. Hebdige, D., 'The Meaning of Mod', in Hall, S. & Jefferson, T. (eds), *Resistance through Rituals, Youth Subcultures in Post-War Britain*, London: Routledge, 1996, p.88

29. Dawson, G., 'The Blond Bedouin', in Tosh, J. & Roper, M. (eds), *Manful Assertions*, London: Routledge, 1991, p.118

30. Hawes, *Men Can Take It*, p.7

31. Evans, M., *The Morality Gap*, Ohio: Alba Books, 1976, p.32

32. Greer, *The Female Eunuch*, p.37

33. Quoted in, 'Nature Boy', *The Face*, vol.2, no.14, November 1989, p.60

34. Hollander, A., *Sex & Suits, The Evolution of Modern Dress*, New York: Kodansha, 1995, p.181

35. Lipovetsky, G., *The Empire of Fashion, Dressing Modern Democracy*, Princeton, NJ: Princeton University Press, 1994, p. 143

36. Daly, S., 'He's Got the Whole World...In his Pants', *The Face*, vol.2, no.87, December 1995, p.142

37. Evans, C., 'Dreams that Only Money Can Buy...Or, The Shy Tribe in Flight From Discourse', *Fashion Theory, The Journal of Dress, Body & Culture*, vol.1, issue 2, June 1997, p.170

38. Williamson, K., 'Heart of the Bass', Champion, S. (ed.), *Disco Biscuits*, London: Sceptre, 1997, p.113

39. Carter, A., 'Notes for a Theory of Sixties Style', in Carter, *Nothing Sacred*, p.87

40. Quoted in Briscoe, J., 'The New Unisex', *Elle*, November 1994, p.94

41. Schor, N., 'Dreaming Dissymetry: Barthes, Foucault, & Sexual Difference', Jardine, A. & Smith, P. (eds), *Men in Feminism*, London: Methuen, 1987, p.100

42. Singer, J., *Androgyny, Towards a New Theory of Sexuality*, New York: Anchor Press/ Doubleday, 1976, p.20

43. Ibid., p.20

44. Del Gaudio, S., *Dressing the Part, Dietrich and Costume*, London: Associated University Presses, 1993, p.101

45. Weil, K., *Androgyny and the Denial of Difference*, Charlottesville: University Press of Virginia, 1992, p.160

46. Maynard, J., *Looking Back, A Chronicle of Growing Up Old in the Sixties*, London: Michael Joseph, 1975, p.116

47. Weil, *Androgyny*, p.2

48. Quoted in Wilson,C., 'Drugs and Fashion', *The Telegraph Magazine*, 27.6.98, p.35

Bibliography

Books

Allen, F.L., *Only Yesterday, An Informal History of the Nineteen-Twenties*, New York: Harper & Brothers, 1931

Allen, R., *The Complete Richard Allen, vol.1*, Argyll: S.T. Publishing, 1992

Arnold, E., *Eve Arnold, In Retrospect*, London: Sinclair-Stevenson, 1996

Barnett, H.G., *Innovation, The Basis of Cultural Change*, New York: McGraw-Hill, 1953

Baudrillard, J., *Symbolic Exchange and Death*, London: Sage, 1995

Bell, Q., *On Human Finery*, London: Allison & Busby, 1992

Bergler, E., *Fashion & the Unconscious*, New York: Robert Brunner, 1953

Booker, C., *The Neophiliacs*, London: Collins, 1969

Bourdieu, P., *Distinction, A Social Critique of the Judgement of Taste*, London: Routledge, 1996

Brownmiller, S., *Femininity*, London: Hamish Hamilton, 1984

Bruzzi, S., *Undressing Cinema, Clothing and Identity in the Movies*, London: Routledge, 1997

Buck-Morss, S., *The Dialectics of Seeing, Walter Benjamin and the Arcades Project*, Cambridge, Ma: MIT Press, 1997

Carlyle, T., *Sartor Resartus*, Oxford: Oxford University Press, 1987

Carter, A., *Nothing Sacred, Selected Writings*, London: Virago, 1992

Champion, S. (ed.), *Disco Biscuits*, London: Sceptre, 1997

Collard, A. with Contrucci, J., *Rape of the Wild, Man's Violence Against Animals and the Earth*, London: The Women's Press, 1988

Coupland, D., *Generation X, Tales for an Accelerated Generation*, London: Abacus, 1997

Coward, R., *Female Desire, Women's Sexuality Today*, London: Paladin, 1984

Curle, R., *Women, An Analytical Study*, London: Watts & Co, 1949

Dariaux, G.A., *Elegance, A Complete Guide for Every Woman who Wants to be Well and Properly Dressed on All Occasions*, London: Frederick Muller, 1964

Davis, F., *Fashion, Culture & Identity*, Chicago: Chicago University Press, 1994

de Beauvoir, S., *The Second Sex*, London: Vintage, 1997

Debord, G, *The Society of the Spectacle*, New York: Zone Books, 1994

Del Gaudio, S., *Dressing the Part, Dietrich and Costume*, London: Associated University Presses, 1993

Dent Candee, M. (ed.), *Current Biography, Who's News and Why, 1954*, New York: The H.W. Wilson Company, 1954

Dingwall, E.J., *The American Woman, A Historical Study*, London: Gerald Duckworth, 1956

Dior, C., *Christian Dior's Little Dictionary of Fashion, A Guide to Dress Sense for Every Woman*, London: Cassell, 1954

Durkheim, E., *Suicide, A Study in Sociology*, London: Routledge & Kegan Paul, 1970

Dyer, R., *The Matter of Images, Essays on Representation*, London: Routledge, 1993

Easton Ellis, B., *American Psycho*, London: Picador, 1991

Ellis, A., *The American Sexual Tragedy*, New York: Twayne, 1954

Evans, C. & Thornton, M., *Women and Fashion, A New Look*, London: Quartet, 1989

Evans, M., *The Morality Gap*, Ohio: Alba Books, 1976

Faludi, S., *Backlash, The Undeclared War Against Women*, London: Vintage, 1992

Feher, M. with Naddaff, R. & Tazi, N. (eds), *Fragments for a History of the Human Body, Part 2*, New York: Zone, 1989

Fraser, J., *Violence in the Arts*, Cambridge: Cambridge University Press, 1974

French, K. (ed.), *Screen Violence*, London: Bloomsbury, 1996

Friedan, B., *The Feminine Mystique*, London: Penguin, 1983

Gaines, S., *Halston, The Untold Story*, New York: G.P. Putnam's Sons, 1991

Gane, M., *Baudrillard's Bestiary, Baudrillard and Culture*, London: Routledge, 1991

Girard, R., *Violence and the Sacred*, Baltimore, MD: Johns Hopkins University Press, 1981

Golden, T. (ed.), *Black Male, Representations of Black Masculinity in Contemporary American Art*, New York: Whitney Museum of American Art, 1994

Greer, G., *The Female Eunuch*, London: Granada, 1971

Hall, S. & Jefferson, T., (eds) *Resistance through Rituals, Youth Subcultures in Post-War Britain*, London: Routledge, 1996

Harrison, M., *Appearances*, London: Jonathan Cape, 1991

Hawes, E., *Men Can Take It*, New York: Random House, 1939

Hebdige, D., *Subculture, The Meaning of Style*, London: Routledge, 1993

Hollander, A., *Sex & Suits, The Evolution of Modern Dress*, New York: Kodansha, 1995

hooks, b., *Outlaw Culture, Resisting Representations*, London: Routledge, 1994

Hopkins, H., *The New Look, A Social History of the Forties and Fifties in Britain*, London: Secker & Warburg, 1963

Jardine, A. & Smith, P. (eds) *Men in Feminism*, London: Methuen, 1987

Jones, T. (ed), *The I-D Bible, Part Two*, London: Terry Jones & Tony Elliott, 1988

Kohn, M., *Narcomania*, London: Faber & Faber, 1987

Kohn, M., *Dope Girls, The Birth of the British Drug Underground*, London: Lawrence & Wishart, 1992

König, R., *The Restless Image, A Sociology of Fashion*, London: George Unwin, 1973

Levine, D.N. (ed.), *Georg Simmel, On Individuality and Social Forms*, Chicago: University of Chicago Press, 1971

Lidz, C.W. & Walker, A., *Heroin, Deviance and Morality*, London: Sage, 1980

Lipovetsky, G., *The Empire of Fashion, Dressing Modern Democracy*, Princeton, NJ: Princeton University Press, 1994

Lundberg, F. & Farnham, M.F., *Modern Woman, The Lost Sex*, New York: Harper & Brothers, 1947

Marshall, G., *Skinhead Nation*, Argyll: S.T. Publishing, 1996

Maynard, J., *Looking Back, A Chronicle of Growing Up Old in the Sixties*, London: Michael Joseph, 1975

McCracken, G., *Culture and Consumption*, Bloomington: Indiana University Press, 1990

McRobbie, A. (ed), *Zootsuits & Second-Hand Dresses, An Anthology of Fashion & Music*, London: Macmillan, 1989

McRobbie, A., *Postmodernism and Popular Culture*, London: Routledge, 1994

Meikle, W., *Towards a Sane Feminism*, London: Grant Richards, 1916

Moore, J.B., *Skinheads Shaved for Battle, A Cultural History of American Skinheads*, Bowling Green, Ohio: Bowling Green State University Popular Press, 1993

Mosely, C., *The Letters of Nancy Mitford, Love From Nancy*, London: Hodder & Stoughton, 1993

Nava, M., *Changing Cultures, Feminism, Youth and Consumerism*, London: Sage, 1992

Nietzche, F., *On the Genealogy of Morals*, Oxford: Oxford University Press, 1996

Norman, P., *The Age of Parody, Dispatches from the Eighties*, London: Hamish Hamilton, 1990

Radcliffe Richards, J., *The Sceptical Feminist, A Philosophical Enquiry*, Middlesex: Penguin, 1994

Rattanasi, A. & Boyne, R. (eds), *Postmodernism and Society*, London: Macmillan, 1990

Rawsthorn, A., *Yves Saint Laurent, A Biography*, London: Harper Collins,1996

Reed, J.R., *Decadent Style*, Athens, Ohio: Ohio University Press, 1985

Robertson, G., Mash, M., Tickner, L., Bird, J., Curtis, B. & Putnam, T. (eds), *Future Natural, Nature, Science, Culture*, London: Routledge, 1996

Rose, P., *Jazz Cleopatra, Josephine Baker in her Time*, London: Vintage, 1989

Ross, A., *No Sweat, Fashion, Free Trade and the Rights of Garment Workers*, London: Verso, 1997

Rutherford, J. (ed.), *Identity, Community, Culture, Difference*, London: Lawrence & Wishart, 1990

Said, E., *Orientalism, Western Conceptions of the Orient*, London: Penguin, 1995

Segal, L. & McIntosh, M., *Sex Exposed, Sexuality & the Pornography Debate*, London: Virago, 1992

Showalter, E., *Sexual Anarchy, Gender and Culture at the Fin de Siècle*, London: Virago, 1992

Showalter, E., *The Female Malady, Women, Madness, and English Culture, 1830–1980*, London: Virago, 1985

Singer, J., *Androgyny, Towards a New Theory of Sexuality*, New York: Anchor Press /Doubleday, 1976

Slim, I., *Pimp, A Story of My Life*, Edinburgh: Payback Press, 1996

Sontag, S., *Against Interpretation*, London: Vintage, 1994

Steinberg, C., *Reel Facts, The Movie Book of Records*, London: Penguin, 1981

Stivers, R., *The Culture of Cynicism: American Morality in Decline*, Oxford: Blackwell, 1994

Sumner, C., *The Sociology of Deviance, An Obituary*, Buckingham: Open University Press, 1996

Tosh, J. & Roper, M., *Manful Assertions*, London: Routledge, 1991

Tulloch, L., *Fabulous Nobodies*, London: Picador, 1989

Vreeland, D., *D.V.*, New York: Alfred A. Knopf, 1984

Walter, N., *The New Feminism*, London: Little, Brown & Company, 1998

Weil, K., *Androgyny and the Denial of Difference*, Charlottesville: University Press of Virginia, 1992

Wilson, E., *Adorned in Dreams, Fashion & Modernity*, London: Virago, 1987

Wilson, E. & Ash, J., *Chic Thrills, A Fashion Reader*, London: Pandora, 1992

Windlin, C. (ed.), *Juergen Teller*, Cologne: Taschen, 1996

Witzenmann, H., *The Origin and Overcoming of the Materialistic World-Outlook, The Natural-Scientific Attitude of Consciousness as World Danger and Hope for the Future*, London: Living Art Publishing, 1976

Wolf, N., *The Beauty Myth*, London: Vintage, 1990

Wollen, P., *Raiding the Icebox, Reflections on twentieth-Century Culture*, London: Verso, 1993

Zefferelli, F., *Franco Zefferelli, The Autobiography*, London: Arena, 1987

Journal Articles

Barraclough Paoletti, J., 'Ridicule and Role Models as Factors in American Men's Fashion Change, 1880–1910', *Costume* no.19, 1985

Bill, K., 'Attitudes Towards Women's Trousers: Britain in the 1930s', *Journal of Design History*, vol.6, no.1, 1993

Evans, C., 'Dreams that Only Money Can Buy ... Or, The Shy Tribe in Flight from Discourse', *Fashion Theory, The Journal of Dress, Body & Culture*, vol.1, issue 2, June 1997

Koda, H., 'Rei Kawakubo and the Aesthetic of Poverty', *Dress*, vol.11, 1985

Martin, R., 'Destitution and Deconstruction: The Riches of Poverty in the Fashions of the 1990s', *Textile and Text*, vol.15, no.2, 1992

Montague, K., 'The Aesthetics of Hygiene: Aesthetic Dress, Modernity & the Body as Sign', *Journal of Design History*, vol.7, no.2, 1994

Pumphrey, M., 'The Flapper, The Housewife and the Making of Modernity', *Cultural Studies*, vol.1, no.2, 1987

Steiner, R.L. & Weiss, J., 'Veblen Revised in the Light of Counter-Snobbery', *Journal of Aesthetics and Art Criticism*, vol.9, no.3, March 1951

Newspaper and Magazine Articles

Armstrong, L., 'The New Snobbery', *Vogue*, April 1995

Bennett, C., 'High Exposure', *Vogue*, February 1987

Bradberry, G., 'The Man who Combined Beauty with Vulgarity', *The Times*, 16.7.97

Brampton, S., 'The Prime of Miss Vivienne Westwood', *Elle*, September 1988

Briscoe, J., 'The New Unisex', *Elle*, November 1994

Briscoe, J., 'The Skull Beneath the Skin', *The Guardian*, Section 2, 18.2.97

Chunn, L., 'Not a Simple Black and White Case', *Evening Standard*, 10.4.97

Coren, V., 'Why Thatcher is Wrong about the Nation's Young', *Evening Standard*, 25.5.96

Daly, S., 'He's Got the Whole World ... in his Pants', *The Face*, vol.2, no.87, December 1995

Elms, R., 'The Golden Age of Football Violence', *The Face*, vol.1, no.73, May 1986

Fowler, R., 'How to End the Fashion Famine', *The Independent*, 1.6.96

Freedland, J., 'Sex & the Psycho Girl', *Elle*, February 1995

Gaudoin, T., 'Could it be Furever?', *Elle*, December 1995

Gilbey, R., 'Doom Generation: New Tales from the Dark Side', *The Face*, vol.3, no.4, May 1997

Grant, L., 'Why Fay Doesn't Want to Look like Naomi ...', *The Independent on Sunday, Real Life*, 25.9.94

Grant, L., 'Cut and Thrust', *The Guardian*, Section 2, 5.2.96

Grant, L., 'The Old Colour of Money', *The Guardian* Section 2, 15.4.97

Harvey, M., 'Drug Chic gets a Shock', *Daily Mail*, 23.5.97

Helmore, E. & Pryor, N., 'Clinton Rages at Fashion Industry Over Sick Taste for "Heroin Chic" ', *Evening Standard*, 22.5.97

Hume, M., 'A History of Controversy on the Catwalk', *The Independent, Section 2*, 10.2.95

James, O., 'The Happiness Gap', *The Guardian*, Section 2, 15.9.97

Jones, D., 'Chasing Dragons', *The Independent on Sunday, Sunday Review*, 1.6.97

Langley, W., 'Farewell to High Fashion?', *Evening Standard*, 22.1.93

Letts, Q., 'Flash is Back!', *Evening Standard*, 15.9.97

McDowell, Colin, 'Breathtaking', *The Sunday Times, Style*, 5.2.1995

McDowell, C., 'Depravity Bites', *The Guardian, Weekend*, 9.8.97

Mower, S., 'Who's Shocking Who?' *Elle*, November 1995

Mower, S., 'Margiela does Hérmès', *Harper's Bazaar*, June 1998

'Nature Boy', *The Face*, vol.2, no.14, November 1989

Nilgin, Y., 'Outward Bound', *Elle*, August 1990

Patterson, S., 'Cosmic Girl', *The Face*, vol.3, no.1, February 1997

Perry, G., 'Fear and Clothing', *The Sunday Times Magazine*, 14.4.96

Pike, L., 'Life is a Drag', *Elle*, March 1992

Polan, B., 'The Triumph of the Trousers', *Evening Standard*, 11.3.92

Polan, B., 'J'Accuse', *Daily Mail*, 19.7.97

Savage, J., 'Brother Beyond, *The Face*, vol.3, no.2, March 1997

Sherwood, J., 'All the Fun of the Fur', *The Independent on Sunday, Real Life*, 14.9.97

Smith, J., 'What's the Problem with Women?', *The Guardian*, Section 2, 20.2.98

Spencer, M., 'Return of the Rich Bitch', *Evening Standard*, 24.3.97

Spencer, M., 'Big, Beautiful, but Will it Stay in Vogue?', *The Evening Standard*, 22.5.97

Spindler, A.M., 'Tracing the Look of Alienation', *New York Times*, 24.3.98

Thornton, P., 'CKDKNYOK?', *The Face*, vol.2, no.87, December 1995

Turner, L., 'Indecent Exposure', *ES Magazine*, December 1991

Usborne, D., 'Cheap, Strong and Chic: Heroin is Back with a Bang', *The Independent on Sunday*, 25.5.97

Walter, N., 'Who's Afraid of the Catwalk?', *The Independent*, 6.3.95

Wilson, C., 'Drugs and Fashion', *The Telegraph Magazine*, 27.6.98

Wilson, E., 'Outsiders', *The Guardian, Weekend*, 26.11.94

Filmography

À Bout de Souffle, dir. Jean-Luc Godard, 1959

Alien, dir. Ridley Scott, 1979

Baby Doll, dir. Elia Kazan, 1956

Barbarella, dir. Roger Vadim, 1968

Belle de Jour, dir. Luis Buñuel, 1967

Betty Blue, dir. Jean-Jacques Beineix, 1986

Blue Velvet, dir. David Lynch, 1986

Bonnie and Clyde, dir. Arthur Penn, 1967

Casino, dir. Martin Scorcese, 1995

Cat on a Hot Tin Roof, dir. Richard Brooks, 1958

Christiane F, dir. Ulrich Edel, 1981

Drugstore Cowboy, dir. Gus Van Sant, 1989

Evita, dir. Alan Parker, 1996

From Russia with Love, dir. Terence Young, 1963

Gilda, dir. Charles Vidor, 1946

The Godfather, dir. Francis Ford Coppola, 1972

Goldfinger, dir. Guy Hamilton, 1964

Kalifornia, dir. Dominic Sera, 1993

Kids, dir. Larry Clark, 1995

The Lady from Shanghai, dir. Orson Welles, 1948

Leave Her to Heaven, dir. John M. Stahl, 1945

Notebook on Cities and Clothes, dir. Wim Wenders, 1989

Paris is Burning, dir. Jenny Livingston, 1990

Performance, dir. Donald Cammell & Nicolas Roeg, 1968

Pulp Fiction, dir. Quentin Tarantino, 1994

Reservoir Dogs, dir. Quentin Tarantino, 1992

Scarface, dir. Howard Hawks, 1932

The Secret Life of Walter Mitty, dir. Norman Z. McLeod, 1947

Shaft, dir. Gordon Parks, 1971

Superfly, dir. Gordon Parks jnr, 1972

Sweet Sweetback's Baadasssss Song, dir. Melvin Van Peebles, 1971

Trainspotting, dir. Danny Boyle, 1996

True Romance, dir. Tony Scott, 1993

Wall Street, dir. Oliver Stone, 1987

Index